Praise for the First Edition of *How Digital Photography Works*

Chosen in 2006 as one of the Best Photo/Digital Books of the Year by *Shutterbug Magazine*

It's ...an indispensable guide for anybody who wants to learn the nuts and bolts of digital photography from optics to the best explanation of noise you will read anywhere....This may sound like dry stuff, but Ron White's tightly written prose and [Tim] Downs' illustrations make it fun. If you want to learn how digital photography works, get this book.

—Shutterbug

This book is well written and loaded with great illustrations that get you inside the mechanics of the digital camera. It is clear enough for the hobbyist and detailed enough for a scientist. The graphics really tell the story. You can move as quickly as you want through the design for a quick reference or slow down and make yourself an expert. Your next camera will be bought on understanding the technology rather than on the marketing hype.

—Peter D. Gabriele, scientist

Best book I've seen on this subject so far. Seriously. Everything is explained very clearly with a step-by-step process on each page that explains how something works or what makes something happen. The colorful illustrations are excellent and so well laid out, that you can often just look at them and figure out what's going on.

I give this book a 5 out of 5 because before this book even starts explaining how DSLRs work, it lays the groundwork and thoroughly shows you how film cameras, lenses, and light all interact and work together—which you must understand first, if you really want to understand how DSLRs work. But, if you choose, you can just jump to a section and learn about it without difficulty.

I got this book as a gift for someone and am now ordering one for myself, because I miss reading it!

—Lithium Nitrate, Amazon reviewer

The Enemy of Misinformation. Anyone with a solid background in photography and digital imaging can tell you that popular digital photography resources—particularly online, and particularly those with unmoderated user forums—are filled with partially (or entirely) incorrect information on this topic. As a rule, most people who use digital cameras on a regular basis do not understand how they work...even when they think they do.

This book is a quick study and a tremendous aid in understanding the underlying technology, mechanisms, and science behind digital photographs. There is also quite a bit of useful information on how lenses work, and rightly so as they are at least 50% of the "picture quality equation." The illustrations alone are worth the cost of the book. The writing style is down-to-earth but not dumbed down, which is refreshing.

I have formal (collegiate) education in the field of photography, have worked in the industry for over five years, and still found many pages in this book to be a huge help / great refresher. Unless you are an engineer working for Nikon or Kodak, there is something in this book that will increase your understanding of digital photography. Definitely recommended.

—CMOS, Amazon Reviewer

And Praise for Ron White and Tim Downs' Bestseller for 10 Years, *How Computers Work*

If knowledge is the light of the world, then the contents of How Computers Work will certainly illuminate much about the inner workings of today's home and business computers without requiring the user to look under the hood.

—*The New York Times*

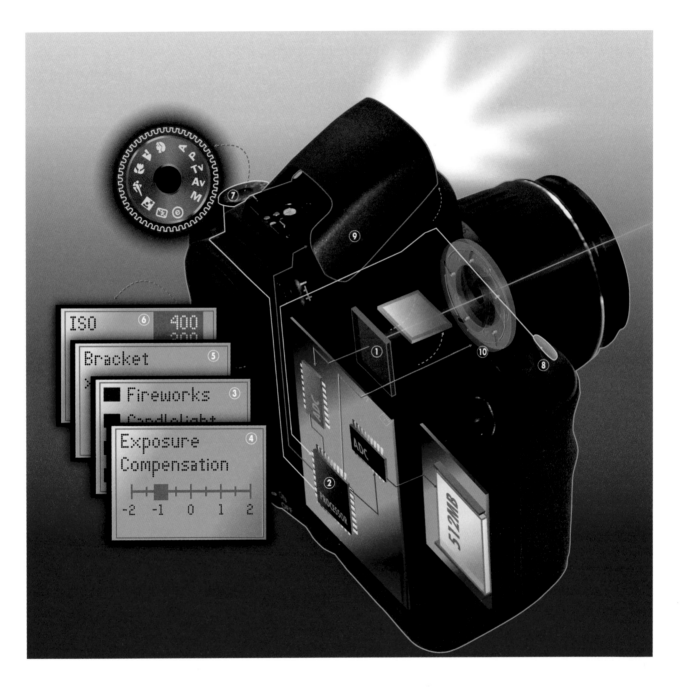

How Digital Photography Works

Second Edition

Ron White

Illustrated by Timothy Edward Downs

800 East 96th Street
Indianapolis, IN 46240

How Digital Photography Works, 2nd Edition
Copyright © 2007 by Ron White

Associate Publisher	Greg Wiegand	Copy Editor	Jessica McCarty
Acquisitions Editor	Stephanie McComb	Proofreader	Linda K. Seifert
Development Editor	Todd Brakke	Indexer	Erika Millen
Technical Editor	Jay Townsend	Publishing Coordinator	Cindy Teeters
Illustrator	Timothy Downs	Cover/Interior Designer	Anne Jones
Managing Editor	Gina Kanouse	Cover/Interior Artist	Tim Downs
Project Editor	Lori Lyons	Page Layout	Jake McFarland

International Standard Book Number 0-7897-3630-6

Printed in the United States of America

First Printing: February 2007

10 09 08 07 4 3 2

Trademarks

Warning and Disclaimer

Bulk Sales

Que Publishing offers excellent discounts on this book when ordered in quantity for bulk purchases or special sales. For more information, please contact

U.S. Corporate and Government Sales
1-800-382-3419
corpsales@pearsontechgroup.com

For sales outside the United States, please contact

International Sales
international@pearsoned.com

 This Book Is Safari Enabled

The Safari® Enabled icon on the cover of your favorite technology book means the book is available through Safari Bookshelf. When you buy this book, you get free access to the online edition for 45 days.

Safari Bookshelf is an electronic reference library that lets you easily search thousands of technical books, find code samples, download chapters, and access technical information whenever and wherever you need it.

To gain 45-day Safari Enabled access to this book:

- Go to http://www.quepublishing.com/safarienabled
- Complete the brief registration form
- Enter the coupon code 5FFU-MLYG-BUBT-JMGR-K5FC

If you have difficulty registering on Safari Bookshelf or accessing the online edition, please e-mail customer-service@safaribooksonline.com.

Library of Congress Cataloging-in-Publication Data

White, Ron, 1944-
 How digital photography works / Ron White ; illustrated by Timothy Edward Downs. — 2nd ed.
 p. cm.
 ISBN 0-7897-3630-6
 1. Photography—Digital techniques—Popular works. 2. Photography—Equipment and supplies—Popular works. I. Title.
TR267.W4873 2007
775—dc22
 2007001058

For Sue, without whom this book and the best things in
life would be impossible,

Ron

For Olivia and Marco, my daily inspiration,

Tim

About the Author

Ron White is the author of the award-winning, decade-long best-seller *How Computers Work* and a dozen other books on digital photography, computers, and underground music. He has been a photojournalist for three decades, both shooting photos and writing for some of the best-known publications in the United States. He gained attention early in his career by leaving the water running in the darkroom at the *San Antonio Light*, flooding the publisher's office. He has since acquired drier recognition as a newspaper and magazine executive and as an award-winning writer and publication designer. He has been recognized by the National Endowment for the Humanities and the Robert F. Kennedy Awards for his criticism and investigative reporting and by the National Magazine Awards for his self-effacing humor as a feature writer and columnist at *PC Computing*. He has been a host on NPR's *Beyond Computing* and a frequent guest on television and radio to explain new technology. Currently, he is working on *The Daily Digital Digest*, a newsletter and Internet blog to expand on the information found in his books. Tim Downs and Ron White have worked together on editorial and advertising technical guides for more than 10 years. Ron lives with his wife, Sue, in San Antonio. He can be reached at ron@ronwhite.com.

About the Illustrator

Timothy Edward Downs is an award-winning magazine designer, a photographer, and the illustrator of the best-seller *How Computers Work*. He has directed and designed several national consumer business, technology, and lifestyle magazines, always infusing a sense of "How it Works" into every project. By tapping his vast computer system and process knowledge, Tim has developed the richly illustrative style that is unique to the *How It Works* series. In *How Digital Photography Works*, Tim has further blurred the lines between informational illustration and photography.

Acknowledgments

WRITING this book was my own exploration into many areas about which I was so unfamiliar that I didn't know how much I didn't know about them until they raised their obscure, obtuse, and unfathomable faces, from which dripped entangled equations and a new vocabulary with terms such as *Airy discs* and *circles of confusion*. What I saw originally as a three-month or four-month project when I started grew by leaps of weeks and bounds of months. While I spent time assimilating optics, one of the strangest sciences I've encountered, a lot of people waited with patience—most of the time, anyway—and encouragement. To them, I owe such tremendous debts of gratitude that I never will be able to repay them adequately. But for now, here's a down payment of thanks to Tim Downs, whose artistry explodes into a new universe with every book we do; my editors at Que, Stephanie McComb, Greg Wiegand, and Todd Brakke; technical editor Jay Townsend; and my agent, Claudette Moore. I'm enormously grateful to John Rizzo for pitching in and writing some of the material in the software section. (If you're a Mac user, check out his *How Macs Work*.)

Usually I have to track down experts and convince them to share their valuable time to answer my layman's questions. After the first edition of *How Digital Photography Works*, however, I unexpectedly received email from two experts offering advice, information, and, ah-hem, corrections. Robert E. Fischer, the CEO of OPTICS 1, Inc., was generous with his time, information, photos, and illustrations. Stephen Shore, an old friend from our days at Ziff-Davis and now president of Stradis Corp.—and who I didn't know did his graduate work in optics—reappeared with helpful advice I really needed. A reader, Don Wagner, pointed out that I had changed the speed of light to about a tenth of what it actually is. I, and the laws of physics, thank him.

For sharing their knowledge, research, and photography, I'm grateful to outdoor photographer Ed Knepley, Ravi Nori, light field camera developer Ren Ng, and Michael Reichmann, whose Lucious Landscape site (http://www.luminous-landscape.com/public/) is a must-see for all photographers. Sabine Su[um]sstrunk of the Swiss Federal Institute of Technology Lausanne, David Alleysson of Universite Pierre-Mendes France, Ron Kimmel of Technion Israel Institute of Technology, as well as Alan Schietzsch of interpolateTHIS.com for sharing their insights and photos regarding the fine art of demosaicing, or demosaication, or... whatever. I couldn't have done this without the help, information, and equipment loans from

Steven Rosenbaum of S.I.R. Marketing Communication, Andy LaGuardia and Craig Andrews of Fujifilm, Eric Zarakov of Foveon, Steve Massinello and Christa McCarthy-Miller for Kodak, Alexis Gerard, President, Future Image Inc., Sam Pardue, CEO of Lensbabies, Ernie Fenn of Sto-Fen Products, Hilary Araujo of Steadicam, Tom Crawford of the Photo Marketing Association International, and Karen Thomas, who first drew me into digital photography.

There are others I'm afraid I've overlooked. One technician at Colorvision was enormously helpful for me understanding color calibration, but I can't for the life of me find his name in my notes.

It's a cliché for authors to thank their spouses for their patience, encouragement, inspiration, and for not running off with someone who spends way less time in front of a keyboard. The thing about clichés, though, is they're often based on truth. I could not have done this without my wife, Sue. She was encouraging, patient, angry, forgiving, insistent, comforting, and a great editor and advisor. Writing a book is not easy, and without someone like Sue, I'm not sure it's even worthwhile.

—Ron White
San Antonio, 2007

We Want to Hear from You!

AS the reader of this book, *you* are our most important critic and commentator. We value your opinion and want to know what we're doing right, what we could do better, what areas you'd like to see us publish in, and any other words of wisdom you're willing to pass our way.

As an executive editor for Que Publishing, I welcome your comments. You can email or write me directly to let me know what you did or didn't like about this book—as well as what we can do to make our books better.

Please note that I cannot help you with technical problems related to the topic of this book. We do have a User Services group, however, where I will forward specific technical questions related to the book.

When you write, please be sure to include this book's title and author as well as your name, email address, and phone number. I will carefully review your comments and share them with the author and editors who worked on the book.

Email: feedback@quepublishing.com

Mail: Stephanie McComb
 Acquisitions Editor
 Que Publishing
 800 East 96th Street
 Indianapolis, IN 46240 USA

For more information about this book or another Que Publishing title, visit our website at www.quepublishing.com. Type the ISBN (excluding hyphens) or the title of a book in the Search field to find the page you're looking for.

Introduction

It's weird that photographers spend years, or even a whole lifetime, trying to capture moments that added together, don't even amount to a couple of hours.

—James Lalropui Keivom

If I could tell the story in words, I wouldn't need to lug around a camera.

—Lewis Hine

WHEN you talk about the quality of a photograph—how good a picture is—what are you talking about? One obvious meaning is creative quality, the photographer's choice of subject matter, the light falling on the subject, and how the photographer frames the picture so that the arrangement of objects in the photo—the picture's composition—all add up to the effect the photographer wants the picture to have when someone else looks at it.

In this book, however, when we discuss *quality*, it means something less esoteric. We're talking about the technical quality of the picture. Here *quality* refers to the sharpness of an image, how well the exposure settings capture the details that are in shadow and in bright light, and how accurate the photo's colors displayed on a computer monitor are to the colors in the original subject, as well as how accurate a hard-copy print is to the colors on the monitor.

Actually, this book rarely speaks of quality at all. That's because it's possible to take good, even great, photos using a $9.99 disposal camera. And it's even easier to take terrible, terrible photos using the most expensive, technically advanced photo system you can buy. One anonymous quotation I came across in my research says, "Buying a Nikon doesn't make you a photographer. It makes you a Nikon owner." I've tried to be nondenominational in this book and generally ignore camera makers' claims that their technology is better than their rivals' technology. There's no blueprint or schematic for creativity. Creativity, by definition, springs out of the originality of one person's mind. If you follow a scheme written in some book about creativity, you aren't creating. You're copying.

Some books and teachers can help you unleash the creativity you already have lurking in your mind. This book simply isn't one of them. And its artist and writer aren't trying to be one of those teachers. Instead, our goal is much simpler: to make you, as photographer, the master of your tools, whether camera, darkroom software, or printer. And to be the complete master of your tools, you must understand how they work, not use them by blindly following someone else's instructions.

With all tools, it's possible to misuse them. Ask anyone who has tried to use pliers to hammer a nail or a hammer to loosen a lid. If you understand how pliers and a hammer work, you're far less likely to push them beyond their capabilities. And if you know how your camera's lens, exposure meter, focusing mechanism, and the dozen or so other controls work, you'll have fewer bad photos—whether intended for the family album or a museum wall—that are ruined because of photographer error.

And speaking of error, if you find anything in this book that you disagree with, please drop be a line at ron@ronwhite.com. One of the things that continually amazed me is the extent to which photographers disagree with one another about the workings of this or that principle or tool. It's as if the science of optics is still up for grabs. I left out much of what could be said about photography because there is so much I could have said. If you think some omission is particularly egregious and you'd like to see it in a future edition, please let me know about that, too. And if you have any photos you're particularly proud of, send those along, too. They are finally what this is all about.

I plan to start a daily newsletter, "The Digital Daily Digest," covering photography, cameras, photo software, and assorted other topics that should interest professional and amateur photographers. There is so much email going on these days that this will be as brief a digest as possible of all the day's photography news, with links to the original stories for those with the time and interest to read more. If you'd like to subscribe—it's free—drop me a line at ron@ronwhite.com.

lens elen

Getting to Know Digital Cameras

I always thought of photography as a naughty thing to do—that was one of
my favorite things about it, and when I first did it, I felt very perverse.

Diane Arbus

PUT a digital camera next to a camera that still uses film—if you can find a new camera that still uses film. How are they different? Some digital cameras are dead ringers for the 35mm SLR—single-lens reflex—that dominated photography for professionals as well as everyman for more than half a century. Nevertheless, a lot of the digital cameras are smaller than any film cameras you'll see outside of a spy movie. A few have some bizarre touches. One twists so that half the camera is at a right angle to rest of it. Some Kodaks have two lenses. Other digitals have abandoned the traditional boxy shape and taken on the forms of credit cards or a child's pencil holder. Still others hide within phones, watches, and binoculars.

However odd their housings might be, digital cameras externally retain much in common with their film ancestors. They both have lenses, some sort of viewfinders to peer through, and similar assortments of buttons and knobs.

The important difference between film and digital cameras is not in their shapes, but what the cameras hide inside. Take off the back of a film camera, and you'll see a couple of slots at one end where you insert your canister of film and an empty spool on the other end to take up the roll of film as each frame is exposed. Between them, directly inline with the lens, is the pressure plate. It provides a smooth, flat surface for the film to rest against. In front of the pressure plate is a shutter made of cloth or metal sheets that open quickly to expose the film and then close just as quickly so the film doesn't get too much light. (Some cameras have shutters in the lens, but you can forget that fact without any ill consequences.)

Take a digital camera and open up the back—you can't! There is no way to open it and see what's inside.

That's what this book is for, to show you what you ordinarily can't see on your own. You'll see in this part that some components of the film camera have survived in digital equipment, most notably lenses and shutters. And you get to look inside digital cameras where much of the apparatus common to film cameras—and the film itself—have been replaced by microchips packed with transistors, electronic switches smaller than dust motes.

Two types of microchips are particularly important, and we'll examine what they do in more detail later on in the book. One is a microprocessor similar to the microchips in computers, wireless phones, and just about anything else these days that runs on electricity—the type computer writers like to refer to as the "brains" controlling an apparatus or a procedure. Some cameras have more than one microprocessor. One "brain" might apply special effects to

photos, whereas another is adept at hurrying photos along to the storage space on memory chips. The other type of chip is less of a brain. It's more like an idiot savant that mindlessly performs a job other microchips would be hopeless at. This chip, called an image processor, is covered with a special type of transistor—millions of them—that is sensitive to light and converts that light into electricity. It takes the place of film.

The image sensor's capability to translate different colors and intensities of light into constantly changing electrical currents is what accounts for the other important differences between digital and film cameras. The most obvious can be seen on digital cameras in the form of the LCD screen on the back of them, like a tiny TV set, where the camera displays the scene to be shot or the photographs already stored in the camera. The LCD has its own array of transistors that do just the opposite of the image sensor's transistors: They convert electricity into light.

If you inspect the two cameras closely enough, you may find some other differences. The digital camera may have, for example, a button or switch for something called white balance. Or have controls for on-screen menus, or for displaying information about a shot you've snapped. It may have a dial with icons on it for shooting sunsets, close-ups, or fast-moving sports, or a button with a trash can on it like the one used for deleting files on a PC. The differences in digital cameras lead to differences in how you shoot pictures, how you use software to process them—the digital equivalent of developing film—and how you print them. But much of what you're used to with film cameras works the same with digital equipment. You still need to put some thought into how you frame your picture. You still must expose the photo correctly. You need to focus the lens on what's important. Digital cameras help you do all of that. But you're on your own when it comes to developing the skill to push the shutter button at the moment of visual truth.

Once you click the shutter, letting light fleetingly strike the image sensor, you've created not just one picture, but the possibility for scores of pictures. And as you'll see later, the future of that picture is limited only by your imagination, and even that is likely to grow as you become more familiar with the possibilities of digital photography.

The Workings of a Digital Camera

You push the button, we do the rest.
**George Eastman, 1888, pitching
the first Kodak camera**

AND there was, indeed, a time when it was just that simple. I recall my father's Kodak. I don't know what happened to it after he died, and so it took some research on eBay to find out that it was most likely a Pocket Kodak 1 or 1A, which Eastman Kodak began selling about the turn of the century—the *last* century, like 1900.

It was not a fancy camera. The upscale Kodaks had red leather billows, polished wood rails for the lens assembly to travel as you focused, brass fittings, and lenses from Zeiss. Daddy's Kodak was serviceable, and a lovely creation in its own right. To take a picture, you looked down into a viewfinder that was a mirror set at a 45-degree angle. It had no motors. You cocked a spring manually and pressed a plunger at the end of a cable tethered to the lens to make the shutter snap open and shut. Focusing was a combination of guesswork and luck, although now that I think about it, I don't recall seeing an out-of-focus picture come out of the camera.

When not in use, the bellows—made of pedestrian black leather—and the lens collapsed into the case, which also held the roll of film. Despite its name, the Pocket Kodak would have been a tight fit in most pockets. But it wasn't a toy. It was meant to be carried and used anywhere.

The thing is, it took very decent photos. And it did so with few means to adjust exposure or focus—and with no opportunity at all to adjust settings we assume should be adjusted with today's cameras. There were no white balance controls, no bracketed shooting or exposure compensation, no depth of field to worry about, no flash or backlighting. You pretty much clicked the shutter and a week later picked up your photos from the drugstore.

Not your father's Kodak maybe...but it was mine.

Today's cameras, with all their automation and intelligence, are very easy to use. But you couldn't blame a novice if the sight of so many knobs and buttons makes him suddenly grow weak. It's not so bad if you take all the controls leisurely and a few at a time. That's what we'll do here to familiarize you with the lay of the land before you embark into the deeper territory of how digital photography works.

Gathering the Light

Here we're looking at two types of digital cameras. The small one is less expensive, so it doesn't have all the features found on the giant to its side. Both cameras, though, follow the same process when they capture a moment of time and a slice of space as millions of numbers that describe perfectly the shapes and colors that constitute a digital photo. Both cheap and expensive cameras start the process the same way—by gathering in light with all its shadows, colors, and intensities, and channeling it through its digital metamorphosis. Here are the parts of a digital camera that kick off the show by latching onto the light.

On/Off switch: It does run on electricity, after all.

Viewfinder: Peer through this window to frame your picture. (See Chapter 4, "How Light Plays Tricks on Perception.")

Menu controls: Knobs or buttons that allow you to make selections from a software menu displayed on the **LCD screen**.

Viewfinder

Lens elements

Light passing through lenses

Light meter: Measures the amount of light bouncing off a subject, information the camera's electronics use to expose the picture correctly. (See Chapter 5, "How Digital Exposure Sifts, Measures, and Slices Light.")

Light meter system: More expensive cameras use a system of light meters to measure light readings from specific parts of the subject.

Viewfinder

Ground glass

Lens elements

Light passing through lenses

Image sensor: A microchip sensitive to light. It replaces film. (See Chapter 7, "How Light Becomes Data.")

Mirror: Reflects light so that the light coming through the lens is seen in the viewfinder. In some cameras, the mirror is replaced by a **beamsplitter**, a combination of prisms, which are blocks of glass or plastic that reflect light through the viewfinder and to other parts of the camera, such as the image sensor. (See Chapter 4.)

Lens: Collects light, passing it through a small opening to focus on a type of microchip called an **image sensor**. (See Chapter 3, "How Lenses Work.")

A Camera's Electronic Circuitry
Like the motherboard in a computer, cameras have printed circuit boards inside them that send electrical signals scurrying from one part of the camera to another, to control and synchronize the many functions of the camera.

Creating the Image

When light first strikes the lens, it is **incoherent** light, or light that travels in all directions indiscriminately. The light might be no brighter than a shadow in a cave, or it might be the glare of the Sahara at noon. But that light is no more an image than mere noise is music. It's the role, mainly, of two parts of a camera—the focus and exposure systems—to mold light into an image that captures and freezes one momentary slice of time and place. In the digital world, new tools let us refine the photograph even further, but the photography still starts with the tools that get the pictures into the camera in the first place.

White Balance button: Adjusts the camera so that, when the camera photographs a white object, it displays a "true" white regardless of how artificial lighting might introduce off-white hues. (See Chapter 5.)

LCD read-out window: Usually in combination with the digital control, this window tells you information such as the resolution, number of shots left, and battery power.

Infrared light source: The **autofocus** mechanism uses infrared rays that have bounced off the subject to determine the distance from the camera to the subject. (See Chapter 3, "How Lenses Work.")

Infrared receiver

Built-in flash

Viewfinder

Additional control knob

Menu controls: Knobs or buttons that allow you to make selections from a software menu displayed on the **LCD screen**.

Shutter button: A switch that, when pressed, triggers an exposure by locking autofocus and autoexposure and opening the shutter. (See Chapter 5, "How Digital Exposure Sifts, Measures, and Slices Light.")

Built-in zoom lens

Light meter: A microchip that senses and measures the intensity of light striking it. (See Chapter 5.)

Rechargable Li-ion battery pack

Viewfinder: Peer through this window to frame your picture. There are many types of viewfinders, their accuracy improving as the camera's price rises. (See Chapter 4, "How Light Plays Tricks on Perception.")

Shoe and/or plug for external flash: Provides a way to synchronize the flash of an externally powered light with the opening of a camera's **shutter**.

Viewfinder

Mode setting control dial

Flash: Produces an intense, brief flash of light when available light is too dim. See Chapter 6, "How Technology Lets There Be Light.")

Internal light metering system: Located near the prism, it measures light coming through the lens, which, compared to an external meter, provides a more accurate and versatile way to set exposure. (See Chapter 5.)

White balance

Focus ring: Lets you adjust the lens so it focuses best on objects that are a certain distance from the camera. (See Chapter 3, "How Lenses Work.")

Mirror

28-105mm

button

mitter/receiver

Image sensor

Iris

Motors for autofocus and zoom

Shutter: Opens and closes quickly to control the amount of light (exposure) the image sensor receives. (See Chapter 5.)

Manual zoom control: Changes the Optical zoom factor of the lens, so distant objects seem closer or so the lens has a wider range of view. The control is usually a ring that manually adjusts the zoom or a rocker switch that transmits electrical signals to tiny motors that turn gears inside the lens. (See Chapter 4.)

Storing the Image

After a camera has created an image from light, it has to put the image somewhere. Conventional cameras store images on film. Digital cameras store photographs in digital memory, much like you save a Word document or a database to your computer's hard drive. Storage begins in your camera and continues to your personal computer.

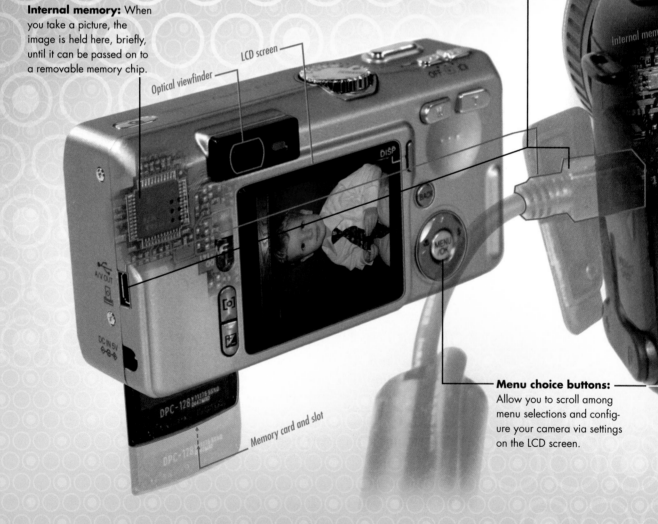

USB connection: A jack where you plug in a universal serial bus (USB) cable to send photos from your camera to your computer.

Internal memory: When you take a picture, the image is held here, briefly, until it can be passed on to a removable memory chip.

LCD screen

Optical viewfinder

Internal memory

DISP

BACK

MENU OK

A/V OUT

DC IN 5V

DPC-128

DPC-128

Memory card and slot

Menu choice buttons: Allow you to scroll among menu selections and configure your camera via settings on the LCD screen.

Optical viewfinder: Gives you a way to frame your image, often combined with read-outs of crucial information, such as aperture and shutter speed settings. (See Chapter 4, "How Light Plays Tricks on Perception.")

Diopter eyepiece correction: An additional lens on the viewfinder that fine-tunes the eyepiece focus, usually for the benefit of those who wear glasses, to accommodate individual differences in vision.

Memory card and slot: An opening in the camera that allows you to insert a piece of electronic circuitry to store the digital image your camera creates.

LCD screen: Gives you a viewfinder that avoids parallax error, and is a place where you view photos you've already shot. It also displays a menu that lets you select settings for the camera and photos. (See Chapter 4.)

Delete button: Erases a photo from digital memory to make room for another one.

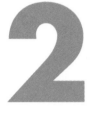

Inside Digital Video Cameras

Pick up a camera. Shoot something. No matter how small, no matter how cheesy, no matter whether your friends and your sister star in it. Put your name on it as director. Now you're a director. Everything after that you're just negotiating your budget and your fee.
James Cameron

MY father rarely used the ancient Pocket Kodak I described in the last chapter. It might have been the cost of film. He was notorious in most of the stores and restaurants on San Antonio's south side for his reluctance to part with spare change, much less a couple of bucks. But I suspect that he was still looking for the right instrument to match his artistic temperament, and the still camera just wasn't it. He was in his 50s when he finally found it—an 8mm Keystone movie camera. That's 8mm *film*, not 8mm magnetic tape used in some digital video cameras today. The frame on 8mm film is smaller than the nail on your little finger. The film is shot at a jerky 18 frames a second. One roll of the film was good for five minutes. My father edited four rolls into a single 20-minute reel. ("Edited," I'm sure, suggests to you the kind of editing that creates pacing, tension, and moves the action along. My father's editing produced one roll of film out of four, it only took him three splices to do it, and that was all.) He showed the consolidated reels using a projector that clattered and whined and regularly deposited on the floor a snake's nest of film that had missed the take-up reel.

People today who carry around better video cameras in their cell phones will wonder how that Keystone could rouse anyone's muse. It had no microphone because you couldn't record sound on 8mm. The lens didn't zoom, although later my father traded up for another Keystone with three lenses mounted on a turret. In the middle of a scene, he could stop filming, give the turret a twist, and resume filming with a wide-angle, telephoto, or normal lens. This was not as disruptive as it sounds because there was never anything going on in front of Daddy's camera that was more interesting than anything that might interrupt it.

This was because my father saved the movie camera to use at our family's equivalent of affairs of state, when my sister's family—eight kids—would crowd into my parents' two-bedroom house for Sunday dinner, Thanksgiving, Easter, or any holiday that culminated in the opening of presents or eating bodacious amounts of food. My father was best known for his *oeuvre* that includes "Xmas 1971," "Xmas 72," and "Xmas 73 and 74." (His titles were always rendered in crumpled aluminum foil twisted into letters and numbers that were glued to some suitable object, such as a grandchild.)

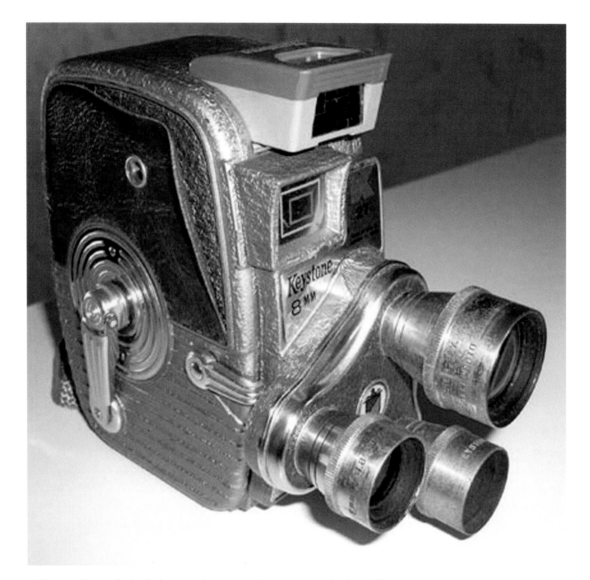

A Keystone 8mm—the kind of camera that captured a generation, silently, on film.

There is a remarkable consistency in the body of his work. This was the result of his contrarian theory of film that motion pictures should have as little motion in them as possible. He achieved his auteur's style by mounting on a tripod his Keystone and four lights so large and so bright and so hot that I suspected he stole them from an airport. As Daddy sat, smoking, in the cooler darkness at the back of the room, he directed each child and adult to sit in a chair in front of the Christmas tree and gradually lose all sight as they followed instructions to look into the camera, and the airport lights, while they unwrapped and held up each of their presents for the camera to see for at least one minute.

What does all this have to do with the state of digital video cameras 50 years later? Just this: Today my father would have access to cameras with zoom lenses, built-in sound systems, automatic focus, exposure, and white balance compensation. He could shoot for hours without having to change his memory card, writable DVD, or whatever medium was saving his movies digitally. After shooting his tape, he wouldn't have to mess with glue and a primitive editor to piece parts of his film together. He'd be able to use software comparable to what real Hollywood editors use to slice and splice their movies. Compared to all he had to go through half a century ago, he could skate through the artistic process of creating home movies where everyone in the family would still just sit in front of the Christmas tree and open presents one by one.

As James Cameron and Ken Rockwell suggest, it's not the camera that makes a great movie. It's the camera operator. And sound operator. And editor. And writer. And a lot of other people whose jobs have become easier because of the technological advances in video and movie cameras. But that equipment hasn't managed to draw imagination, art, and creativity out of people who didn't have them already. Remember, for *Titanic*, Cameron used pretty much the same cameras, lights, and sound equipment that were used to make *Snakes on a Plane*.

How the Digital Camcorder Captures Future Memories

The digital camcorder is not your father's 8mm movie camera. Fifty years ago, family events and vacations were recorded on narrow silent film that faded with the years and grew jerkier each time it was fed through the home projector. Today, the family video camera comes within a hairbreadth of producing movies—videos that are technically as good as you see in the theaters or on a TV set. For all the similarities between digital video and still cameras, they are, for the time being, different animals. Because the subjects in videos are constantly moving, the eye doesn't notice if the image is not as sharp as a good photo. But the two animals are evolving into a new creature—one that builds in the different circuitry and mechanisms needed to shoot both stills and motion.

The second choice is a larger LCD screen that can be twisted to any position, even toward the front of the camera so that the photographer can be in the **frame**, all the while keeping an eye on what the camera is seeing.

The operator of a low- to mid-range digital camcorder has a choice of equipment for framing a shot. A **viewfinder** with a magnifying glass in the end of it enlarges a small LCD image that shows the lens's vantage point, focus, and amount of zoom, regardless of whether the camera is recording. The method cuts out distraction and lets the photographer better concentrate on the subject.

The focused light from the lens falls on an **image sensor**, called a **charge-coupled device (CCD)**, or **complementary metal-oxide semiconductor (CMOS)** chip. Over the surface of the sensor lie thousands of **photodiodes**, or **pixels**, each of which generates electrical current in proportion to the brightness of the light that strikes it. Note that camcorders use fewer pixels than still cameras, which count their pixels in the millions. Camcorders are more concerned with hustling images through the system, at the rates of a dozen or two each second, than with image sharpness. In fact, the millions of pixels in a camera would quickly be bottlenecked by the relative slowness with which camcorders can store the visual information they gather.

The image sensor in less expensive camcorders is larger than the actual image size. This is so the camera can use **electronic stabilization** to compensate for any jiggle or vibration that would otherwise be captured by the camera. Small gyroscopes in the camera detect the movements and signal the camera's circuitry. If the movement, for example, shifts the image hitting the sensor to the right, the circuitry shifts which pixels are being recorded to the right. Note that the pixels do not actually move, but rather the responsibility each has to capture a certain part of the image moves to a different pixel. More expensive camcorders make use of optical image stabilization to move the actual image sensor. See "How Digital Cameras Cure the Shakes," in Chapter 8.

After an **image processor** in the camera massages the visual data passed on by the sensor, the processor converts the image to a system of numerical values that represent different colors and hues. They are joined to similar digital information coming from the camera's microphone. The combined signal is recorded, usually to magnetic tape.

LCD display

Microphone

Built-in light
Exposure meter

Infrared source

Motion sensors

LCD display

Image sensor

Start/Stop switch

POWER

Wide-angle/
Telephoto switch

W

T

Microprocessor

Digital tape

Hard drive

Mini DVD

Flash memory

An **active autofocus** system bounces **infrared light** off the subject and measures the time it takes to return to gauge the distance from the camera to the subject. Small motors use the distance information to adjust the lens so the subject is in focus. See more in Chapter 3.

A sophisticated zoom lens system provides real, **optical zoom** as strong as 10X. Some cameras try to embellish that with **digital zoom**, but as you'll see in Chapter 5, optical zoom is what really counts.

An **exposure system**, similar to those found in still cameras, measures the lighting and adjusts the lens's diaphragm to the correct aperture opening. In most consumer video cameras, varying the length of time that the shutter is open is not used to control exposure. But the *number* of times during each second that the shutter is opened to create a **frame** may be varied to produce slow-motion and fast-motion effects. The standard for commercial television in the United States is 30 frames per second (fps); for motion pictures, 24fps.

Some cameras provide an option of recording to solid-state flash memory, similar to that used in still cameras. And others record the video and sound directly to a DVD or a hard disk drive.

How a Professional Digital Video Camera Works

The everyday tool of documentary film makers, a staple of crews working to create "film at 11:00," and the object of technolust by amateurs chaffing under the restraints of the common camcorder, the professional **videocam** is the answer for anyone aspiring to be the next Spielberg. The latest models are capable of HDTV-quality images. Not only is it packed with features that matter to a pro, it is built rugged enough to survive daily use under adverse conditions not usually encountered at a six-year-old's birthday party. Finally, let's not forget the cool factor. While the size of consumer camcorders is shrinking, almost by the hour, the videocam is a heavy, glowering monster—a camera that tells the world you're serious about your video, serious enough to pay the big bucks and endure the big backaches.

1 For the professional video maker, sound is as important as images. High-end video camera **microphones** are expensive and have directional capabilities to isolate the sounds being recorded from the surrounding bustle. They may even perform neat tricks, like being able to gauge which way the wind is coming from so the mike can alter the directional function to filter out wind whoosh.

2 High-end video cameras allow **zoom lenses** to be swapped as is possible with professional digital still cameras. Most have some sort of system to minimize shakiness caused by movement or vibration. These high-end cameras usually use one of two anti-shake methods. One uses a **lens element** called a **vari-angle prism** that changes its shape to deflect light rays so the movement is hidden. The other method uses small motors to move a lens element horizontally and vertically to accomplish the same deflection. We'll look at both the methods in Chapter 8, "How New Tech Changes Photography."

Lens hood

Zoom lens elements

6 Although consumer video cameras provide a range of the latest high-tech recording media, from memory chips to DVD to hard drive, with some exceptions the professional video camera still uses **digital magnetic tape** for the images and sounds it captures. The reason is the sheer quantity of storage the cameras require. It's an economic decision influenced by the need to get the most out of legacy equipment that would otherwise depreciate too soon. Back at the studio, though, tape is now usually transferred to computer hard drives where an editor can use **non-linear editing software**. Older analog methods required editors to wind through however much tape it took to get to the shots that would actually be used. Non-linear processes let the editor go directly to those scenes without having to plow through intervening footage.

Most professional cameras have a profusion of controls and jacks for auxiliary equipment. Most common among these are connections for handheld microphones or **boom mikes**. The latter is a highly directional micr phone on the end of a lightweight pole that the boom operator can twist to point in different directions over the heads of people speaking while keeping the microphone outside the camera's frame. Such microphones are necessary because the mikes built into cameras often cannot pick up wanted sounds without also receiving distracting unwanted sounds.

5 The beam splitter uses three **dichroic prisms** to separate light into the three wavelengths—colors—and to aim each at a different sensor. The surfaces of a dichroic prism are coated with chemicals in a layer whose thickness is one-fourth that of the wavelength of the light the coating is designed to affect. The coatings, such as zinc sulfide and titanium dioxide, interact differently with different wavelengths. One coating reflects light with a wavelength below 500nm (nanometers, or 1 billionth of a meter) to break out the blue light. A second coat reflects light above 600nm, which separates red light. Green, the remaining light, passes through both coats without deviating from its path.

Red image sensor

Blue image sensor

Green image sensor

Tape cassette

Prisms

Microprocessor

3 Although a video camera may have an auto-focus mechanism, its lenses are also likely to have a **focus ring** the camera operator can turn by hand for critical or creative adjustments. Similarly, a hand-controlled zoom gives the operator more control over the speed at which a zoom takes place.

4 The light focused through the lens winds up hitting three **image sensors** rather than the one found in the usual family camcorder. First, though, it goes through a **beam splitter** that separates the color into red, green, and blue constituents—the same three colors used in film and digital still photography.

When a video calls for the camera to move—say, to follow someone who is walking—the most common method to eliminate distracting camera movement is to use a **stabilizer**, which is essentially a long, weighted stick.

P A R T

How Digital Cameras Capture Images

C H A P T E R S

No matter how advanced your camera you still need to be responsible for getting it to the right place at the right time and pointing it in the right direction to get the photo you want.

Ken Rockwell,
Your Camera Does Not Matter

A CENTURY and a half ago, when photography took its first steps into journalism, family portraits, landscapes, and wars, the process of capturing images was relatively simple because the cameras of that time were far less versatile than the cheapest disposable camera of today. There simply wasn't a lot that a photographer could do with a camera other than make sure the picture was in focus, that the exposure was correct, and that the camera was pointed in the right direction.

At the same time, that meant whatever the photographer did was entirely a measure of the photographer's skill with his equipment. The photographer couldn't amaze his customers with brilliant colors; most photos were black and white with perhaps some pastel shading added by hand. People didn't look for a photographer to capture the inner soul of Uncle Vernon; they simply wanted Uncle Vernon to be recognizable, which was as awe-inspiring then as live videos from space are today. There was no opportunity for shooting test Polaroids, for studying histograms showing the range of exposure, nor, in many cases, even a second chance. The process was tedious and tiring not only for the photographer, but for the subjects, who were often asked to remain motionless for unnatural spells, all the time encased in their best, but stiff and hot, Sunday go-to-meetin' clothes. With no more than two or three chances to get it right, the photographer had to know exactly what his camera could and couldn't do.

Focusing was the simplest task. At the back of the camera, spring-loaded brackets held a frame containing a sheet of film shielded from the light by a metal slide. The photographer covered the back of the camera with a black cloth, stuck his head under the cloth, and removed the film holder. In its place was a sheet of glass roughened on one side. The roughness caught the light so that it didn't simply pass through the glass but instead formed an image—upside-down to be sure—coming through the lens. The image from the lens rode the light waves to the focusing glass through a billows made of leather. A track and gears beneath the billows let the photographer move the lens back and forth until the image was sharp.

Exposure was trickier. There was no diaphragm to control how much light was allowed to expose the film nor shutters to control how long the film was exposed. In place of both, there was a lens cap. The photographer simply removed the lens cap so light could stream through the lens. Luckily film of that time was so insensitive to light that exposures less than a second or two weren't even a consideration.

In 1887, photography was extended to the night when two German scientists introduced *Blitzlichtpulver,* or "lightning light powder." A mixture of magnesium, potassium chlorate, and antimony sulfide in a shallow pan held aloft by the photographer, *Blitzlichtpulver* exploded in a burst of intense light when it was set afire. It also often set other objects on fire, including photographers, many of whom died in the quest for the night shot.

Improvements in the camera were slow to come for the next 100 years. In the 1950s, press photographers were still using basically the same camera that Matthew Brady used, although with modern touches such as shutters that sliced time into fractions of a second and flash attachments that kept the burning light source safely within a glass bulb.

Even before the digital camera began its takeover of the photographic world at the turn of the millennium, digital contraptions were becoming part of film photography. Simple calculating chips improved the accuracy of light meters and automatic focusing. Some cameras accepted microchips on cards, not unlike the memory cards used to store digital photographs, but in this case to vary operations such as automatic exposure and focusing to meeting the requirements of sports shots, night photography, and other specialized situations.

The real change in cameras came with the digital image sensor. We'll see later in this section how the sensor is a fundamental change. It's as important as the development 150 years ago of the negative/positive process that permits photographers to manipulate their images after they've left the camera. That ability to play, endlessly, with images takes photography further from being a record of one place and one time to a new realm of creativity. One of the two times the photographer can exercise that creativity comes when an image reaches a digital darkroom such as the one we'll visit in Part 3.

The other opportunity is in the realm of a new form of digital magic that uses some of a camera's oldest, non-digital components. It comes in the fleeting moment when light travels through the lens, the diaphragm, and the shutter. The opportunity continues when a chip absorbs the light. The chip is studded with photoelectric cells and massaged by a camera's on-board computer. Is this section of the book, we'll see how that concoction works.

How Lenses Work

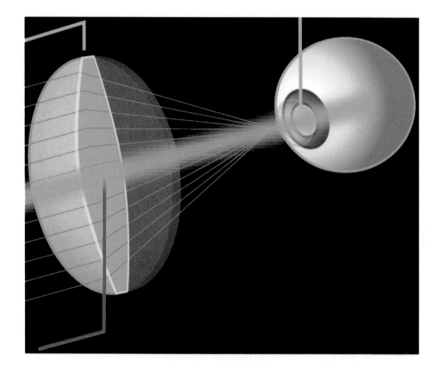

*If your pictures aren't good enough,
you aren't close enough.*
Robert Capa

*Best wide-angle lens? Two steps backward.
Look for the "ah-ha."*
Ernst Haas

IT'S possible to make a camera that has no lens. It's called a pinhole camera. You can make one in just a few minutes. All it takes is a box with a tight-fitting lid that won't let light in. Punch a small hole—a pinhole, made with a straight pin or needle—in the center of one side of the box. You can even make a pinhole digital camera by putting a hole in the center of the body cap that that goes on a camera when its lens is removed. Because light enters the box or the pinhole digital through such a small opening, it does not spread out and become diffused the way light does, say, entering a room through a window. The result is a focused image striking the other side of the box. A pinhole camera is not only a fun project, but serious photographers use it to create excellent photographs. (For more information, including how to build your own pinhole camera, check out Bob Miller's Light Walk at http://www.exploratorium.edu/light_walk.)

Pinhole cameras aside, the image deposited on film or a digital sensor is only as good as the image that emerges from the lens. The use of glass or plastic, how many pieces of plastic or glass elements make up the lens, and the precision with which its focusing and zooming mechanisms work all determine the quality and price of a camera. The most important function of the lens is to focus the light entering the camera so that it creates a sharp image when it hits the back of the camera.

You may control the focus by turning a ring running around the barrel of the lens as you check the focus through the viewfinder. Or you might have nothing to do with it at all. The lens might focus automatically, or it might not change its focus at all. The cheapest cameras—digital or film—have fixed-focus lenses that bring into definition everything in front of the lens from a few feet out to infinity. This is not as good a deal as it might seem at first glance. Everything is somewhat in focus, but nothing is sharply in focus. Plus, a good photographer doesn't always want everything to be focused. Blurred images have their place in photography, too.

The lens is not the only player in the focus game. The elements of the exposure system, the image sensor, and the processing a digital camera does to a picture before depositing it on a memory chip all influence how crisp or mushy the final photo is.

How Light Works

Photography is all about light—light bouncing off pigments and dyes, light shining through gels and filters, and the shadows and depth that come with the absence of light. Light is one of the basic influences in life. In fact, it brings life. Without light there would be no energy on the planet except that lurking deep in its bowels. And yet we're not exactly sure what light is. The scientific answers at times contradict each other, and if you start to peer at it too closely, the physical nature of the universe develops cracks. So we're not going to do that, but we will look at it in less intimate terms.

LOW FREQUENCY **HIGH FREQUENCY**

| SOUNDS | INFRARED | VISIBLE LIGHT | ULTRAVIOLET | X-RAY | GAMMA RAYS |

0Hz 10^{25}Hz

1 Light is a form of energy. It is just a small segment of the vast energy that fills the universe in the form of the **electromagnetic spectrum**. Energy moves through space as waves. The distance from the peak of one wave to the peak of the next is the **wavelength**, which determines many of the characteristics of a particular form of energy. The only energy we can see is a narrow band of wavelengths in the middle of the spectrum. We call this band light. We sense other wavelengths in the form of heat, and we've created various devices that detect energy with wavelengths longer than those of light— infrared—and shorter wavelengths, such as ultraviolet.

2 The wave characteristics of the spectrum account for several useful aspects. Waveforms give energy size and shape. Microwaves are blocked by the screen filled with small holes in the window of a microwave oven because the waves are too large to pass through the holes. Light, however, is small enough to pass through easily.

3 Light can also take the form of a particle. Each particle carries a specific amount of energy. This is useful when measuring light, as we do with light meters. A meter essentially counts the number of particles that strike a light-sensitive surface. The amount of energy in a light particle is related to the light's wavelength. The shorter the wavelength, the more energy the wave contains. (Most of us would probably say a yellow or red light is warmer, but a blue light actually packs more energy.) The energy levels of different colors of light are not so different as to be a concern— or use—in photography.

4 Light spreads as it travels, like the ripple on a pond. If light passes through a hole or past the edge of some obstacle, it will spread out from those points. The waves of light are not perfectly in step. The peaks of some waves will meet the troughs of other waves, with the effect that they cancel each other out, producing a **diffraction** pattern. This accounts for the fact that spotlights and flashlight beams do not produce perfectly smooth circles of light.

5 As light waves spread, the energy originally contained in the light becomes weaker because it's spread thinner over a larger area. In photography, this is particularly significant because an object 5 feet away, being photographed with a flash, is four times as brightly lit as the same object 10 feet away.

How a Lens Bends Light

The lens performs multiple jobs when it comes to gathering the light that the camera then shapes into a photograph. The lens frames all the subject matter and determines how close or how far away it seems. The lens controls how much light passes through it, and which subjects are in focus. Framing with a viewfinder and the zoom controls still needs your aesthetic judgment. But with most digital cameras, the lens is happy to do all the focusing entirely on its own. Whether you focus the camera manually or let autofocus do the job, focusing works because of what happens when light passes through glass or plastic.

1 When light bounces off an object, the **reflected** light spreads out equally in all directions.

2 Light travels at slightly different speeds depending on whether it's passing through plastic or glass or some other transparent **medium**, such as air or water.

AIR GLASS WATER

3 When a ray of light passes from the air into glass or plastic—the most common materials used for lenses—the light continues at an infinitesimally slower speed. It's like a speed limit enforced by the laws of nature.

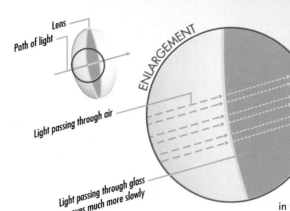

Lens

Path of light

ENLARGEMENT

Light passing through air

Light passing through glass moves much more slowly

4 But if the ray of light is at an angle to the plane where air and glass meet, not all parts of the ray move at the same speed as they cross from air to glass. The edge of a light beam that hits the glass first slows down while the opposite edge, still in the air, continues to move at a faster speed. The difference in speed results in the beam of light traveling in a different direction. The effect is similar to a car that has its right wheels in sand and the left wheels on pavement. The right wheels spin without moving the car forward much. The left wheels, with more traction, push the car forward more than the opposite wheels, causing the car to skid to the right.

Original path of light

Refracted path of light

Surface of glass

5 The process of bending light to travel in a new direction is called **refraction**. How much a substance causes light to bend, or **refract**, is called its **index of refraction**. Refraction is the principle that allows a camera lens to create a sharp, focused image.

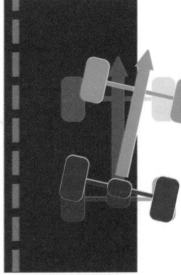

Left wheels continue to move forward while right wheels in sand fail to move

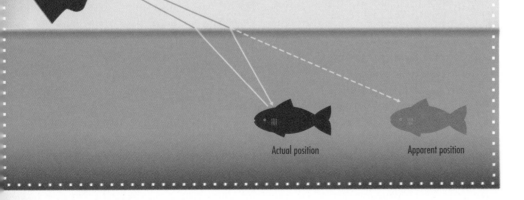

Air Versus Water

The next time you go spear fishing, remember that air and water have different indices of refraction. Because of that, a fish that appears to be 3 feet in front of you might actually be 2 feet away.

Actual position

Apparent position

How We Perceive Detail

In all the photographer talk about resolution, focus, and depth of field—which we'll get to after we lay a foundation on these pages—it's easy to lose sight of the ultimate restriction to how much detail you can see in a photo—the human eye. The biggest asset in seeing detail is imagination, the ability to make logical connections to fill in the details that are smaller than digital film can capture or photo printers can reproduce or the eye can discern. The tricks our perceptions pull on us are particularly important in digital photography because the technology squeezes the size of digital "film" to an area smaller, usually, than even the 35mm frame. That pushes the concepts of resolution and detail into even finer distinctions and even smaller realms. That's where human vision encounters the, no kidding, Airy discs and circles of confusion...strap yourselves in and keep your hands inside the cart at all times for this one.

Airy disc

1 A point of light, like other points having no width or breadth, is an abstraction. The closest thing to a physical point of light is a spot of light called an **Airy disc** (after astronomer George Airy, who first noticed the phenomenon). An Airy disc is an artifact. It doesn't exist in nature, but instead is created by the interaction of light diffraction and human vision. What began as a point of light changes when it passes through air, a lens, and an aperture. (That includes the eye's lens and pupil. An Airy disc doesn't exist at all unless someone or something looks at it.)

2 Diffraction is caused when impurities in the air and lenses scatter light coming from a point. The pattern that the diffraction creates is predictable. It is concentrated in the center of the disc, fading out in soft, concentric circles until it reaches the disc's rim, where the light is again concentrated.

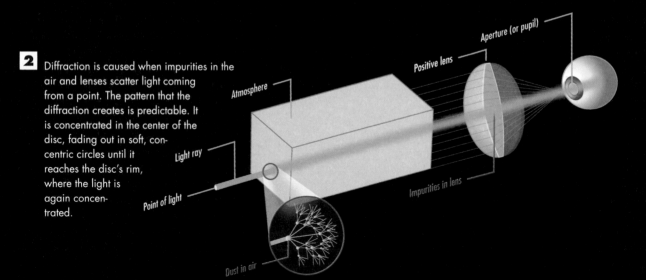

Aperture (or pupil)

Positive lens

Atmosphere

Light ray

Impurities in lens

Point of light

Dust in air

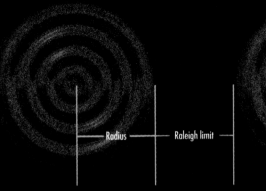
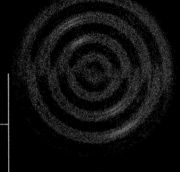

3 If you back away from any two objects, perspective makes them appear to move closer together. As two Airy discs approach each other, they reach a point where the distance between them is equal to the radius of one of the discs, about 0.27 microns (µm). This is called the Rayleigh limit.

Radius ——— Raleigh limit ———

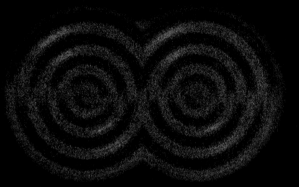

4 When objects cross the Rayleigh limit, they can no longer be distinguished as separate objects. They lose visual information in the form of detail, but they might produce new, gestalt information. If you look closely at a brick wall, you'll see that it is made up of individual bricks with rough textures and a mixture of reds, all surrounded by mortar of a different color and texture.

5 Back off from the wall and the points of light from the bricks cross the Rayleigh limit, blending their visual information. First the wall's color becomes more uniform. Back off farther, and the individuality of the bricks blurs into one solid wall. Although you might lose visual information, such as the type of bricks used in the wall or even that it is made of bricks at all, you now know that the wall is of a two-story building, something that even a close knowledge of the parts of the wall couldn't tell you.

So What Do We Mean by Focus?

Based on the physics of Airy discs, lens makers have established a standard for measuring resolution based on pairs of black and white lines. This, of course, assumes ideal lighting conditions, 20/20 vision, the distance from an object to the eye, and various details concerning brightness and contrast. In photography, the assumptions also include how much a photo will be enlarged from a negative or digital image. Studies on human visual acuity indicate that the smallest feature an eye with 20/20 vision can distinguish is about one minute of an arc: 0.003" at a distance of 10". Optics, dealing as it does with human perception, is in many ways the most imprecise of the sciences that abound with measurements and complex math and formulas.

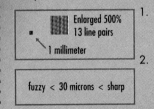

Enlarged 500%
13 line pairs

1 millimeter

fuzzy < 30 microns < sharp

1. The standard that optical engineers use, regardless of human acuity tests, is that 13 pairs of black and white lines per millimeter is the finest resolution that can be seen. More lines than that take the viewer into the gray Rayleigh territory. That's equivalent to about 30µm (.03mm).

2. A point of light can undergo the Airy disc distortion and be enlarged in a photographic print, and as long as it does not exceed 30µm, it is still perceived as sharp. But if the point of light grows larger than that, it's considered blurry; the larger it gets, the blurrier it is. It is this visual definition of sharpness that we're looking for when we say a picture is in focus.

How a Lens Focuses an Image

You must remember boring, sunny summer days in your childhood when you took a magnifying glass outside looking for anything flammable. Having spied a dry leaf, you held your magnifying glass between the leaf and the summer sun. Moving the magnifying glass back and forth with the precision of a diamond cutter, you found the exact point where the magnifier's lens concentrated the sunlight to form an image of the sun on the hapless leaf. Within seconds, the concentrated rays of the sun caused a thin wisp of smoke to rise from the leaf. Then, suddenly, it burst into flame. You had just done the work involved in focusing a camera's lens, though with more dramatic results.

1 To create an image inside a camera, it's not enough that light bends when it goes through glass or plastic. A camera also needs the bending to apply to each and every beam of light that passes through the lens. And it needs the bends to be precise, yet different, for each separate light ray.

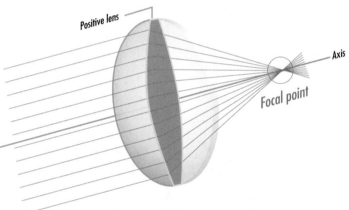

2 To make beams of light converge to a **focal point**—like the hot spot on the leaf—the beams have to pass through the glass at different angles from each other. A **positive**, or **converging**, lens uses a smoothly curved surface that bulges so it's thick in the middle and thin at the edge, creating a **convex** surface. One beam of light that passes dead-on through the center, along the **axis** of the lens, doesn't bend because it doesn't enter the lens at an angle.

3 All other rays of light traveling parallel to that center beam hit the surrounding curved surface at an angle and bend. The farther from the center that the light beams enter the lens, the more they are bent. A **positive lens** forces light rays to converge into a tighter pattern along the axis until they meet at a common focal point, where the energy in sunlight is concentrated enough to ignite a dry leaf. Positive lenses are also called **magnifying** lenses; they're used in reading glasses to magnify text.

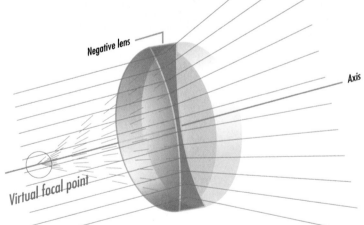

4 A **negative**, or **diverging**, lens does just the opposite. It has **concave** surfaces that make the lenses thicker on the edges and thinner in the middle. Glasses for people who are nearsighted (who can't see distant objects well) use negative lenses.

5 Light waves passing through a negative lens spread away from the lens's axis. The light waves don't meet, so there is no focal point that a leaf need fear. There is, however, a **virtual focal point** on the front side of the lens where the bent rays of light would meet if they were extended backward.

6 Focusing a clear image is a complex job that isn't done well by a single lens. Instead, most lenses consist of collections of different lenses grouped into **elements**. Together, they are able to focus objects at a multitude of distances from the lens with simple adjustments. Together, the elements determine the **focal length** of a lens. The focal length is the distance from the focal plane to the rear nodal point when the lens is focused at infinity. The **rear nodal point** isn't necessarily in the rear. In fact, it can be in front of the lens.

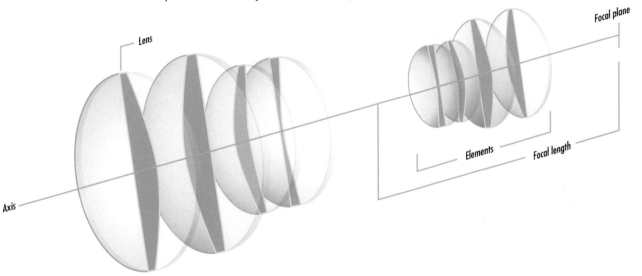

Lens

Focal plane

Elements

Focal length

Axis

The Bend in the Rainbow

Not all colors of light bend at an angle when they pass through a lens. Different colors have different **wavelengths**, the distance between the high point of one wave in a beam of light to the high point in the next wave. That makes each color bend at a different angle, as shown in the drawing.

Photos courtesy of Robert Tobler, who demonstrates the latter method at http://ray.cg.tuwien.ac.at/rft/ Photography/TipsAndTricks/Aberration.

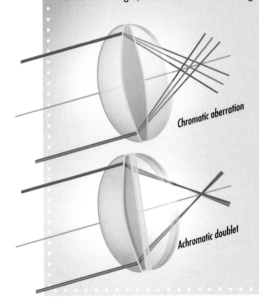

Chromatic aberration

Achromatic doublet

When light passes through raindrops, the drops act as lenses and break sky light into the colors of the spectrum. We call that a rainbow; when something similar happens in a camera, we call it chromatic aberration. In a photograph, it shows up as fringes or halos of color along the edges of objects in the picture, as in the photo shown here.

The aberration is prevented by an **achromatic doublet**, or **achromat**, a single lens made of two materials that are bonded together. Because each material has a different refractive index, their chromatic errors tend to cancel each other. The aberration is also corrected with image editing software, as was used on the second photo shown here.

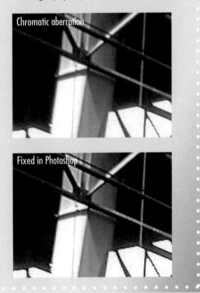

Chromatic aberration

Fixed in Photoshop

The Magnifying Glass Effect

Let's go back to that childhood fascination with magnifying glasses that set the scene for the previous illustration. Take a closer look at the hot spot of light created by the magnifying glass. You'll see that the spot is actually a picture, a small image of the sun. Now, remember how you moved the magnifying glass back and forth until it was just the right distance to start a flame? You were focusing the picture the magnifier made on the leaf. In a camera, you have a lot of controls and sensors to help you focus, but basically you're still moving the lens back and forth.

Image sensor

B

7 When light strikes an object—say, a race car—the car absorbs some of the light. The light that's left bounces off the car, scattering in all directions.

A

Objective

8 At point A, the car absorbs all the light except orange rays. From that one point, billions of rays of faintly orange light spread out in a constantly expanding sphere. The farther the light travels, the more it thins out. Without a lens, all but one ray of light spreads out, away from point B. The only ray of light from point A that can wind up at point B on the surface of an image sensor, or film, is the one traveling in a straight line from A to B. By itself, that single point of light is too faint for the sensor to register significantly.

9 That changes when a camera's lens is put between A and B. Millions of other rays from A enter a camera's lens through the millions of points on the surface of the **objective**. The objective is the first of the half dozen or so **simple lenses** that make up the camera's **compound lens**. The simple, single lenses are distributed along the same line among separate groups called **elements**. The multiple lenses, which might mix **positive** and **negative** lenses, compensate for each other's defects in the way that two lenses fix chromatic aberration, which was shown in the previous illustration. Also, as you'll see, the compound lens design allows precise focusing and zooming.

Curves Ahead

There are two basic types of **simple lenses**: positive and negative. A **positive convex lens** causes parallel light rays entering one side of the lens to converge at a focal point on the other side. A **negative concave lens** causes parallel rays to emerge moving away from each other, as though they came from a common focal point on the other side of the lens.

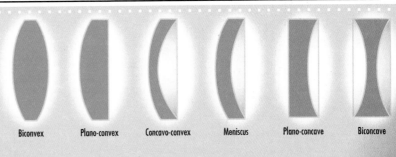

Biconvex Plano-convex Concavo-convex Meniscus Plano-concave Biconcave

With these two basic shapes, optical engineers have engendered a variety of **multiple lenses**, which bond two simple lenses with a transparent glue. Simple and multiple lenses go into making **compound lenses**, which use different combinations of lenses to herd light rays into the corrals of film, eyes, and imaging sensors. Here are some variations on combinations of simple lenses, all of which can show up in the same camera lens.

11 The same process occurs for every point on the car that can be "seen" by the camera lens. For each point on the race car, there is a corresponding focal point for all those light rays that bounce off those points. All together, those focal points make up a **focal plane**. The plane is where you find the surface of a digital imager or a strip of film. Light that is focused on that plane produces a sharp, focused photo.

10 Although the rays of light from point A on the race car entered the objective at different points, after passing through—and being bent by—all the elements in the camera lens, the rays of light exit the lens, all of them aimed at the same focal point. The accumulated power of all those faintly orange rays of light creates a focal point bright enough for the digital image sensor to register.

Focal plane

Elements

How Lenses Don't Focus

12 You can more easily understand focus if you see why some images are unfocused. Picture focused rays of light—the ones converging on a point of the focal plane—as a cone. If there's nothing at the focal plane to stop them, such as film or a digital image sensor, the light continues on to form another cone that's the mirror image of the first.

Focal plane

13 The tips of the two cones meet at the same point on the focal plane. If an image sensor were located either in front or in back of the focal plane, the light would form not a point of light, but a circle. It would be **unfocused**. Because the rays of light would not be concentrated, the circle would be hazy, and dimmer than a focused point of light. The unfocused parts of the image, particularly when they contribute to an artistic effect, are called the **bokeh**, a great word for Scrabble and out-pretending the pretentious at parties.

14 The location of a focal plane is partly the result of the optical characteristics of the lens and of the distance from the lens to the subject. Objects at different distances, some too close to the lens and some too far away, will be out of focus.

Broken Fixed Focus

Some cameras have **fixed-focus** lenses that don't require adjustments for each shot. This type of lens tries to get everything in focus from a few feet in front of the camera to infinity, but it's a poor compromise. Nothing is in truly sharp focus, and you can forget about close-ups.

15 Rather than bring an object into focus by walking toward or away from it, the photographer turns a **focussing ring** that runs around the barrel of the lens. (Virtually all digital cameras also provide **autofocus**, which adjusts the lens without the aid of the photographer. That's the subject of the next two illustrations.)

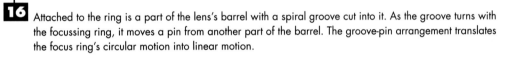

Objective

Focussing ring

Groove

Focussing elements

16 Attached to the ring is a part of the lens's barrel with a spiral groove cut into it. As the groove turns with the focussing ring, it moves a pin from another part of the barrel. The groove-pin arrangement translates the focus ring's circular motion into linear motion.

17 That motion, in turn, moves the lens elements toward and away from one another. The different distances among them change the optical effect they have on each other and shift the paths that light beams take as they careen through the lenses. When the light rays reach the digital image sensor, the optical changes now bring to focus a part of the scene that's closer or farther away.

How Active Autofocus Makes Pictures Sharp

Photographers can't always rely on automatic focusing because it's subject to the vagaries of any mechanism that cannot see but pretends it can. For the most part, autofocus has all but eliminated pictures of relatives with fuzzy faces and blurred birthday bashes, and it's a must for action shots and subjects who won't stand still for a portrait. The implementations of autofocus are as diverse as the minds of the ingenious engineers who invent them. We'll look here at two types of **active autofocus** found on less expensive cameras. One is akin to the echo technology of radar and sonar; the other is based on the triangulation used in rangefinders. Over the next few pages, we'll also take a look at passive autofocus designs and the motor that makes them all work.

Echo Active Autofocus

1 When a photographer presses the shutter button, it sends a burst of electricity to a **transducer** on the front of the camera. A device that changes one form of energy into another, the transducer generates volleys of infrared light toward the subject of the photograph.

2 When the infrared light bounces off the subject and returns to the transducer, it picks up each burst. The transducer turns the light energy into electrical currents that tell the camera's circuitry how long it took the infrared light to travel from the camera to the subject and return.

3 The round-trip time for the light takes a little under 2 nanoseconds for each foot from the camera to the subject. The measurement of that time goes to a microprocessor that controls a small motor built into the lens housing. The motor rotates to a position that's been calibrated to focus on an object at the distance determined by the infrared bounce.

4 This type of autofocus works with subjects no more than about 30 feet from the camera. With any subject farther than that, the returning light is too faint to register. In that situation, the camera sets the lens to **infinity**, which brings into focus any subject from 30 feet to the farthest star.

Triangulation Active Autofocus

1 **Active triangulation**—unlike timing autofocus, which uses the same transducer to generate and receive bursts of light—works with one device to shine an infrared beam of light at the photo's subject and a second device to receive the light after it bounces off the subject.

5 When a slot in the mask reaches the returning beam of light, the slot allows the light to strike the light-sensitive strip. In the case of a spring-powered mechanism, the strip generates an electrical current that energizes an electromagnet, which stops the motion of the lens at the point at which the lens revolves into focus. In a motor-assisted lens, the current switches off the motor.

2 The separate devices allow the autofocus mechanism to make use of the different angles formed by the light's path to the subject and its path on the return trip. An object far away from the camera reflects the light at a smaller angle than an object closer to the camera.

4 The mask is linked to the lens's focusing mechanism. As a motor turns the lens, the mask moves across the strip.

3 When the returning light enters a window in the camera, a mask prevents the light from reaching a strip of light-sensitive material.

How Passive Autofocus Sees Sharp and Fuzzy

Viewfinder

Prism

Prism

Image sensor

Auxiliary prism

Focusing photocells

1 Light passing through the lens of a camera is diverted from the image sensor at the back of the camera by a mirror, or prism.

2 The light falls on a strip of 100–200 photocells, called **linear sensors**, which are similar to those that make up the imaging sensor. The strip is positioned so that the distance the light travels to it is equal to the distance to the imaging sensor.

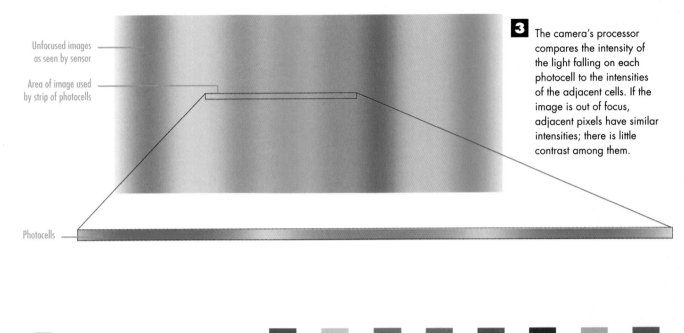

3 The camera's processor compares the intensity of the light falling on each photocell to the intensities of the adjacent cells. If the image is out of focus, adjacent pixels have similar intensities; there is little contrast among them.

Unfocused images as seen by sensor

Area of image used by strip of photocells

Photocells

4 The microprocessor moves the lens and again compares the photocell intensities. As the scene comes more into focus, the contrast between adjacent photodiodes increases. When the microprocessor gauges that the difference in intensity is at its maximum, the scene is in focus.

Photocells

Autofocus Limitations

Both passive and active autofocus have advantages and disadvantages. Active focusing works at night and in dim lighting, but the infrared light can bounce off glass or mirrors, confusing the camera's processor. Using passive focusing, you aim through windows and there are no distance limitations beyond which it cannot work. But a blank wall or a scene devoid of straight edges, particularly vertical lines, throws some passive autofocus for a loop.

To minimize the effects of shooting through glass, the photographer can put the lens directly on the glass. The infrared light passes through the glass. Any light that bounces back makes the trip too quickly for the camera to use its timing information.

With passive autofocus, turning the camera 90° can give the camera the perpendicular lines it needs. Higher-end cameras take readings on both vertical and horizontal lines to avoid having to turn the camera. In scenes with little contrast, try focusing on an object elsewhere about the same distance away as your subject. Then keep the shutter button pressed down about halfway as you turn to frame your real subject. On some cameras, holding the button locks the focus until you press the button all the way to shoot your photo or until you release it.

How a High-Tech Motor Moves the Lens

Any automatic focusing camera must have a motor to move the lens elements to bring the subject into focus. That's not a simple task when you consider how much speed and precision the camera requires and how little space the lens provides to hide a motor. As with the autofocus mechanisms devised to measure the distance from camera to subject, camera makers have come up with several ingenious ways to slip motors into minuscule spaces. We'll look here at a motor designed by Canon that many other camera manufacturers have adapted: the **ultrasonic motor (USM)**.

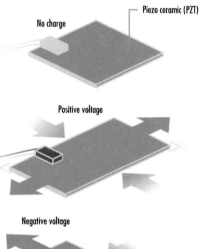

No charge

Piezo ceramic (PZT)

Positive voltage

Negative voltage

1 The ultrasonic motor is built on a phenomenon called the **piezoelectric effect**. The effect turns up in certain substances, such as the ceramic lead **zirconium titanate** (**PZT**). When an electrical voltage is applied to a strip of PZT, the ceramic expands in one direction and compresses in the other. If the voltage's **polarity**—the plus or minus charge—is reversed, the ceramic now compresses in the first direction and expands in the second.

2 To create a **piezo bender**, or **bimorph**, PZT is bonded to both sides of a thin strip of steel spring metal. A positive charge is applied to one side and a negative charge is applied to the other side. Now the only way the ceramic can expand or contract is to bend the metal strip. The negatively charged side bends out, and the other, positively charged side bends inward. If the charges are reversed, the bimorph bends the opposite way.

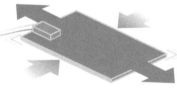

(+) Positive

(-) Negative
Spring steel

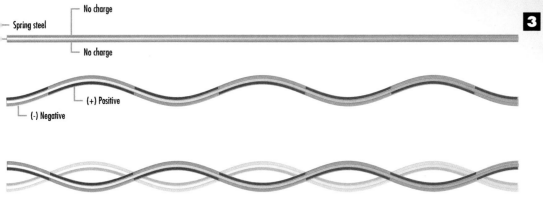

Spring steel

No charge

No charge

(+) Positive

(-) Negative

3 The next step in creating a piezo motor, or **actuator**, is to send opposite charges to alternating sections of the bender. The charge on one section makes the bender bow out at the same time the opposite charges going to the sections on either side make them curve inward.

4 By using an alternating current that switches its polarity several times a second, the bender seems to ripple as the adjacent sections bend first one way and then the other, looking like waves that have up-and-down motion but no lateral movement. The amplitude of the combined waves is only about 0.001mm, but it's enough movement to power adjustments on even a weighty telephoto lens.

Rotor

Stator

5 The final step in creating an ultrasonic motor is to mold the bender into a circle. An elastic material studded with flexible nubs is bonded to the circle's rim, creating a **stator**, which is the stationary part of a machine that moves a **rotor**. It looks like an endless caterpillar, a resemblance that's more than superficial. As the piezo strip makes waves, the feet press against the rotor, turning the lens elements. Each of the two layers of PZT has its own AC voltage that is slightly out of sync with the other. This allows the autofocus control to determine which way the rotor turns. When both springs are turned off, the friction between the stator and rotor holds the focus steady.

Silent Waves
An ultrasonic motor is not called that because of the sound it makes. It is virtually silent. Ultrasonic refers to the fact that the vibrations of the piezo waves are higher than the frequency of sound waves humans can hear: 20 kilohertz, or 20,000 vibrations a second.

How the Eye Controls Autofocus

Few things are as easy as simply looking. You turn your eye, and everything else happens automatically. Muscles tug on the cornea to pull it into the proper shape to bring into focus whatever you're looking at. Other muscles contract or relax their holds on the iris so that the pupil shrinks in bright light or expands in dim light so the light-sensitive cells lining the retina at the back of your eyeball see details without strain. If only other things, such as focusing a camera, were so easy. If the true object of your photo isn't dead-center in your viewfinder, most cameras—digital or film— require you to do a sleight of hand with the shutter button, aiming at where you want it focused and then pressing the button halfway while you frame the picture for real. But some cameras, pioneered in the film days by Canon, have found a way to make focusing, literally, as simple as looking.

Focus screen

1 When the photographer puts his eye to the viewfinder, he sees an image that has come through the camera lens and been reflected up to a focusing screen, a plate of glass that has been ground to have a rough surface on one side. The rough surface catches the light so it can be seen, like the image on a rear-screen projection TV.

2 The photographer sees the image on the screen after it has been reflected up by a mirror and passed through a prism, which flips the reversed image from the screen 180° so the photographer sees the image in its proper orientation. A smaller mirror behind the main mirror sends the image to the autofocus sensor in the base of the camera.

7 From that comparison, the microprocessor quickly determines what part of the image the photographer is looking at. It conveys that information to the camera's focusing mechanism, which is capable of evaluating up to 21 metering zones that are linked to 45 autofocus points that cover the whole frame of the picture. The signals tell the autofocus which of the zones to pay attention to, and the autofocus sends signals accordingly to motors that adjust the lens to focus on the target of the photographer's eye.

Sensor

6 The sensor detects the image of the eyeball, iris, and pupil and sends information about the location of the eye's image on the sensor to a microprocessor. Earlier, to calibrate the mechanism to the physiology of the picture taker's eye, the photographer had looked through the viewfinder in various directions. The processor stored the images that the eye's movement made on the processor during the calibration. Now it compares the new information from the sensor with the stored data.

5 The reflected light passes through a lens that focuses the image of the photographer's eye on a **complementary metal-oxide semiconductor (CMOS)** autofocus sensor. This is an array of CMOS photodiodes that creates a current when they are stimulated by the infrared light.

Dichroic mirror

Eyeball

4 The infrared light reflects off the eye. It passes, with no noticeable distortion, through a lens used to focus the photographer's vision on the reflected image from the ground glass. Then the infrared light reflects off a dichroic mirror set at an angle. A mirror has a thin coating of transparent metal oxides chosen, in this case, to reflect infrared light while letting visible light pass through the mirror.

Lens

Infrared LED

3 At the same time, an infrared **LED (light emitting diode)** shines light, invisible to the photographer, on his eye.

CHAPTER

How Light Plays Tricks on Perception

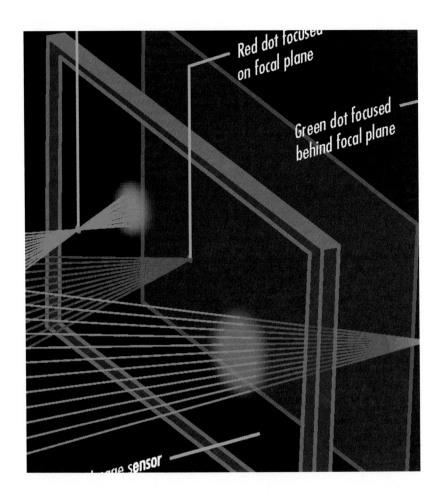

Red dot focused on focal plane

Green dot focused behind focal plane

Image sensor

They consider me to have sharp and penetrating vision
because I see them through the mesh of a sieve.
Kahlil Gibran, "A Handful of
Sand on the Shore"

WE all know we shouldn't trust our own eyes. Mirages lead us from the path. The instinct to avoid shadows has been buried inside us since our Cro-Magnon days. Magicians and our eyes conspire to make fools of our perceptions. Colors fade and melt and blend from dawn to midnight. Out of the corners of our eyes, we see someone pass by fleetingly and turn to find no one's there.

One reason our eyes are untrustworthy is that, combined with the wetware processor that sits right behind them, they are highly efficient image processors. Our eyes would embarrass the megapixel counts of most digital cameras. Combine both eyes' light-detecting cells—cones for color and rods for night vision—and you have an 18-megapixel set of optics constantly taking new frames. Fortunately, there is no need to save exact pixel-for-pixel records of each ocular snapshot, or else our brain would need to swell into some grotesquely large bulbous organism, leaving our body dangling from it like the head of an engorged tick.

But the human visual system—our eyes and brain—has to do something even more difficult, if nowhere as icky. Our vision has to make sense of what it's seeing, a chore a camera rarely is called on to perform. (Canon has developed a technology that allows a camera to recognize a face in a crowd of other perceptions so the camera's focusing mechanism has a likely target.) For the first year of life, a baby spends much of the time trying to make sense of the changing patterns of light, color, and brightness that constantly play on his retinas. He must figure out, pretty much on his own, how things like size, distance, direction, brightness, patterns, irregularities, and a host of other visual sensations work together to represent that world outside the crib. Strictly speaking, he doesn't *see* a mobile of cartoon characters hanging over his head; he sees patterns of light, color, and movement that the brain processes to represent a physical thing, like a dangling, dancing toy. The baby laughs at the mobile, not because it is inherently funny, but because the act of making sense of a small part of the existence around him invokes its own merriment.

It is also this need to process what we see that allows magicians to fool us, optical illusions to puzzle us, and digital cameras to offer much needed aid when we're trying to make sense out of the light, shadow, color, brightness, movement, distance, and focus that must be processed into a image on paper or screen that looks like the vision we had in our head.

Seeing *is* believing because it certainly isn't knowing. You believe you see the Grand Canyon in front of you—or in a photo—because your brain processes all that visual data and tells you it's the Grand Canyon. Has your brain ever lied to you? Of course it has. In this chapter, with "circles of confusion," "Airy discs," and other concepts with simpler names but which are no less daunting, we'll tackle some of the most basic but slippery factors in photography. The attributes of a photo we take for granted will be revealed as subjective qualities we agree on because there is no real objective alternative. We'll explain how tricks of the light affect cameras and photographs and how you can use the slipperiest of them to pull a fast one on the unsuspecting people who see your photographs.

How Viewfinders Frame Your Pictures

Using the viewfinder on a camera is so instinctive that we hardly give it a thought. It's literally point and shoot. Earlier photographers didn't have such an easy time of it. To see what their cameras saw, the photographers had to drape heavy black cloths over their cameras and their own heads. This was to shut out surrounding light so they could see the dim image the lens projected on a sheet of **ground glass** at the back of the bulky camera. The glass is etched so the light doesn't just pass through invisibly. The roughness makes the light's image visible the way dirty film on a windshield picks up the light from oncoming headlights. Ground glass is still used in cameras today, but you can leave the black cloth at home.

Ground glass

Full frame seen through the viewfinder

Actual frame caused by parallax error

1 In less expensive cameras, the viewfinder is a simple hole through the camera's case with a plastic lens to make the scene framed in the camera approximate what the photograph will contain.

2 Because the viewfinder is not in a direct line with the camera's lens, the viewfinder actually frames a scene a bit to the left and above the photograph frame. The error is called **parallax**. The effect is more noticeable the closer the subject is to the camera.

Parallax indicator

3 The viewfinder compensates for parallax error by including lines along the upper and left sides of the frame to give the photographer a general idea of what parallax crops out of the picture.

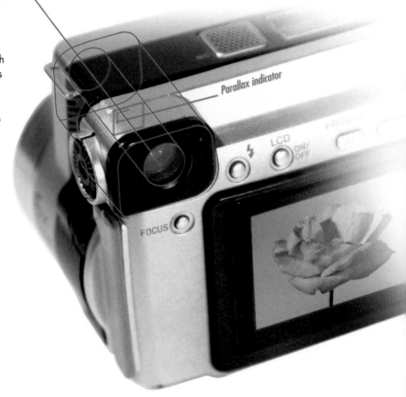

FOCUS

LCD ON/OFF

4 More expensive cameras feature **through-the-lens (TTL)** viewfinders that are far more accurate in predicting the frame the camera will capture. Before light from the subject reaches the image sensor, it is diverted by a mirror. (Some cameras use a beam splitter.)

5 Whether beam splitter or mirror, either method detours the image up onto a clear piece of glass called a **focussing screen**. The glass is rough on one side to catch the light from the lens, making it a rear-projection screen so that the photographer can see what the image sensor will see when the picture is taken. A prism mounted about the screen bounces the light through a loop—the loop that reverses the upside-down, mirror image the lens produces and aims it straight at an **eyepiece** so the photographer sees the image. Because the photographer sees the same light the camera uses to burn the image to the sensor, there is no parallax problem.

Lens

Prism

Ground glass

Viewfinder

Mirror or prism

Image sensor

6 Later, at the precise moment the photo is snapped, the mirror swings up to let the light get to the image sensor. In cameras that use a prism instead of a mirror, the prism splits the light, sending some to the eyepiece and the rest to the imager.

The All-Digital Viewfinder
The **electronic viewfinder (EVF)** on a compact digital camera sits right in front of the eyepiece, where in a TTL camera you'd find the ground glass. It works like a TV screen receiving a live feed from the lens. Not to be confused with the large LCD screen on the back of most digital cameras—still another way to frame a snapshot—the EVF is about one-half inch diagonally; has some 200,000 pixels; and uses a small lens in front of it to magnify the image when seen through the eyepiece. Electronic and optical viewfinders have their pros and cons. TTL images are sharper and don't drain the battery. EVFs are quieter because there's no mirror to flip up, and some are mounted on a swivel so you can pull them away from the camera body to let you frame shots that otherwise might require you to lie on the ground to get the angle you want.

How Lenses See Far and Wide

The obvious jobs of telephoto and wide-angle lenses are that the **telephoto** lenses make things that are far away look close.
Wide-angle lenses make things that are close look farther away, but they also stretch a photo to cover peripheral areas that would otherwise escape capture. But it's not as simple as that. Telephoto lenses don't exist simply so you won't have to walk closer to your subject, and wide-angle lenses aren't just for taking shots in small rooms where you can't step back any farther. Both types of lenses have serious effects on how sharp a scene is at different distances, and they're important tools to show what's important in a photograph. They can make subtle or exaggerated statements about what you're taking a picture of. Here's how they work.

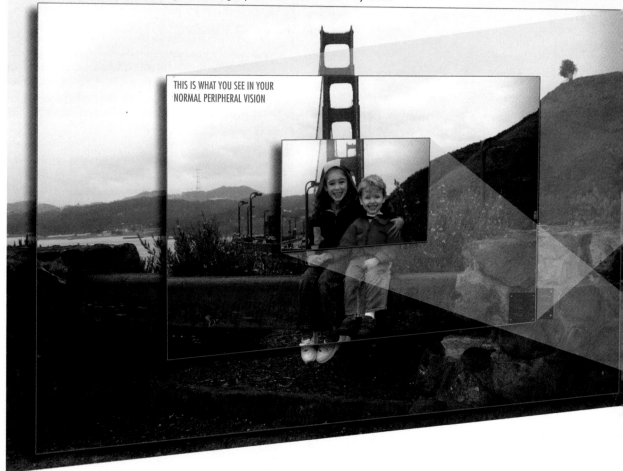

THIS IS WHAT YOU SEE IN YOUR
NORMAL PERIPHERAL VISION

The images shown here are for photographs taken with different focal
length lenses but at the same distance from the subject. They are also taken
with digital cameras that have the same size image sensor. Toward the end
of this chapter, you'll see the effect of changing distances and sensors.

The Normal Lens

In 35mm photography, a lens with a focal length of 50–55mm is considered **normal**. This is based on a rule of thumb that a normal lens's focal length is equal to the diagonal distance of the image formed on the film—or today, on the image sensor. For cameras with different image proportions, normal lenses have different focal lengths. For a camera using 2 1/4" square film, for example, the normal lens has a 75mm focal length. This is important in evaluating digital cameras, which have no standard image sensor size. (See Chapter 5, "How Technology Transforms Cameras and Lenses.")

When you look through the viewfinder of a camera with a normal lens, your subject looks about the same size, roughly, as it does to your naked eye. The lens elements are designed to focus the rays of light passing through them while still forcing them off their straightforward paths as little as possible.

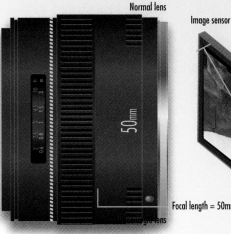

Normal lens

50mm

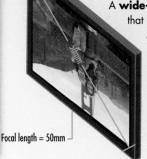

Image sensor

Focal length = 50mm

The Wide-Angle Lens

A **wide-angle** lens is one that has a focal length *shorter* than the diagonal size of the film or image sensor. In the 35mm film world, any lens with a focal length of 35mm or less is considered wide-angle. Wide-angle lenses are also called **short** lenses.

Looking through the viewfinder of a camera equipped with a wide-angle lens shows you more than you would normally see with your peripheral vision if you simply stared straight ahead. It includes areas you would ordinarily have to turn your head to see. (The extreme is a lens with a focal length of 15mm or less. These are called **fisheye** lenses, so named because of their bulbous shape that takes in a 180° angle of view—essentially everything that's in front of the camera.) The design of a wide-angle lens emphasizes **converging positive** elements that squeeze together the rays of light that pass through them. By the time the rays reach the image sensor, individual objects in the scene are small, but a wider expanse now fits on the sensor.

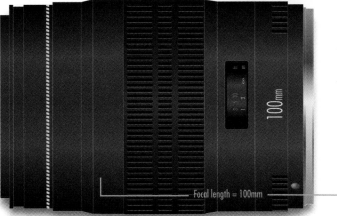

28mm

Focal length = 28mm

100mm

Focal length = 100mm

The Telephoto Lens

The **telephoto** lens has a focal length that is *longer* than that of the image sensor's diagonal. (They are also called **long** lenses.) In 35mm terms, telephoto lenses are those with focal lengths that are longer than 65mm, but for many digital cameras the minimum focal length to be a telephoto shrinks to 50mm. It all depends on the size of the image sensor. A camera with an image sensor whose diagonal measure is half that of 35mm film requires only a 300mm lens to get the telephoto power of a 600mm lens on a film camera.

Not surprisingly, the design of a telephoto lens depends on lens elements that are the opposite of those in a wide-angle. They employ **negative**, or **diverging**, lenses that spread the light rays out of the center axis of the lens. The result is that the image that entered the lens covers a wider area by the time it reaches the image sensor. The sensor records a smaller center area of the total image with the effect that the area is enlarged in the photograph.

How Digital Lenses Manipulate Space

Telephoto and wide-angle lenses do more than change the size of your subject or the breadth of your image. They also change the relative sizes and relationships among individual objects in the photograph. A common misunderstanding is that lenses with different focal lengths change the perspective in photographs. For example, look at the three cubes shown here and guess which are representative of objects shot with a wide-angle, normal, or telephoto lens.

WIDE ANGLE LENS?

NORMAL LENS?

TELEPHOTO LENS?

1 You probably guessed immediately that that was a trick question. The answer is that all the photos were shot with a digital camera using the same focal length. To be precise, they are all part of the same photo, as seen below.

2 What actually changes the perspective is the distance from the camera to the subject being photographed. The box nearest the camera was the most distorted; the box farthest from the camera appears to be more like a regular cube. What causes the distortion is **perspective**. Another of life's visual illusions that we've come to accept as reality, perspective compresses space in proportion to the distance from the observer to what's being observed. (If the objects being observed were small enough originally and are extremely far away, they disappear entirely at the appropriately named **vanishing point**, sort of an optical black hole except that it doesn't actually exist and objects don't really vanish.)

3 Perspective is not a factor of distance alone. The picture of the cubes was taken deliberately with an extreme wide-angle lens to exaggerate the perspective distortion. A normal or telephoto lens the same distance from the first box would not be able to capture the same distortion because its **angle of view** is not as wide as that of a wide-angle lens. In the example here of different angles of view for different focal lengths, keep in mind that these are for 35mm film cameras. As you'll see in a later chapter, the same focal length gets different results from different digital cameras. A wide-angle lens allows the photographer to get close enough to the front of the cube so that the far side of the cube is twice as far from the lens as the front of the cube. If the photographer stepped back 10 feet, the back of the cube would be only 0.06 times as distant from the camera compared to the cube's front.

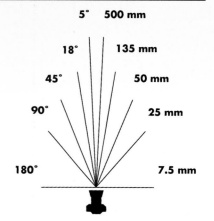

5° 500 mm
18° 135 mm
45° 50 mm
90° 25 mm
180° 7.5 mm

4 Cameras with different focal lengths shooting the same subject from the same location will all produce pictures with the same perspective. In the examples here, photos are taken with (top to bottom) wide-angle, normal, and telephoto lenses. Notice that the pictures on the left were all taken from the same location. The mountains and Alcatraz Island remain the same size, proportionately. On the right, the photographer changed positions so that Alcatraz remains the same size in the picture frame, but the mountains appear to grow.

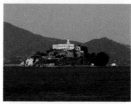

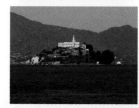

Lens Trickery in the Movies

Tricks using perspective are a staple in the movies. Anytime you see a car race or chase that involves cars weaving in and out at high speed, notice that you're looking at the race from behind or in front of the weaving cars, never from the side. The trick here is to use a long lens from far away. Perspective seems to compress the space between cars, so that whenever one car weaves in and out of traffic at breakneck speeds, it appears to be missing the other cars by inches, as demonstrated in the photograph. If the chase were shot from the side—which it won't be—you'd see that in actuality, there are several car lengths between cars and the car doing all the weaving slips into places as easily as a supermodel trying on a fat lady's dress.

HEAD-ON VIEW

SIDE VIEW

26"

How Optical Zooms Zoom

A single zoom lens lets photographers range through an infinite number of focal lengths from wide-angle through normal to telephoto. At first, the zoom lens was scorned by professional photographers because it lacked the image clarity of a **prime** lens—one that has a fixed focal length. Not surprising. Zoom lenses have as many as 30 separate lens elements that move in complex patterns. Because advances in optics have improved the sharpness of zoom lenses today, zoom lenses are accepted by photo pros and are a standard fixture on most digital cameras. The dozens of designs for zooms are still complex, but the concept for many boils down to the simplified zoom lenses we have here.

Positive element

Negative element

Immobile positive element

Fixed-focus lens

Front of lens

Path of light

Zoom lens afocal system

Telephoto positions

1 Light bouncing off the subject of your photo begins the journey to create a photograph when it enters the front of your zoom lens. Specifically, the light first passes through a part of the zoom called an **afocal** lens system, which, as its name suggests, has nothing to do with focusing the image. The afocal system consists of three lens elements that are concerned only with the size of the image when it reaches the image sensor at the back of the camera. That size is a direct result of the positions of the three elements. Their positions come from the photographer operating the lens's zoom control.

2 The afocal part of a zoom lens has two positive elements, which causes light rays to converge. Between these two is a negative element, which causes light rays to diverge and makes images larger. The elements in this illustration are reduced to a single simple lens for each element.

3 The positive element closer to the camera end of the lens doesn't move. The other positive element (at the front of the lens), along with the negative element, moves in response to the photographer's use of the zoom control.

Call a Zoom a Zoom
The power of a zoom lens—the range of its focal lengths—is commonly expressed in multiples of its widest focal length. For example, a zoom lens ranging from 100mm to 400mm is a 4X zoom. The term hyperzoom is applied, mostly by marketeers, to lenses with exceptionally large ranges, more than 4X, with some as high as 12X.

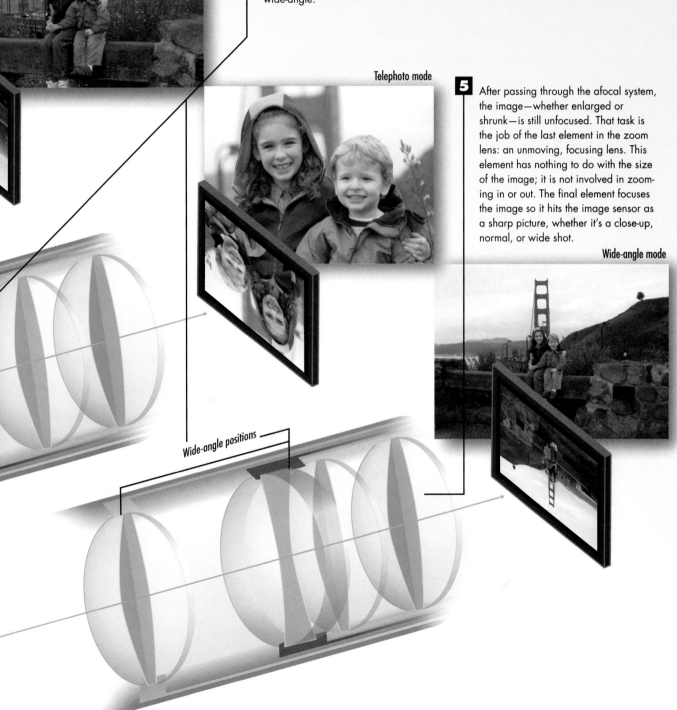

4 The dance of the elements magnifies or diminishes the image. When the negative element is closer to the front of the lens, the zoom is in telephoto mode. As the negative lens nears the fixed, rear positive element, the afocal system turns the zoom into wide-angle.

Telephoto mode

5 After passing through the afocal system, the image—whether enlarged or shrunk—is still unfocused. That task is the job of the last element in the zoom lens: an unmoving, focusing lens. This element has nothing to do with the size of the image; it is not involved in zooming in or out. The final element focuses the image so it hits the image sensor as a sharp picture, whether it's a close-up, normal, or wide shot.

Wide-angle mode

Wide-angle positions

How Digital Zoom Fakes It

Most digital cameras give you both optical zoom and digital zoom. Optical zoom, as you saw in the previous illustration, uses the laws of optics to bend light so that a single lens takes on both the long-distance qualities of a telephoto lens and the expansive vision of a wide-angle lens. Digital zoom uses the blather of the marketing department to sell folks on the idea that they are getting more if their new camera has a 10X digital zoom. They aren't. In fact, a digital zoom only gives you educated guesses about what a picture would look like if it had been shot with a telephoto lens. Some guesses are pretty good, but they're never as good as those from a true, optical zoom. All digital zooms can be created with more control and finesse after you transfer your shots to your computer. Here's how image editing software, either on-the-fly in your camera or on your PC, makes something out of nothing.

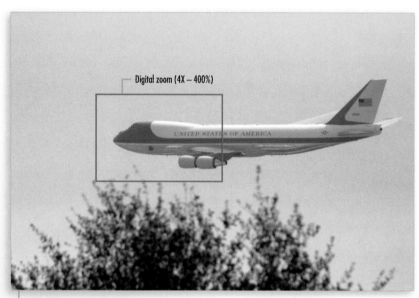

Digital zoom (4X — 400%)

Normal lens

 1 A digital zoom begins by concentrating on just the center portion of the image frame: the same portion that would have filled the viewfinder and the entire image using an optical zoom.

Digital zoom (4X — 400%)

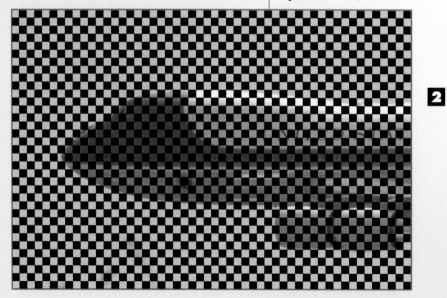

2 Software built in to a chip inside the camera expands the pixels that are in the area being zoomed so that the pixels fill the frame evenly. This leaves pixel areas that are blank surrounding pixels that contain fragments of the image.

3 The software built into the camera compares each blank pixel with the colored pixels nearest it. The software runs the adjacent-color values through a formula to determine which color the blank pixel area would most likely be if the picture were a true zoom.

4 The software fills the missing pixels with colors based on its educated guess to produce an approximation of what an optical zoom lens would have picked up.

ACTUAL SIZE (100%)

ORIGINAL PHOTO (50%)

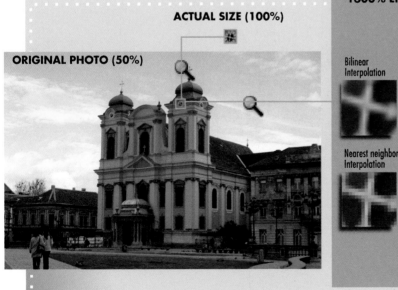

1600% ENLARGEMENT

Bicubic Interpolation

Bilinear Interpolation

Bicubic sharper Interpolation

Nearest neighbor Interpolation

Bicubic smooth Interpolation

Spy in the Sky

In a common scene in movies and television, a blurry photograph is enlarged again and again until the identity of the enemy spy is revealed. That's fiction. In reality, only so much detail can be drawn from a picture if the visual information is not there to begin with. The formulas, or **algorithms**, used by a camera's digital zoom or by photo editing software vary in their complexity and the speed with which they can be computed. They also vary in the results they produce. Here are some comparisons between images shot with a lens zoom and the common types of software enlargements used for digital zooms.

How Perception Creates Depth of Field

The very fact that you have to focus a camera implies that at some point things in front of the camera will be out of focus. In other words, focus must end somewhere. In fact, for the best of lenses there is only a single, spherical plane—one that surrounds the camera like an invisible soap bubble—where any point in the photograph is as sharp as possible. Everything else in front of or behind that plane is out of focus. Then why don't more things in a photo look out of focus? Don't we even speak of **depth of field** as a range before and behind whatever we're focused on where other objects are also in focus? Well, yes, but you see, it's really just an illusion. It's a trick by an imperfect eye that makes the brain accept one standard of fuzziness as sharp focus and another degree of fuzziness as just fuzzy. Fortunately, it's an illusion that obeys some rules and that a photographer can control.

1 An object being photographed will be in focus when it lies on the **plane of critical focus**. It's actually a sphere, rather than a plane, at the center of which is the lens, but convention uses the term *plane*. The location of this plane or sphere is determined by the optics of the lens, the lens's focal length, and how the photographer has adjusted the lens's focus.

2 Rays of light from a point on some object in that plane—the red point in our illustration—extend to all points on the front of the lens, which bends them to form a cone. At the tip of the cone, all the light rays converge on a single point at the **focal plane** of the camera. This is where the digital image sensor or film is mounted. (To make everything easier to understand, we've exaggerated the size of the digital sensor to something that resembles a drive-in movie screen.)

4 Other points from objects in front of and behind the plane of critical focus— such as the green and blue points—are also resolved by the lens to individual theoretical points. The only difference is that these focused points are not on the focal plane. The cones of light from these spots meet at focal points that fall either behind or in front of the focal plane. That plane, instead, is intersected by a section of the cones created by the light beams converging on their points. The digital sensor records not a point of light or even a least circle of confusion as occurs at the focal plane. Instead, the sensor records an everyday, common **circle of confusion**, what we would ordinarily call a **blur**. The farther from the focal plane that the point is actually focused, the bigger the blurred circle.

Plane (sphere) of Critical Focus

5 These circles of confusion, however, are often still so small that our eyes perceive them as a focused point. That's why an equal distance behind and in front of the plane of critical focus appears to also be in focus. This area is called the **depth of field**. The depth, or size, of the depth of field is determined by the focal length of the lens, the design of its optics, the size of the aperture (the opening light passes through when the shutter is snapped), and the distance from the lens to the critical focus plane. The size of the film or sensor compared to the size of the print made from it is another set of factors in which subjective judgment, eyesight, and the distance from a print to someone looking at it all play a part.

3 The newly formed point is only a point in theory. From traveling through the air and the lens, enough of the original light beam has been diffracted so that what actually strikes the focal plane is an Airy disc, such as you encountered in the previous illustration. But, assuming we're using an optically perfect lens adjusted with absolute precision, the Airy disc's diameter would be the **least circle of confusion**. That is the smallest point of light that quantum physics will permit. Because of the limits to how much the eye can distinguish details, objects at the plane of critical focus might actually have some distortion. But because the distortion is smaller than the eye can discern, the objects appear to be in focus.

Blue dot focused in front of focal plane

Red dot focused on focal plane

Green dot focused behind focal plane

Lens

Image sensor (focal plane)

6 As objects get farther from the critical plane, their smaller details are subsumed into overlapping Airy discs, losing individual identity. The process continues until even large objects that are far enough away from the critical plane fall below a threshold of focus that's acceptable to the human eye and perception. That's when we officially declare them to be "out of focus."

Calculating DOF
Depth of field (DOF) might seem like a topic for which a degree in higher math would be handy. Well, in this case, it would. But lacking the degree, you can take advantage of a couple of dozen calculators that will figure depth of field on your computer, handheld, or even without the advantages of electricity at all. The DOF Calculator, shown at the right, is a circular slide rule you can print and assemble that fits nicely on a lens cap. You'll find it and more calculators for DOF and other optic esoterica at http://www.dofmaster.com/, http://www.outsight.com/hyperfocal.html, http://www.betterphoto.com/forms/linkAll.asp?catID=71, and http://www.tawbaware.com/maxlyons/calc.htm.

CHAPTER
5

How Digital Exposure Sifts, Measures, and Slices Light

Every time you go to a different
place it's lit differently.
Annie Leibovitz

ALL photography is about light. Photos may be of important or trivial subjects, in color, or black and white. A picture may be as candid as the next minute's news or a painstaking pose, a slice of reality or a helping of the abstract. It can be still or moving, invoking weighty subjects or the flightiest of fancies. But whatever else photographs are, they are about light.

They are about what light does when it flickers off a river, when it exposes the wrinkles and buried veins of age, how it transforms a sky, or how it creates depth and curves and textures you can feel with your eyes. Photos are even about light when there is none, or at least very little, when a photo's subject is buried in shadows and the slightest feature forcing itself out of the depths of blackness becomes enormously important.

Light is the tool and the curse of photographers. In a studio, hours may be spent adjusting lighting and shooting test shots to create the exact right balance of highlights and shadows. In candid photographs, landscapes, and action shots, the state of lighting is more often an accident, forcing the photographer to make quick, on-the-fly adjustments and guesses about what light the camera will capture at...*this* very moment. If the photographer is successful, and lucky, he captures a moment of light and dark and color that will never exist again except in the bits and pixels where that moment now resides, possibly forever.

A paparazzo snapping a photo of Brad and Angelina is much like a batter hitting a home run. The batter has to calculate the changing speed, trajectory, and spin of a fast ball and its diminishing distance from him, and translate that into the timing, speed, and angle of his swing. The batter analogy would have held up a lot better 50 years ago before automatic features were built into a camera, making off-the-cuff shots less of a grab bag.

Today's digital photographers have even more wonderfully computerized tools to help decide when the light is just right for the nabbing. Plus, they can turn fluorescent lighting into daylight, and daylight into candlelight. They can change the sensitivity of their "film" in the middle of shooting or turn color into black and white. The digital photographer gets to play with light as if he made the rules that light beams must follow. And that's because he does make the rules. Here's how it starts, with the fraction of a second called "exposure."

How a Diaphragm Controls Light

Picture a shy sunbather standing in his skivvies in front of a window hoping to get a tan. The size of that window does the same job as your camera's **diaphragm**. Assuming the curtains are open—more about them in the next illustration—the window size controls how much light gets into the room; in much the same way, a camera's diaphragm changes the size of a hole at its center to control how much light gets into your camera. Too little light, and wonderful details in your photo are buried in the shadows. Too much light, and everything washes out to a pale scene devoid of color and shape. The diaphragm has only the most fleeting slice of a second to collapse from its largest opening to its smallest, and then it must retreat again to be ready for the next instant to be captured. Here's how it does it in one of the most common diaphragm designs.

Diaphragm

1 Light that has been focused through the lens of a camera must pass through a round diaphragm on its way to being registered as an image on the camera's sensor. How much light makes its way into the camera is controlled by an opening in the diaphragm. The opening, called the **aperture**, serves the same function as the human eye's pupil. The diaphragm is the camera version of the eye's iris.

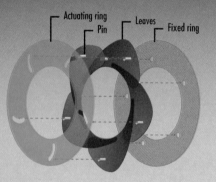

Actuating ring
Pin
Leaves
Fixed ring

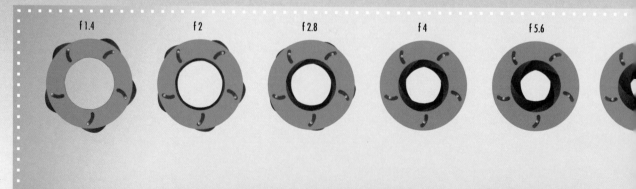

f 1.4 f 2 f 2.8 f 4 f 5.6

2 Mounted between two of the lens's elements is the diaphragm, a circular mechanism made up of tissue-thin metal leaves that overlap each other like the petals of a flower to form the aperture. The leaves are tapered and curve in toward the center of the aperture. Their design creates a rounder circle when the aperture is bigger and when a diaphragm is made of more leaves. When it closes down, the edges of the leaves are more apparent and show up as multi-sided figures in the **bokeh**, or unfocused parts, of a photo. Better lenses have a dozen or more leaves; cheaper ones have as few as five.

Servo motor

4 When the photographer presses the shutter button, one of the camera's processors reads the exposure settings and sends specific electrical signals to a mechanism such as a tiny **servo motor** mounted inside the lens on one of two rings running around either side of the diaphragm. Using a method called **pulse coded modulation**, the servo times the length of electrical pulses and instantly rotates a shaft a precise amount, turning the **actuating ring** to an equally exact angle.

5 Just as muscles tug the iris so that it contracts or expands, changing the size of the pupil, the tugs and prods of the servos control the size of the aperture. Each of the leaves of the diaphragm typically has one peg that fits into the actuating ring and another peg, on the opposite side of the leaf, attached to a ring that does not move. When the actuating ring turns, it makes each leaf pivot around the immobile pins. All the leaves pivot in unison, depending on the direction the ring turns, to make the aperture wide or narrow. The size of the opening is crucial not only to the correct exposure of a photograph, but also—as you glimpsed in the previous chapter—to the image's sharpness.

3 Ordinarily, the aperture is open fully so that as much light as possible reaches the viewfinder and the photographer can see the scene easily. Some cameras have a **preview button** the photographer pushes to close the aperture to whatever it's set for. The preview dims the image, but it gives the photographer an approximation of the depth-of-field.

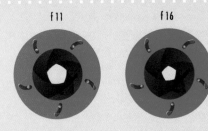

f 11 f 16

F-stops
The various sizes the aperture is set to are called f-stops, usually expressed as f/ followed by a number somewhere between 1.2 and 32. The number represents the focal length of the lens divided by the diameter of the aperture's opening. If the aperture on a 50mm lens is set to be 25mm wide, the f-stop is 50/25, or f/2. The ratio lets the same amount of light fall on each square millimeter of the film or image sensor, although the measured aperture from lens to lens can be different. A 150mm aperture on a 300mm lens exposes the picture with the same brightness as the 25mm opening on the 50mm lens (300/150 = f/2). This seemingly easy system loses some of its simplicity when you realize that bigger apertures have smaller numbers and vice versa. Each smaller f-stop lets in twice as much light as the next larger f-stop and, of course, a setting of f/8 lets in half as much light as f/4. If you want to see f-stops in action, visit www.photonhead.com, where you can experiment with its SimCam without having to go to the trouble of actually photographing anything.

How a Shutter Slices Time

Like most windows, the one in our sunbather's apartment has curtains, a necessity to let light in when you want it and to keep light out when you don't. Our digital camera has curtains, and they serve the same function as those in the window. Most of the time they're closed to keep the light off the image sensor, whose pixels are hundreds of times more sensitive to light than the palest skin. Then for a fleeting moment, a mere fraction of a second, the curtains open with the sudden swiftness of a conjuror and the precision of a surgeon. It's in that moment that the camera captures one fleeting moment of time.

4 Both curtains are spring-loaded, but the springs are restrained by metal latches that hook into the spring mechanism so it can't move. Poised above each latch are the two electromagnets. The first burst of electrical current goes to the magnet associated with the curtain that is already open and covering the image sensor.

Latch
Electromagnet
Image sensor
First curtain

Electromagnet

1 At the same time electronic signals race from one of a digital camera's microprocessors to tell the diaphragm what size to make the aperture, other signals stream to the camera's **shutter** to tell it how long it should open its **curtains** to expose the image sensor hiding behind them to the light streaming through the aperture. There are various designs for camera shutters, but the most common type in the 35mm cameras that have evolved into the digital camera is the **Copal square shutter**, named after the Tokyo company that developed it in the 1960s. That's what we'll look at here.

Second curtain

2 The electrical current travels to one of two electromagnets that are paired with two sets of curtains. The curtains are made of three to five or more thin blades of aluminum, titanium, or metal-coated plastic. The blades making up one of the curtains are spread out—but overlapping one another—to cover the image sensor so that no light reaches it.

3 Mounted on the opposite side of the sensor from the first curtain, the second curtain's blades are collapsed so the curtain takes up little room in the already crowded inner chamber of the camera.

7 When the pulses add up to a number that has been determined to be the shutter speed for this photograph, the processor sends a second burst of electricity to the electromagnet associated with the second curtain, which is still collapsed on the second side of the sensor. Its latch released by the electromagnet, the spring spreads the curtain's blades across the surface of the image sensor.

5 When the current hits the electromagnet, the magnet pulls the spring latch away from the spring. The spring moves arms attached to the curtain covering the sensor and pulls the blades together, exposing the sensor to the light from the camera's lens.

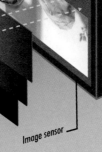

Image sensor

8 The time interval between the withdrawal of the first curtain and the deployment of the second one creates a slot through which light can reach the sensor. Only for the longest shutter times, such as a second or more, is the second curtain delayed until the first curtain has completely revealed the sensor. The faster the shutter speed, the narrower the slot. For a shutter speed of 1/1000 of a second, it actually takes the curtains several thousandths of a second to complete their jobs, but each section of the sensor, as the slot passes over it, is exposed for only a single thousandth of a second.

SECONDS: 00.001

Oscillator

6 Meanwhile, an electronic counter is adding up the pulses from an **oscillator**. The oscillator passes an electrical current through a material such as quartz or lithium niobate, both crystals. The current causes the crystals to vibrate at a constant predictable frequency.

How a Camera Measures Light

Eyes are not the only things that can sense and respond to light. There are—luckily for photographers—various chemicals and minerals that, in combination with each other, can sense when light is striking them and respond by producing electricity. It's a good thing for photographers because these inanimate light sensors are immensely more sensitive and more accurate than the human eye when it comes to measuring exactly how much light they're seeing. Before then, exposing a photograph correctly was largely a matter of guesswork and experience. Now, a camera does it for the photographer with molecular precision while providing options for using light creatively that photographers a century ago could only imagine.

Metal grid

Glass

Negative contact

P-Layer

Depletion Layer

Electrons

N- Layer

Holes

3 The light passes through a layer of glass coated with an anti-reflective film and into the **P-layer** made of silicon that has been infused, or **doped**, with boron. The P-layer is no thicker than 1μm—a micrometer, or one millionth of a meter. That particular thickness is what makes the photodiode responsive to light in the visible spectrum.

4 Longer wavelengths in the light make it through the P-layer into the thicker **N-layer** at the opposite side of the photodiode. Along the way, the light also passes through the **depletion layer** formed at the conjunction of the P-layer and the N-layer.

5 Before light strikes the diode, electrons in the three layers of silicon move in a fairly synchronized manner. When one electron breaks off from a silicon atom, another electron takes its place, much like customers at a busy but not overburdened lunch counter. When light enters the silicon, however, it raises the energy level of the electrons so that fewer of them settle into the vacancies left by other electrons. It's much as if all the customers at the lunch counter ate too much of the same bad, overseasoned chili. Suddenly, they are rushing away from the counter leaving empty seats, called **holes** in semiconductor terms.

6 An electrical field in the depletion layer pulls electrons out of the P-layer, accelerating them into the N-layer. It moves holes in the opposite direction, toward the P-layer.

1 Even the most elaborate exposure system begins with a tiny device called a **photodiode** or **photovoltaic cell**. It's a specialized form of a transistor, or semiconductor, so called because in one situation it conducts electricity and in another situation it acts as an insulator, blocking the flow of current. A lens on one side of the semiconductor concentrates light toward the photodiode.

2 The light passes through a thin layer of glass and through a metallic grid that makes up the negative of two electrical contacts that connect the diode to the rest of the light-measuring circuit. The grid must have enough open space for the light to hit the diode beneath it, but the grid must be substantial enough to easily carry the current the diode will produce. A metal layer covering the entire surface of the opposite side of the diode is the positive contact.

7 The activity creates an imbalance in positive and electrical charges. If the negative and positive contacts on opposite sides of the diode are connected with an electrical circuit, the electrons corralled in the N-layer rush through the circuit to join with the holes, creating a flow of electricity. This is the **photovoltaic effect**.

Positive metal contact

8 In old camera light meters, the electrical current passed through an electromagnet, which in turn moved a metal needle on a gauge a distance proportional to the amount of current, which was proportional to the strength of the light creating the current. Photographers read the light level from the gauge and set their exposure accordingly.

Microprocessor

ADC

TO SHUTTER AND DIAPHRAGM

9 Today, the current passes through an analog-to-digital converter (ADC), which translates the strength of the current into a numerical value that a camera's exposure system and microprocessor uses to set the exposure automatically.

How Light Meters See the World

The most complex part of a digital camera is its exposure system. It's more than a photodiode measuring the light coming through the lens. Among the most versatile cameras, the exposure system has more than one way to measure light and mixes those measurements into a brew made of settings for the type of lighting; the sensitivity of the image sensor; and special settings for action shots, fireworks, black-and-white, or even special effects such as sepia toning. That brew is siphoned to set into action the diaphragm and shutter, all in the blink of an eye.

 Less-expensive digital cameras—called **point-and-shoot (POS)** models—often have only one of the many ways of measuring light that more-expensive cameras boast. It's called **full-frame** and it typically uses one photodiode device mounted next to the lens. On better cameras, full-frame metering uses several photodiodes—as many as 45—mounted in the path of the light on its way from the lens to the shutter hiding the image sensor. Either type of full-frame averages the intensities of light reflected off a subject to determine a shutter speed and aperture that will produce an exposure that is expected to render everything in the photo. But unless a scene is evenly lit and contains only subjects with the same color value, full-frame exposures are usually less accurate.

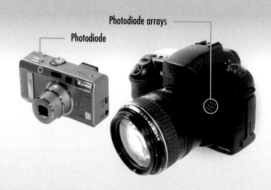

Photodiode

Photodiode arrays

2 In the photo here, for example, the bright sunlight falling on the bricks behind the boy riding in his car has made the camera's autoexposure feature overcompensate and shut down the diaphragm too much. The result is muddy shadows revealing little detail in the most important part of the photo.

3 This occurs because exposure systems think that no matter how bright or how dim something is, it is 18% gray (which is considered a medium gray). In these photographs, you can see white, gray, and black sheets of paper in their true colors when they are all in the same photo. But when each is photographed so that it is the only object measured by the exposure meter, the camera's exposure automatically is set to render the three sheets of paper as the same medium gray.

4 To overcome the perils of using an average of an entire scene's illumination, better digital cameras have alternative ways of measuring light that can be chosen from a menu displayed in the camera's LCD screen or by one of the camera's control knobs or buttons. The first alternative is **center-weighted** measurement. It meters the light in an area that amounts to about a tenth of the total photo area. As the name implies, that tenth is located in the center of the screen on the theory that that's where the most important part of the scene is.

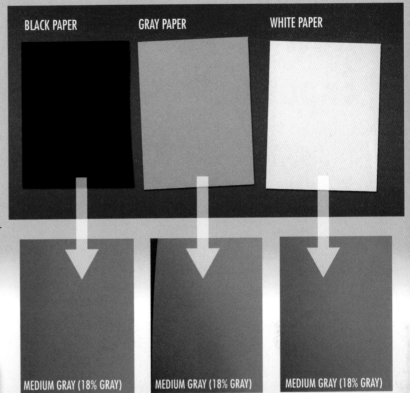

BLACK PAPER GRAY PAPER WHITE PAPER

MEDIUM GRAY (18% GRAY) MEDIUM GRAY (18% GRAY) MEDIUM GRAY (18% GRAY)

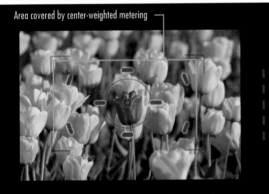

Area covered by center-weighted metering

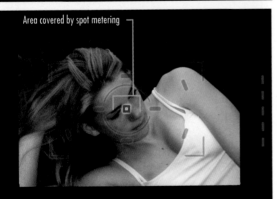

Area covered by spot metering

5 The other common alternative is **spot metering**, which gives the photographer greater ability to expose the part of the scene that is most crucial. Illumination is read from only a small circle in the center of the screen, allowing the photographer to expose for the lighting on a cheek that might be surrounded by dark hair and a beard that would otherwise overwhelm the light readings. When the crucial subject matter is off-center, some cameras have the capability to make small areas on different parts of the image the spot for purposes of metering. For those without such cameras, you can use the **shutter lock** described in the box below.

The Half-Push
When the most important element of a photo is not in the center of the frame, most cameras have a shutter lock feature that lets them focus and get an exposure reading for their picture by aiming the center at that important element. Then, by pushing the shutter button only halfway, the autofocus and autoexposure settings are locked. The photographer then reframes the picture with that key element away from the center and presses the shutter button the rest of the way.

How Digicams Juggle Exposure and Creativity

In the few seconds it takes to snap a picture, there is a windstorm of activity as different parts of the camera measure, calculate, communicate, and finally send out electronic instructions to various other parts of the camera that result in a swirl of switches, gears, and exploding light. Most of this activity is centered on exposure, admitting into the camera the right amount of light for the right length of time to register an image where crucial details are not lost in the shadows or blown away in the highlights. We'll look at each of the elements that go into calculating an exposure in more detail, but first, here's a whirlwind tour of the exposure.

ISO 400

Bracket

Fireworks

Exposure Compensation

-2 -1 0 1 2

ADC

PROCESSOR

512MB

1 Photodiodes catch light from the subject of the photo-to-be. Those photodiodes churn the ethereal light into thin currents of electricity. If the photographer is changing the zoom on the lens, the currents may vary as the zoomed frame takes in a changing amount of light.

2 Those electrical signals shoot to a **microprocessor** that determines from the strength of the signals how much light is streaming from the subject to the lens. Before determining which exposure to set that corresponds to the light meter signals, the camera consults information coming from several other sources.

3 **Special programs:** Some cameras include routines for altering exposure for situations most photographers, and most light meters, would be at a loss to handle entirely on their own, such as fireworks or candlelight.

4 **Exposure compensation:** The processor checks to see if the photographer has ordered that exposure be set for a little lighter or darker than the light meters themselves would dictate.

5 **Bracket exposures:** This setting tells the processor whether the photographer has ordered up additional exposures a stop (or fractions of a stop) above or below what the photodiode devices say the proper exposure should be.

6 **ISO setting:** On many cameras, the photographer has a choice of ratings referred to as International Order for Standardization (ISO). They are the digital camera's equivalent of ASA ratings on film. Although it's convenient to think of ISO settings as determining how sensitive the image sensor will be to the light that washes over it, in fact the sensor becomes no more sensitive. Instead, the electrical signals that the sensor generates are amplified, an important distinction as you'll see later. But all in all, the greater the number for an ISO setting, the less light the shutter and aperture must admit.

7 **Exposure mode:** The exposure mode setting tells the processor whether the photographer has already claimed the right to control the setting of the shutter or diaphragm, or both.

8 **Built-in flash:** The processor does a quick check on the flash unit to determine whether the flash is open and ready to fire if need be.

9 **Shutter button lock:** The processor must check to see if the photographer is holding the shutter button down halfway. If so, the processor ignores changing signals from the light meters and autofocus and bases the exposure settings on the light readings at the time the photographer locked exposure and focus by semipressing the button.

10 Based on all this information, when the photographer presses the button completely to take the picture, the processor sends precise electrical signals to motors and switches controlling the diaphragm, shutter, and image sensor. The diaphragm closes to the proper aperture, and the shutter opens and closes for a precise slice of time. The image sensor, its pixels excited by the light that bursts through the lens, quickly sends the electrical current that the pixels produce in three streams representing red, blue, and green to be converted into digital values that are multiplied by any factor demanded by an ISO setting and stored in memory. Millions of loitering electrons, in less than a second, have become a photograph.

How Exposure Systems Balance Aperture and Shutter

After a camera's photodiodes have measured the light coming from the subject and the camera has sent that information to a microprocessor, all the information needed to obtain the perfect exposure is still not in. The processor must meld the light reading with other exposure controls the photographer might have set in anticipation of the special requirements of this particular photo shoot. Finally, for better cameras, the photographer has veto power to step in and impose his own idea of how a scene should be exposed. Most cameras, however, let you take advantage of specialized settings that take the worry—and thinking—out of photography.

Any combination of shutter speed and aperture that meets at the same diagonal line is an EV. Here, an exposure of f/8.0 at 1/60 of a second is equivalent to f/5.6 at 1/125 of a second. Both exposures have an EV of 12.

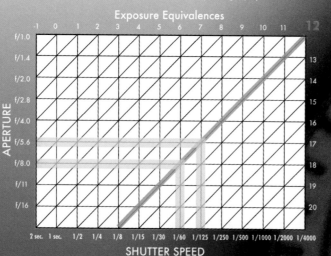

Exposure Equivalences

SHUTTER SPEED

1 The digital processor's job of finessing aperture and shutter settings is simplified by the use of exposure values (EVs). These are numbers assigned to different combinations of aperture and shutter that result in the same exposure. When, for example, the aperture closes down one more stop, the exposure remains the same provided the shutter stays open longer. The new combination causes the same amount of light to fall on the image sensor as did the previous one. This chart shows the range of exposure equivalents.

4 Most digital cameras provide specialized settings, often referred to as **scene modes**, for situations that don't fall into the standard exposure modes. Some cameras provide more than two dozen such scene modes, including one mode for making people look as if they've lost several pounds. Here are a few of the more common:

- **Portrait**—Opens the aperture as wide as possible for a minimum depth-of-field that eliminates distracting backgrounds that could draw attention away from the subject of the portrait.

- **Landscape**—Sets the aperture as small as possible for maximum depth-of-field.

- **Close-up**—Also sets for maximum depth-of-field because depth-of-field naturally shrinks as the distance to a subject gets shorter.

- **Action, or Sports**—The shutter speed is set as fast as possible to freeze action.

- **Night Portrait, or Twilight**—The shutter speed is set to slow, and the flash is brought into action. The flash illuminates the foreground, and the shutter remains open to pick up some of the background.

2 Exposure equivalences are the basis of a common feature among digital—and film—cameras: **exposure modes**. The photographer chooses among modes using a knob located conveniently near the shutter button. Typically the modes include

- **A** **Automatic Exposure**—The processor works unassisted except for the light meter readings and information from the lens that suggest a shot might be a landscape or one that requires a fast shutter to defeat shaky hands. The chip's software decides on both the shutter speed and aperture, usually choosing a combination that works perfectly fine for the average shot.

- **P** **Programmed Exposure**—Similar to automatic mode, except that the photographer can change the shutter or aperture on-the-fly and that the processor responds by adjusting the aperture or shutter, respectively, to maintain the same exposure equivalence.

- **Tv** **Shutter Priority or Time Value**—The photographer chooses the shutter speed, and the processor picks a complementary aperture setting. Shutter priority is useful when it's important, for example, to have a fast shutter to freeze an action shot.

- **Av** **Aperture Priority or Aperture Value**—Just the reverse of shutter priority. The photographer chooses the aperture, and the processor picks the shutter speed. It's useful for a portrait when the photographer wants to maintain a large aperture so the background is blurred and unobtrusive.

- **M** **Manual**—For those times when the photographer has a better understanding of the lighting than the light meter does.

3 The photographer's choice of exposure mode influences which exposure setting, from among several EVs, the processor picks. The chart here shows a multiprogram autoexposure system that allows the photographer to select fully automatic, high-speed, or maximum depth-of-field without having to pick any specific shutter or aperture setting. The exposure system sticks to one of a few specific paths that run through the range of aperture and shutter settings. The setting in each of the paths meets the requirements of the photographer's selection.

For the average photograph, for which the photographer has not chosen any special priority, the exposure system chooses a setting among the EVs shown here in yellow. For depth-of-field priority, the camera's processor chooses among the blue EVs. For action shots, the choices are concentrated along the high—shutter speed EVs, marked in green.

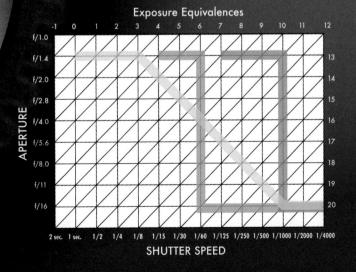

Exposure Equivalences

How Digital Photographers Remain Masters of Their Domains

Despite the sophistication and the artificial intelligence found in digital cameras, there still are circumstances when the photographer must assert the human capacity to understand things that even today's intelligent machines do not. Digital features let photographers give a nudge-nudge to their cameras' very best judgments, and the prospect of taking a badly exposed photo shrinks to nonexistence.

For exposure, the nudge is called **bracketing**. And it puts the element of chance back amid the precision of modern cameras.

How Bracketing Gives Digital Photographers Insurance

1 The photographer sets the bracketing feature on one of the camera's menus. Typically, the menu gives the photographer two types of choices for bracketing. One tells the camera how many pictures to take each time the photographer presses the shutter button. The minimum number is an additional shot on either side of the "official" exposure determined by the light meter readings.

2 The second choice is how much each of those extra exposures should vary from the original settings. Some cameras permit overexposures and underexposures as small as a third of a stop, which lets a third more or a third less light reach the image sensor. The maximum compensation per bracket is usually one stop, which doubles or halves the light. Within a range of one stop above and below a camera's reading, a photographer is almost always certain to find the perfect exposure.

How Photographers Use Exposure Compensation

1 If you recall a few pages back in "How Light Meters See the World," a camera's exposure system averages all the light values coming from different sources: a blue cloudless sky, long purple afternoon shadows, and pink blossoms pushing through deep green leaves. After it has averaged all that, the camera's system assigns a value of middle gray—actually an 18% gray—to that average and sets the exposure for that value only. For the average outdoor scene, the result works well.

2 In both photographs of the seal, the snow and the animal's white coat practically fill the frame. An exposure system sees nearly pure white as the average light value in the scene and, as shown in the simulation above, underexposes the shot so all that white gets only enough light to turn it into middle gray, which makes for a dirty seal and dirty snow. Just the opposite—a black cat on a black couch—would trigger an overexposure and result in a murky, washed out kitty.

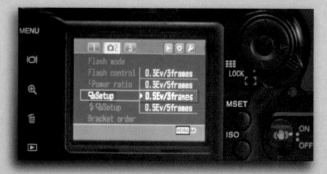

	Zone	% black	RGB
	0	100%	0
	1	90%	30
	2	80%	55
	3	70%	80
	4	60%	105
	5	50%	128
	6	40%	155
	7	30%	180
	8	20%	205
	9	10%	230
	10	0%	256

How Photographers Get in the Zone

How does even an experienced photographer know how much exposure compensation to use? Next to seat-of-the-pants guesses, the most popular method is the Zone System. It divides the **grayscale** range into 11 **zones** from 100% white to 100% black. Each of the zones corresponds to a one-stop difference from the zones preceding and following it. The Zone System was developed by Ansel Adams as a way, combined with careful, custom developing and printing, to give his landscapes the full range of tones possible in black and white. Is it possible for Adams's technique to be relevant for photographers working in color, with no film developing, and in entirely different ways of printing? The answer is yes.

Of course, it takes an experienced eye to gauge zones correctly in the real world, where things are in colors rather than shades of gray. It's not necessary, however, to assign a zone value to every color in a scene. What works is to correctly identify one color that translates into a Zone V or 18% gray, the middle gray that a digital camera's exposure system sees as the proper shade for all things. Take a spot reading of that color to set exposure, and the entire scene is exposed correctly. Grass will usually translate as a Zone V; Caucasian skin is usually a VI; and a shadow from sunlight is often a IV.

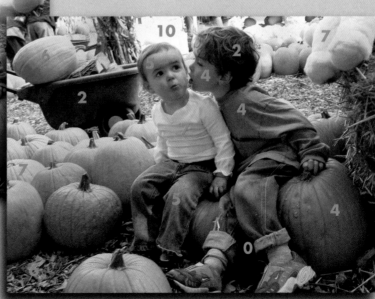

How Digital Cameras Create a Whiter Shade of White

Eyes do only half the work of seeing. They generate a lot of nerve impulses in response to stimulations from light striking the retina. But you ain't seen nothin' until the brain interprets the impulses. All the information that seems to come so naturally through the eyes—shape, size, color, dimension, and distance—is the result of the brain organizing sensory information according to a set of rules the brain starts compiling soon after birth.

The truth of this is found in how we can play visual tricks on the brain with optical illusions, 3D movies, and *trompe l'oeil* paintings. The brain plays one trick on itself: It convinces itself that white is white even though under different lighting—daylight, incandescent, fluorescent, and so on—white might actually be gray, brown, or blue. Photographs, though, are callously truthful. They capture light that the brain insists is white and reveal its true color. This is why digital cameras have a feature called **white balance**.

1 White light is the combination of all the colors of the visible spectrum, something easily demonstrated by shining a white light through a prism. Different light sources, however, produce what the brain is willing to accept as white by combining the colors of the spectrum in different proportions from those found in daylight. Some sources use colors from a continuous spectrum. Others use light from only a few narrow bands in the spectrum.

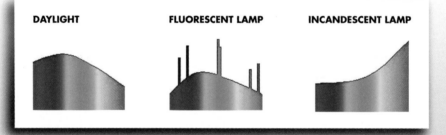

| | DAYLIGHT | FLUORESCENT LAMP | INCANDESCENT LAMP |

Artificial Light Sources	Kelvins
Match flame	1700
Candle flame	1850
40-watt incandescent tungsten lamp	2650
100-watt incandescent tungsten lamp	2865
Photoflood or reflector flood lamp	3400
Common fluorescent tube	4000
Xenon arc lamp	6450
Daylight Sources	
Sunrise or sunset	2000
Early morning or late afternoon	4300
Noon	5400
Overcast sky	6500
Average summer shade	8000

All Kelvin measurements are approximate.

2 The colors these light sources produce are correlated to the temperature of the light measured in Kelvin (K), which starts with 0 at absolute zero (–273° centigrade [C]). The use of Kelvin is more convention than science. The Kelvin temperatures assigned to colors do not translate to the heat generated to produce the colors. In other words, light that has a warmer appearance has a lower temperature and light that has a cooler appearance has a higher temperature.

8000	Daylight Metal Halide **5,500K**
7500	
7000	Cool White Fluorescent **4,200K**
6500	
6000	Std. Clear Metal Halide **4,000K**
5500	
5000	Warm (3K) Metal Halide **3,200K**
4500	
4000	Halogen **3,000K**
3500	
3000	Standard Incandescent **2,700K**
2500	
2000	High Pressure Sodium **2,200K**
1500	

lower the number, the warmer the lamp.

3 Of these temperatures, the ones most commonly affecting photography are the temperatures of outside light, ranging around 5500K, and those from inside, artificial lighting, around 3200K. The lower temperatures tend to have a redder, warmer tint that gradually changes to a bluish tint at the higher temperatures. As a consequence, photos taken indoors with film designed for outdoor use or taken digitally with a camera set to expect outdoor lighting have a warm, orange discoloration. Photos taken outdoors with either film or a digital imager expecting indoor lighting are cold and bluish. The pictures of Daffy were shot without color correction, left to right, in fluorescent light, daylight, and incandescent (tungsten) light. The spectra show how colors were distributed in each photo.

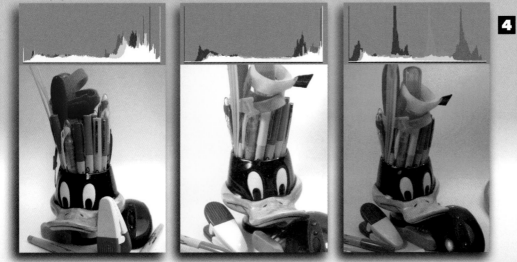

4 In film photography, there are three ways to counter the inconsistency of light: film designed for outdoor or for artificial lighting, lens filters that temper the light with colors that balance out the inaccurate hues of outdoor or indoor light (filters can also be used in the dark-room, but relatively few photographers do their own color film printing), and a flash unit that gives outdoor colorations to indoor scenes.

5 The fixes for film photography require some degree of planning, and they are tricky to accomplish given all the possibilities for false whites. Digital photography can correct for off-white lighting on an ad hoc basis by changing a setting for white balance. On some digital cameras, the process of setting white balance is accomplished by giving the camera an example to go by. The photographer merely presses a certain button while pointing the camera at something known to be white (despite our human tendency to interpret many different hues of white as being identical). This is similar to taking an exposure meter reading by pointing the camera at something known to be a medium gray. But the two types of readings are measuring different qualities of light around your subject matter, and taking one measurement does not replace your need to take the other measurement. White balance can also be set by dialing in a specific Kelvin temperature or a precal-culated setting for common situations such as indoors or candlelight.

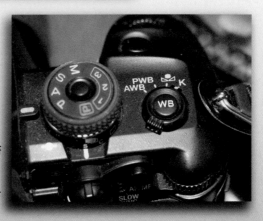

6 The camera's software notes the ratio of red to blue pixels in the white example. (Green does not have a significant effect on white balance.) If the ratio doesn't match the usual proportions of red and blue for a white object in normal daylight, the camera's processor adds more red or more blue pixels to the image to correct the color. Subsequently, when a photo is snapped, the processor makes the same red/blue adjustments to it.

7 Should small lighting changes occur without the photographer noticing and resetting white balance, a digital photo's white balance can often be easily adjusted later using photo-editing software.

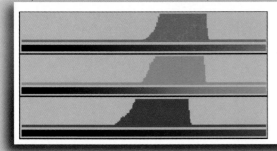

How Speed Creates Noisy Pictures

We've all driven through the night, trying to tune in any radio station to keep us company and keep us awake as we motored through stretches of countryside barely on the fringes of distant radio signals. What faint broadcasts we could receive sounded as if they were being pan-fried as the incoherent sizzle of static would swell to drown out music and voices. Radio static comes from the random dance of electrons and stray electromagnetic waves that have been throwing a party throughout the universe since the Big Bang. The same type of electromagnetism, though not with so grand an ancestry, peppers digital photographs with visible static, **noise** as it's called in photography despite its silence. Here's where it comes from, what you can do to avoid it, and how, sometimes, you need it when it isn't there.

Photographic noise is digital photography's equivalent of the grain in photos derived from film whose sensitivity to light has been pushed to the limit. In film, grain shows up as dark clumps that rob the photographs of finer resolution. In digital photographs that have also stretched normal exposures to eke out some detail in the shadows, noise appears as white or faint pastel specks that can add texture or simply be distractions. Noise commonly comes from several sources.

Dark noise comes from the imaging sensor and its accompanying circuitry. The heat these electronics produce boils off electrons that bounce around in the form of **dark current** until they end up in one of the photosites, where they're counted along with the legitimate photons captured through the lens. Depending on the type of image sensor used, an increase of 6°–10° C can double dark noise. Some photosensors, called **hot pixels**, generate more dark current than their neighbors and so produce more noise, but at known locations.

Digital photograph shot at 3200 ISO, f/22 for 30 seconds

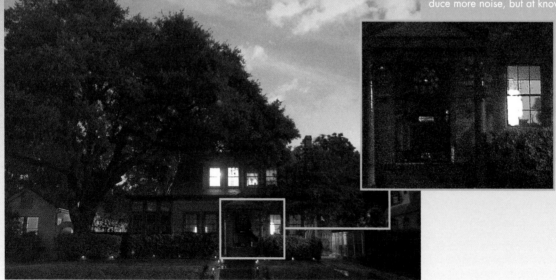

Signal noise is the noise that's inherent to all imaging and electromagnetic transmissions, which are the **signal**. The photons raining onto the photosensors do so in a statistical pattern called **Poisson statistics**. They decree that the rate of photons arriving at each photodiode, or **photosite**, fluctuates over time so that one pixel may record twice as many hits as the one next to it, producing inevitable noise. Put simply, noise is the everyday background clatter you can't get away from because there is no such thing as a pure signal. It's the electronic equivalent of traffic sounds, birds, and kids playing outside. Some signal noise is necessary to give objects texture. Photoshop backgrounds and computer-generated art without noise look flat and unrealistic. There are, in fact, programs that let you add noise to photos that are too quiet. The ideal is a **noise-to-signal ratio** that is low but still has some presence.

Amplified noise is akin to the grain you get using a high ISO film, especially when you **push** the film by exposing it as if the film had a higher ISO than it does. When you use a high ISO setting on a digital camera, the camera's sensor doesn't become more sensitive. Instead, the camera increases its amplification of the signals created by the light photons. As you amplify the signal, you also amplify the background electrical noise that is present in any electrical system. Even if no extraordinary amplification is used, reading the signals so they can be converted to digital values still contaminates the signal with noise originating in the amplifiers. This is also called **read noise** or **bias noise**.

Accumulative noise is akin to amplified noise. When you use extremely long shutter speeds in low light situations, you also give noise from its various sources a longer time to accumulate until, like amplified noise, it becomes visible.

Photons

Electrons boiling
off circuitry

CMOS amplifier

Hushing Your Photo

With so many sources of noise, like the visible chatter in the shadows of the photography on the left, you'd think there must be many ways to silence it. You're right. No one method works best in all situations, and unless you do a lot of night photography— pushing the exposure with long shutter times and high ISOs—you usually don't have to worry about noise. If you do shoot in noisy situations, you're still covered. Some camera makers include circuitry to baffle noise. Because the locations of some noise are predictable, the camera's processor sub-

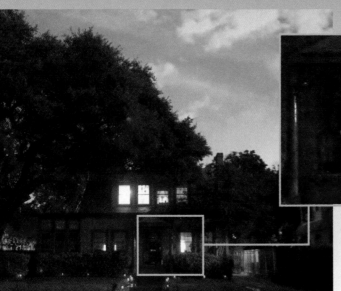

tracts from noisy pixels a value that brings them in line with less raucous photodiodes. As shown in the picture on the right, retouched with Noise Ninja, if the camera doesn't get rid of noise, most photo editing software can.

How Histograms Run the Gamut

The signature look of Ansel Adams's photographs is the rich, dimensional details that fill every inch of his prints. Sunlight gleams off rivers without washing out the water itself. Shadows give mountains density and form without hiding the trees, waterfalls, and outjuts that fill the shadows. Some of it, even Adams admitted, was luck, having a loaded camera pointing at the right spot when bulging, dark clouds decide to part long enough for the light to extend a finger to stroke the landscape. The rest of it was hard work and genius. Adams spent as much time polishing his own technique of developing film and perfecting his print-making as he did shooting large-format pictures in the field. Few of us have the patience, knowledge, or equipment to follow Adams's lead. But digital photographers have something almost as good: It's the **histogram**. A histogram tells you instantly whether your exposure is simply correct for much of a picture or whether light and shadow are perfectly balanced for the entire photo.

Ansel Adams's "Tetons and Snake River"

1 On many digital cameras, the LCD screen that functions as viewfinder and private screening room also provides a graph—a histogram—that supplies more information than a light meter can give you. An exposure deemed acceptable by a light meter, when analyzed in a histogram, can actually turn out to consist of clumps of darkness and light that smother and burn away the details that add visual richness to a photo.

2 While the photographer is composing a shot, the digital camera's processor tallies up how many of the imaging sensor's pixels fall into each of 256 levels of brightness. The processor graphs the levels to 256 columns— or fewer for expediency—but still enough to do the job. The column farthest to the left represents 100% black. The column farthest to the right represents 100% white. The columns between them represent a steady progression of brightness levels, beginning on the left with a level virtually indistinguishable from black itself and proceeding to the right, with each column slightly lighter than the one to the left of it. The height of each of them is proportionate to the number of pixels of each shade found in the frame being shot. On some cameras, the histogram reacts in real time as you adjust the exposure so you'll know before you press the shutter how close you're coming to an acceptable dynamic range.

3 **Dynamic range** is a ratio of extremes. It exists in music as well as photography. A piano has a wide range based on the ratio of the highest note it creates to the lowest. Cymbals and tubas both have small ranges because there's little difference between their highest and lowest notes. In photography, dynamic range is the ratio between the darkest pixel and the lightest. When dynamic range is narrow, the result is a photo such as this one. The red dots under the bridge show where the colors aren't covered by the sensor's **gamut**—the range of colors the camera can capture. For values outside its gamut, the camera substitutes the nearest value it can provide. In this photo, the gamut runs to blacks too soon to capture the shadow details beneath a bridge. It's like an orchestra that lacks a bass section.

4 Inadequate range also causes details to wash out in light areas. Here, overexposure is documented by a histogram in which the columns crowd the right edge. This photo is overexposed by a seasoned photographer who knows that sometimes no single exposure captures an image successfully.

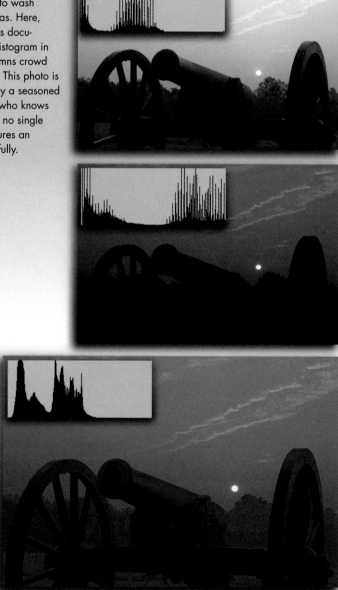

Nature photography by Ed Knepley (www.knepley.net)

5 After deliberately over-exposing a shot by one f-stop, the photographer underexposes the same shot by two f-stops. As expected, the columns congregate on the left end of the histogram in the second shot. In this variation, light areas are properly exposed but the same shadow detail that was visible in the first photograph recedes into the darkness.

6 In the digital darkroom, the photographer combines the two pictures to capture details in both the light and dark areas. Although aesthetic judgments might lead to photos that have a predominately dark or sunny cast, generally a photo looks best—looks *richer*—if its histogram consists of columns distributed across the bed of the graph. Some peaks and valleys along the way are perfectly acceptable. The pattern to avoid is any clumping or vacancy at either end of the histogram unless your subject is primarily bright or dark.

CHAPTER
6

How Technology Lets There Be Light

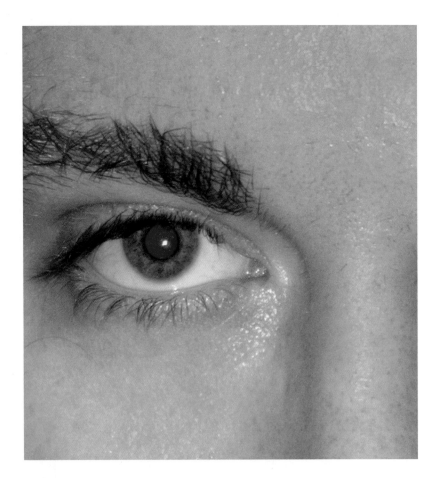

I was quite a purist about it and when
some of the people came in and began
to use flash I thought it was immoral.
Ben Shahn

PHOTOGRAPHS are recordings of light. And the photographer has two choices for the type of light to be recorded—available light and artificial light. The difference between the two is the difference between a comic ad-libbing in front of a brick wall and an actor performing Shakespeare before an audience of English teachers.

The definition of available light is any lighting—sun, moon, table lamps, street lamps, neon signs, candlelight—any lighting that the photographer doesn't add to the scene. Landscape photography is automatically done with available light. No one yet has a floodlight powerful enough to illuminate a mountain or a prairie. Available light is also the realm of dark alleys and battlefields. It is the essence of photojournalism, where, in its purest form, the goal of the photographer is to record reality, to capture a moment as it might have been seen by anyone who happened to be looking at the same spot the moment the shutter was tripped. At most, the journalist-photographer may use a flash attachment. But the flash isn't used to sculpt the subject; it's there simply to make the subject visible. What is possible today with Photoshop and other photo editing programs was unthinkable at the highest realms of photojournalism. When image editing was used to darken O.J.'s face for a magazine cover, the change was berated as visual distortion—and racism—by traditionalist journalist to whom photography must be truthful before all else.

Step away from photography as journalism, though, and all bets are off. Pinups were airbrushed long before Photoshop brought digital perfection to the art. Now before photos ever get to the touch-up stage, advertising, feature photography, portraits, weddings, and other staged pictures are as thoroughly lit as a surgeon's operating table and as precisely as a laser beam.

To expose an image sensor or a film for a few hundredths of a second, a studio photographer may spend hours setting up and adjusting lights. A *Playboy* photo session of a Russian model documented in *Popular Photography & Imaging* describes how Arny Freytag used 24 lights to light everything in the shot just so, from separate lights for each leg to a light dedicated to pumping light on the model's eyes. It's not stretching the point to say that in a studio the photographer's real work is done with how the subject is posed, dressed, made up, and lit. The actual photography is simply a record of the art the photographer has created using the tool of light.

Just as microchips and technology have changed cameras, so have they changed artificial lighting. Not so many years ago, a flash attachment required that the photographer insert a flash bulb into the center of a reflector for each shot. Inside the glass bulb was a bundle of filaments that burned intensely—and completely—when electricity seared through it. Today flash attachments and studio lights don't simply provide light, they provide the right shade of light with the correct color temperature for as long, as short, or as many times as a photographer needs it. Here's a glimpse of how the photographer controls the light with god-like brilliance and intensity.

How Electronic Flash Works

Whether those flashing lights are from the small flash built into point-and-shoot cameras, a professional flash attachment, a bank of studio lights, or even the frenetic flashing above a disco floor, they all work the same way. A gas is excited electrically, until it bursts forth with a high intensity blast of energy in the form of light. Of course, it's actually a little more complex than that. Here, using a high-end flash gun as an example, is the intricate electronic flash dance that begins when the photographer presses the shutter button—a dance that turns mere electrical excitement into enlightenment. Preparations for the dance begin early....

1 Whether the electrical source is a studio's AC wall outlet or a single AA battery in the camera or flash, it's not powerful enough to generate the blinding flash of light the camera needs. The typical 1.5-volt direct current (DC) of the batteries in a flash gun passes through the wire coils of an **oscillator**. The coils cause a transistor switch to open and close rapidly, reversing the current's flow so that it becomes alternating current (AC).

2 AC is needed for the next step in the dance: the **step-up transformer**. Here the current spirals through another coil, one wrapped about an iron core. As the alternating current flip-flops its direction, it creates magnetic fields in the core that expand and collapse with each reversal of the current. This is the source of the whining sound you hear as a flash attachment ramps up.

3 The fluctuating fields create an electrical current in a second iron core wrapped with many more coils of wire than the first core. The voltage of the new current is in direct ratio to the numbers of coils around the two iron cores. (Lest anyone think this creates electrical energy out of nothing, note that the increasing voltage is accompanied by a decrease in **amperage**, or the amount of current, so that it all evens out.)

8 The charge on the trigger plate contributes electrons to the xenon gas inside the tube, a process called *ionization*. At that moment, the larger capacitor discharges its electricity, which races through the xenon. The current excites the gas's electrons, causing them to gain energy. Immediately, the electrons shed that energy in the form of photons, or light.

7 That relatively small charge, called the *trigger charge*, goes to a metal plate called the *trigger plate* located outside a tube of glass or fused quartz that will in an instant produce the flash of light.

6 When you press the camera's shutter button, the camera normally waits until the shutter is completely open. Then it sends a signal to the flash gun. The circuitry inside the flash sends another signal to the smaller of the two capacitors, telling it to unleash its electrical charge.

5 If a flash isn't built into a camera, flash attachments send and receive the signals necessary to coordinate the camera and flash in as many as three ways. The most common is to fit the flash in a **hot shoe**, mounted atop the camera, in line with the lens. The flash may also use a **sync cable** connecting it to a camera's **PC terminal**. (The "PC" has nothing to do with computers. The connector is named for German shutter makers Prontor and Compur.) Finally, and not as common in everyday shooting, the camera and flash communicate with one another through radio signals, or it may be built into the camera. With any of the methods, when the flash is turned on, the first thing it must do is send an electrical notice to the camera that it's there. (Some flash units also send the camera the Kelvin temperature of the light they produce to help the camera automatically set white balance.) That knowledge may change the way the camera's processor would otherwise expose a photo based on only ambient lighting. Dedicated flashes are programmed to work with specific cameras, and swap information that extends the ranges of what the flash and camera can do when they combine their features.

4 The current, now boosted to thousands of volts, is stored in two **capacitors**, electrical components that hold large amounts of electricity for later use, much like a dam harnesses the energy in a flowing river. One of the capacitors stores only a small amount of the electricity. The other, called an **electrolytic capacitor**, is designed to store and quickly release the powerful charge destined to create the flash of light.

Killer Capacitors

A capacitor can retain a powerful, even fatal, jolt of electricity long after a device has been turned off, unplugged, and consigned to the trash bin. That's why you see warnings on electrical equipment not to open some areas even if the device isn't running.

How the Flash Knows When to Quit

The explanation in the previous illustration telling what takes place when the flash is used may have been more complex than I promised it would. But it could have been more complicated still. After all, it's not enough simply to get a big flash of light at the same time your shutter opens. It has to be the right amount of light, and last for the right amount of time, so that the photograph is properly exposed. To get the full picture—pun purely accidental—let's step back a bit, to the point at which the photographer is pressing the shutter button.

2 Some flash units determine the most important part of a scene from reading the distance the camera is focusing on when the camera tells the flash the distance it's focused on. Or a flash may send out infrared beams, measure their return time, and apply some photography common sense. There may be mountains in the distance and an elk 20 feet away. But the flash's microprocessor brain sees only the elk. Because its light could never illuminate faraway mountains, the flash settles on something within its range—the elk—and sets its light intensity accordingly.

1 Pressing the shutter button does more than cause the shutter to open. First it signals that the photographer is happy with the focus and that the photo is framed properly in the viewfinder. The circuits and motors that control focus instantly freeze. Some cameras take a reading of the **ambient light** levels. These are the light from any source, sun, candles, fluorescent lights—anything except the flash itself. Many camera/flash combinations are able to concentrate on the light levels in the background, where the flash will not reach. Based on the type of exposure the photographer has chosen by selecting aperture or shutter priorities, or scene settings for sunsets, action shots, or as many as two dozen other possible scenes, the camera decides on the best setting for the main subject and the surroundings, information it shares with the flash.

Microprocessor

Thyris

3 Using the information it gathers from the camera's focusing and its own sleuthing, many high-end flash units respond by activating small motors that move its **Fresnel lens** back and forth to the point where the most light is concentrated on the subject.

4 When the shutter button finally reaches the end of its travel, some flashguns fire a **preflash** while the shutter is still closed. This is the camera's reality check. Its autoexposure sensors determine the real, exact brightness of the flash and adjust exposure settings accordingly. Other cameras forgo the preflash, and figure out the correct amount of light to produce on-the-fly from readings taken through the lens. On less expensive point-and-shoot cameras, a light meter mounted on the front of the camera reads the light levels. Some flashes store information about how long their bursts of light should last to achieve proper exposures.

5 A camera such as the Minolta 7D or its heir, the Sony Alpha 1, is designed to mate with an integrated but separate flash. The flash uses a complex but precise and quick way to calculate the required flash using the camera's through the lens (TTL) light metering. The camera commands the flash to fire a series of 14 pre-flashes, one for each of the 14 exposure sensors used in the 7D. The readings from those sensors, combined with the distance to the subject reported by the focus mechanism, the position of the subject in the viewfinder, and the ambient light brightness, allow the camera to determine the exact amount of light needed for a proper exposure—the threshold limit stage—and how much of the charge in the unit's capacitor is needed to produce the correct amount of light.

Threshold limit

Preflashes Primary flash

6 Other flash units depend on a **thyristor**, a transistor and switch that's snuggled in the flashgun's circuitry and staring a photodiode eye toward the scene being shot. The thyristor measures the amount of light bouncing back toward the camera. When the predetermined amount of exposure has been reached or the TTL system in the camera gives the word, the thyristor switches off the flow of electricity that has been feeding the flash. The thyristor prevents the escape of whatever charge still remains in the capacitor so the

How Shutter and Flash Sync

The burst of light from a flash and the amount of time a shutter is open are both so fast that the two operations must take place with precise timing. They must be in synchronization, or sync. Contributing to the problem is the fact that on most focal plane cameras, a shutter speed faster than 1/250 of a second means the shutter is never completely open at one time so that the entire frame can benefit from the flash. As the speed of the shutter increases, synchronization becomes a greater problem that is countered by increasingly clever scene programs and more intelligent flash attachments.

1 As part of the dance of flash and exposure we just saw in the previous chapters, one of the other things that occurs when the photographer presses the shutter button is that the shutter and the flash begin a nimble *pas de deux* called **synchronization** or **sync**. On most cameras that use **focal plane shutters**, or **leaf shutters**, only shutter speeds as slow as 1/60 or 1/125 of a second allow the entire image sensor to be exposed at the same time. These exposures use **X-sync**. The flash waits until the shutter's curtains have completely exposed the image sensor. Then, in just 1/1,000 of a second, the flash releases its full fury before the shutter can start to close. The top shutter speed for most cameras using X-sync is 1/500 of a second.

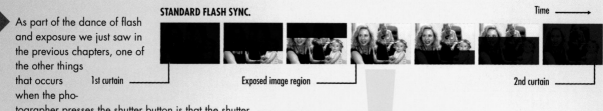

STANDARD FLASH SYNC. Time →

1st curtain Exposed image region 2nd curtain

Single flash burst

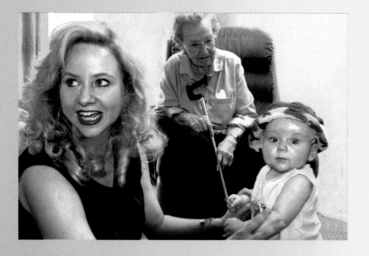

2 Faster shutter speeds require the second shutter leaf to start covering up the sensor before the first leaf has finished exposing it (see Chapter 6). The exposure is made through a slot formed as the shutter's two curtains pass in front of the sensor. An X-sync flash used with this type of shutter operation, instead of producing a photo that looks like this...

...would turn out a picture more like this.

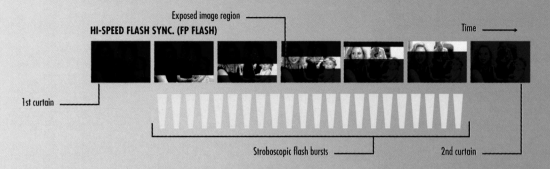

HI-SPEED FLASH SYNC. (FP FLASH)

Exposed image region

Time

1st curtain

Stroboscopic flash bursts

2nd curtain

3 What is needed in this situation is a relatively long flash with reduced brightness. But flash units are pretty much full-speed ahead until it's time, according to the thyrister, to turn the light off. Short exposure times call for **focal plane sync**, or **FP sync** (also called **HSS**, for **high speed sync**). With this setting, the flash executes a series of short bursts at a high frequency, about 50MHz. None of the bursts swell to the flash's full brilliance, but the series lasts long enough to illuminate the full frame evenly. FP sync can work with some cameras at shutter speeds up to 1/8,000 of a second.

4 Photographers use another type of synchronization, **slow sync**, to capture movement using flash. The flash is timed to go off only when the shutter is fully open. Meanwhile, with most of the shutter open, the image sensor is already recording the moving subject of the photo. Because the subject is moving and because the scene is dark enough to require a flash, this part of the exposure is more suggestion than documentation. The subject is blurred, and even the blur is hard to distinguish except for any lights or bright reflections. Right before the shutter snaps shut, the flash goes off, adding a clear, exposed view of the subject. In this case, the streaks from a car's lights, captured before the flash went off, provide the sense of movement.

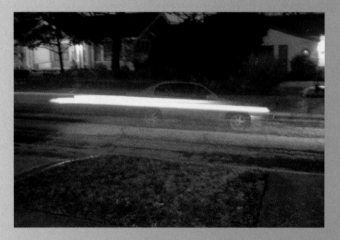

5 But notice how the proper synchronization is crucial to the effect. If the flash goes off just as the shutter has opened, as in this photo, the hammer appears to be streaking backward. Slow sync is also called **rear curtain sync**.

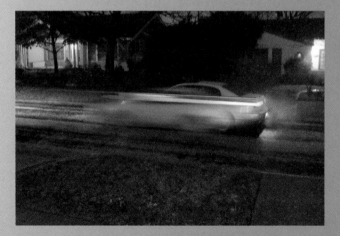

How a Flash Turns Eyes Red

All digital cameras come with a built-in flash. (If I'm wrong and you know of a digital camera built in the Outer Hebrides that has no flash, please write. I can't wait.) Built-in flash—either the type that pops up above the lens or the kind that sits flush with the front of smaller cameras—is too weak to light up a subject more than a few yards away. This is fine for birthday candle blowing, and it's the simplest way to use **fill flash**. But built-in flash has a serious flaw: It's built in and, often, in exactly the wrong place. (Directly over your lens is not the most intelligent place to mount a flash.) A **flash attachment**—or, more accurately, I suppose, **detachable flash**—gives you more light and more ways to use that light in your picture.

Red Eye: Getting the Red In…

1 A flash mounted directly inline with the axis of a lens fires as the picture is taken. The light from the flash enters the eyes of the subject through his irises. Because the setting is dark enough to require a flash, chances are it's dark enough to cause the irises to open as wide as they can.)

2 The light from the flash passes through the clear liquid that fills the eye and strikes the retina at the back of the eye. The retina is rich with blood vessels that give it a bright red coloration. Light from the flash reflects off the red retina and travels back out the wide-open iris to be captured by the image sensor (or film). The result: Your subject looks possessed by a demon.

Other Ways to Reduce Red Eye
- Have the subject look away from the camera.
- Hold a **flash gun**, attached to the camera with a cable, away from the camera.
- Bounce the light from the flash off the walls or ceiling.
- Use an image editor such as Photoshop or Paint Shop Pro to cover up the red portion of the eye.

...And Getting It Out

3 Some cameras minimize red eye by first shooting a short flash without taking a picture. This short flash causes the subject's irises to reflexively contract.

4 This short flash is followed by one matched to the opening of the camera's shutter. Light from the second flash is largely blocked by the nearly closed iris so that little light enters the eyeball and still less is reflected off the retina back to the camera.

How Fill Flash Works

The ubiquitous built-in flash on digital cameras ranging from drugstore disposables to professional rigs from Nikon and Canon are good for one thing in common: Shooting pictures in bright sunlight. As oxymoronic as that may seem, there's method in the moron.

1 On sunny days, subjects often wear wide-bill hats that cast deep shadows on their faces—particularly on their eyes, which are invariably the most telling feature in a portrait. Have them take off the hats, and they squint in such an ugly way, you'd prefer their eyes were hidden. So, it's back on with the hats, and you wind up with a photo that looks like this.

2 That's when **fill flash** steps in. Fill flash does exactly what its name suggests. The flash fills in the dark shadows while it does not noticeably lighten the already sunlit portions of the photo. The result looks like this.

3 The best thing about fill flash is it often requires no elaborate preparation beyond making sure your flash is turned on. If your subject enjoys staring wide-eyed into the sun, the added burst of light from the flash goes unnoticed. I've known many newspaper photographers who often get only one shot at a photo and can't take chances. They only rarely take a photo without using a flash, even if they're in the Sahara Desert at noon.

Flashing All Around

Of course, not all flash attachments are mounted directly over the lens. Nor to the side, a much more preferable location. Photographers who are into **macro photography**—shooting extreme close-ups of extremely small subjects, such as June bugs and cavity-ridden molars—often use special flash units, called **ring flash** or **macro flash**, that let them illuminate their subjects without their lenses blocking their view. The flashes are either based on the same xenon gas arrangement from earlier in this chapter or consist of dozens of bight LEDs. In either case, they are designed to encircle the lens, putting the lights within inches of the subject. When it comes to June bugs, red eye is not a consideration.

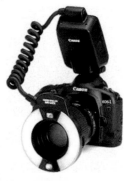

How Studio Lighting Works

The most important difference between a flash attachment built into a camera or riding on the camera's hot shoe and studio lighting is *possibilities*. Flashguns have the obvious advantage of portability, but there is only so much that you can do with them. In a studio, the only constraint on what you can do with lighting is your budget. A meticulous photographer may use a dozen or more lights at once, with some focused on only a small element of the scene. But even with a couple of studio lights, a photographer can create endless light environments.

1 A photographer's studio uses two basic types of lights. One is the xenon-based flash covered in the preceding illustrations, although in a studio they are most often called **strobes**. Although it's not unusual to see flashguns used as studio lights, strobes usually differ from the camera-mounted flash by being able to produce more light. Instead of the internal batteries and capacitors that generate the light in a flash attachment, several strobes may be connected to a **power pack,** a free-standing electrical component containing a more powerful transformer/capacitor combination that draws power from an AC outlet. The box may also be connected to the camera and have the circuits to fire all the strobes at the same time. (Alternatively, the strobes may be made to fire by radio signals sent from the camera or in reaction to the flash of a light connected directly to the camera.)

2 The other type is continuous lighting that remains turned on instead of flashing on momentarily. Studio lighting also uses **incandescent** ("hot lights") and **fluorescent** lighting ("cool lights"). Both are variations of the common household light bulb. An incandescent bulb creates light by sending electricity through a wire that resists the current's flow. Because the electrical energy can't continue through the wire, it has to go somewhere, and it does, in the form of light and heat energy.

3 Fluorescent lights work a bit like flashguns. Electricity flows through argon gas contained in the fluorescent tubes, causing it to ionize and release electrons. The electrons strike the phosphor coat on the inside of the tube, imparting energy to the phosphors, which, in turn, release the energy in the form of light. Both incandescent and fluorescent light differ from their household cousins by being brighter and more closely attuned to the Kelvin temperature of sunlight. The capability of digital cameras to perform **white balance** adjustments on-the-fly makes it simpler to work with light sources that don't have the same color balance as daylight. Both incandescent and fluorescent have the advantage over strobes that they can be left on continuously, giving the photographer a chance for **modeling**, the art of adjusting light to bring out different highlights and shadows.

4 All three types of light may be combined with a variety of devices that modify and control the lights.

Bare bulb—Used without any modification, a bare bulb produces stark, flat light and shadows, washing out detail that depends on more delicate shading.

Umbrella—An umbrella has a dual use. With light shining through it from the underside, it works like a softbox. If the light is aimed at an underside lined with a light-reflecting material, the umbrella acts like a concentrating lens keeping the light parallel, but at the same time, widening the beam of light so that it is softer.

Softbox—Harnessed to the housing of a strobe, an incandescent, or a fluorescent light, a softbox, made of cloth over a wire frame, widens to enfold the strobe in a semi-translucent material. Light passing through the front layer of cloth is diffused so that the light overlaps itself and appears to come from a larger source than the strobe itself. The result is softer shadows and more subtle shading. The larger the softbox and the closer it is to the subject, the more flattering the light is.

Reflector—A reflector is most often used in a single light situation, usually to reflect some of the light from the main light source so that it creates **fill light** in the shadows to reveal details that otherwise would have been lost. Some reflectors have a silver or gold coating to add a bit of brilliance or warmth to a subject.

Snoot—An alternative to barn doors is the snoot, a cylindrical attachment to the front of a light that restricts the light to a narrow beam.

Barn doors—When a photographer doesn't want light to fall on some area, barn doors are flat panels attached to a light to block light in specific directions, like blinders on a horse.

Do-It-Yourself Studio

Studio lighting can cost thousands of dollars—or not. A trip to a hardware store can get you studio light rigs. **PVC pipe** is a cheap way to make light stands and background supports. Metal reflectors with a spring clamp are cheap. For a few dollars more, you can buy the heavy-duty quartz work lights already on portable stands. They can be too hot for extended use with live models, but they pour out a lot of light. For softboxes, check with a photography supply store for Rolux, a translucent material you can use to make your own softboxes that can withstand the heat of your homemade lights.

How Photographers Control Light and Shadow

The world of the studio photographer is as different from the photo journalist's as a painting by Norman Rockwell is from one by Van Gogh. Rockwell paid careful attention to every brushstroke in an attempt to capture reality in meticulous detail—a reality that's warmer, prettier, funnier, and more perfect than everyday reality. Van Gogh strove to use the materials of the moment to create a reality where perfect was not a question, but rather a raw look at an inner reality. Anyone who thinks studio photography is "of the moment" has never spent all afternoon watching a photographer manipulate everything, especially the light, to capture a single moment. Here are some of the ways studio lighting creates different realities in a portrait.

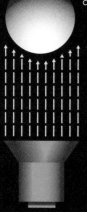

1 A single light shines directly at the subject of a photograph evenly and smoothly in straight lines from the light sources. Without any material in front of the light to modify the light, and no other lights on the subject, the single light creates a flat, featureless face and well-defined shadows.

2 The photographer can do two simple things to better reveal the subject's face. (Both these can also be accomplished with a flash attachment that connects to the camera with a cord rather than the hot shoe.) One technique is to move the light to the side so that the light is striking the subject from about a 45-degree angle relative to the camera horizontally, and vertically from about a foot or two higher than the camera. The lighting reveals more of the contours of the subject, but it is still stark.

3 The second technique is to use an attachment that softens the light coming from the light source. A **softbox** takes the sharp edge off the shadows. As light passes through the translucent front cover of the softbox, the fibers in the cover diffuse the light, bouncing it first one way and then another. The result is that light strikes the subject from many directions so that there is no single edge to shadows. The bigger the area of the softbox, the softer the light becomes.

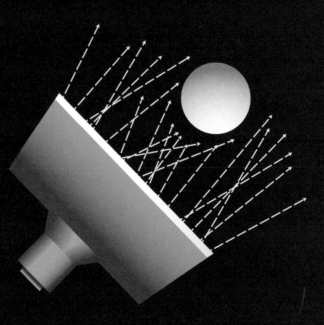

5 An alternative to a reflector is a second light. A common addition to studio lights is an **umbrella**, which can be used two ways. An umbrella both reflects and diffuses light from the source pointed away from the subject and into the umbrella's concave underside. Or the light and umbrella may be turned around so the light shines through the umbrella. In both arrangements, the effect is similar to that of a softbox. A **snoot** light is one that shines through a long cylinder that restricts the light to a small spot. It is often used to point down on the subject to add highlights in the hair.

4 A **reflector** located on the other side of the camera from the light creates a **fill light** by bouncing the light back into shadowed areas. A photographer may use a reflector with a gold surface to add warmth to the lighting or a silver surface for a brighter, crisper fill. The fill light makes the subject appear less harsh.

Softboxes for On-Camera Flash

A photographer in the field gets the same lighting effects as if he were in the studio by using one of these devices that attach to a portable flash. They diffuse the flash as a softbox does, reflect it the same way an umbrella works, or both. They're inexpensive and lightweight. Combined with a lightweight, collapsible reflector, they're the easiest way to give pictures taken "on the go" a studio look.

CHAPTER

7

How Light Becomes Data

I don't think there's anything unique about human intelligence. All the neurons in the brain that make up perceptions and emotions operate in a binary fashion.

Bill Gates

THE real difference between a film camera and a digital camera is not how the cameras take pictures, but how they store them. After a picture is stored on film, there is only so much that can be done with it. How the film is processed can change the image—once. Then the picture is frozen in the form of chemical molecules that have clumped together to form microscopic dots of color. There's no subtle way to manipulate those molecules. Sure, you can disguise the information stored on the film. When you make prints from the negative, you can burn here and dodge there, and use a special paper for a silvery look. You can...well, that's about it. It's purely cosmetic. The fact remains that once visual information is stored on film, it is fixed for all time...or until the chemicals deteriorate so much that the information is lost entirely.

But with a digital camera, or with film-based photos scanned into your computer, there's no limit—none whatsoever—to what you can do with an image after it's stored on a memory card, CD, or hard drive. That's because the image is stored as a huge array of numbers. And as you learned early on about numbers, they stretch to infinity.

Not that we need an infinity's worth of numbers. Truthfully, for most photo purposes, there are only 256 numbers that really count—no pun intended. But you may be surprised what you can do with such a meager supply of integers. Each of the three colors used in digital photography—red, blue, and green—can have any of 256 shades, with black as 0 and the purest rendition of that color as 255. The colors on your computer monitor or the little LCD screen on the back of your camera are grouped in threes to form tiny full-color pixels, millions of them. When you change the values of adjoining colors in the pixels, you suddenly have 17 million colors at your disposal for each pixel. (Or thereabouts: $256 \times 256 \times 256 = 16,777,216$.)

With colors now expressed as numbers, it's much easier changing hues and shades with grade school arithmetic than by mixing cans of paint. To lighten a photograph, all anyone has to do is add 25 or so to the color values of every pixel in the picture—all 3–5 million of them. If you want to lighten only the shadows, just choose those pixels that have a value under 125 and add 25 only to them. Or, go wild and rip out entire sections of the photograph and replace them with entirely different constructs of numbers that represent anything from comets to cattle.

The math is simple, in principle, at least. The tricky part is converting all the possible combinations of colors into numbers. Here, we'll show you how your digital camera pulls that off.

How Film Photography Captures an Image

Digital and film cameras are 90% the same. Optics, exposure, timing, and the skill it takes to use either of the cameras are not much different from one another. Where the difference is greatest is in the topic of this chapter—how light streaming through the lens is trapped and preserved, how film and electronics both take a slice out of time and space to make them into something immutable. We're going to step into our Way Back Machine for a short hop to a few years ago, when digital photography was esoteric and imperfect. When all professional photography was still an analog process—a process that was itself so esoteric as to make it a snap to learn how to use those new digital computers.

1 Although we usually think of light as something to help us avoid walking into walls, it's also packed with energy—a fact you can demonstrate to yourself by lying in the sun too long. That energy is essential to photography. In film photography, the energy in light ignites chemical reactions when color or black-and-white film is exposed to the light when a camera's shutter is tripped. The light, focused by the lens, shoots through layers of a **gelatin emulsion** about a thousandth of an inch thick that rests on a base made of **celluloid** or **polyester**, both transparent plastics. The base, four to seven times thicker than the gelatin, exists primarily to support and protect the fragile emulsion layers.

2 Buried throughout the gelatin are microscopic crystals that are there to make a record of where the light strikes the film. They are the chemical equivalent of the photodiodes in a digital camera's image sensor. The crystals are made by combining silver-nitrate with different mixtures of halide salts, including chloride, bromide, and iodide. Their crystalline structure allows film manufacturers to grow them smaller or larger. The greater surface areas of larger crystals make the film more sensitive to light but result in lower resolution and contribute to noticeable **grain**, the speckled equivalent of **noise** in digital photographs. Smaller crystals, while not able to gather in as much light, can delineate smaller features in a photograph. The result is a trade-off between film that can take photos in dimmer light, with faster shutter speeds and using larger apertures, or film that captures more and smaller details with less grain but requires more light.

FAST FILM

Silver-halide crystals

Gelatin

Base (celluloid or polyester)

FINE GRAINED FILM

COLOR FILM

Spectral sensitizers

3 The sensitivity of the crystals, which ordinarily are mediocre receptors of light, increases when certain chemicals are fused into the crystalline structure. These organic molecules, called **spectral sensitizers**, increase silver halide's sensitivity to light generally. In color film, different combinations or sensitizers make crystals embedded in separate layers in the emulsion respond to specific colors.

4 When light strikes one of these crystals, a **photon** (the particle form of light) raises the energy level of loosely bound electrons in the crystal's halide salt. The electrons unite with positive holes in the silver portion of the crystal to form a pure atom of silver. In color film, crystals in different layers are sensitized to respond only to red, blue, or green light rays.

Halide salt

Photon

Electron

Silver

REDUCING AGENT

5 The pattern of millions of silver grains forms a **latent image**, one that is not yet visible. Color film forms three latent images, one for each of the layers devoted to a specific color. To make the image visible, the film is **processed** through a chain of chemical baths. The first is a **reducing agent**, commonly called **developer**, that converts silver ions into silver metal.

STOP BATH

6 The grains that make up the latent image develop faster than the other crystals. The right combination of temperature, agitation, and time is followed by a **stop bath** solution that neutralizes the reducing agent before it changes the unexposed grains.

7 A **fixing bath** dissolves the unexposed and therefore undeveloped remaining silver halide that was not exposed to the light, leaving only the silver metal behind to form, in black-and-white film, a negative of the pattern of light the camera's lens had projected onto it.

FIXING BATH

COLOR FILM

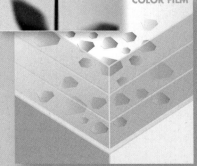

8 In color film, chemicals called **couplers** are matched with the color-sensitized silver halide in each of the three color layers. During developing, the couplers form red, green, or blue dyes concentrated around the silver grains left by the reduction process. After a brief drying, the film is ready to produce prints or to become slides.

How a Microchip Catches a Picture

Here we are, finally, at the point that separates the digital from the analog. The microchip imaging sensor that takes the place of film is the heart of digital photography. If you've been reading since the beginning of the book, you already have an idea of the workings of those microscopic devices that make up an image sensor: pixels. It's a term that's often used loosely but is short for picture elements. Basically, it's a supercharged version of the photodiode we saw at the core of light meters in Chapter 6, "How Digital Exposure Shifts, Measures, and Slices Light." While the basics are similar, the light meter measures only a blurred average of an image. Unlike the light meter, the image sensor doesn't measure simply the intensity of light. It must distinguish all the gradations of light in all the colors that play on its surface, pass that information on in a way that lets it be translated to numbers, and then get ready to capture the next image—all in slivers of a second.

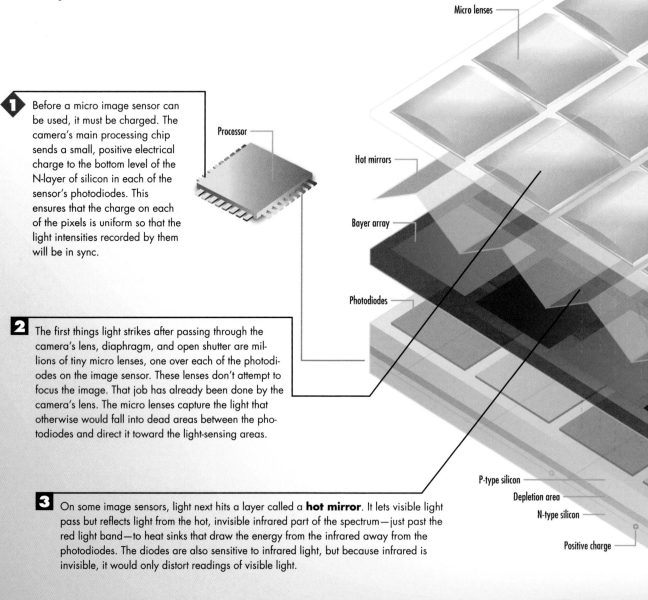

Micro lenses

Processor

Hot mirrors

Bayer array

Photodiodes

P-type silicon

Depletion area

N-type silicon

Positive charge

1 Before a micro image sensor can be used, it must be charged. The camera's main processing chip sends a small, positive electrical charge to the bottom level of the N-layer of silicon in each of the sensor's photodiodes. This ensures that the charge on each of the pixels is uniform so that the light intensities recorded by them will be in sync.

2 The first things light strikes after passing through the camera's lens, diaphragm, and open shutter are millions of tiny micro lenses, one over each of the photodiodes on the image sensor. These lenses don't attempt to focus the image. That job has already been done by the camera's lens. The micro lenses capture the light that otherwise would fall into dead areas between the photodiodes and direct it toward the light-sensing areas.

3 On some image sensors, light next hits a layer called a **hot mirror**. It lets visible light pass but reflects light from the hot, invisible infrared part of the spectrum—just past the red light band—to heat sinks that draw the energy from the infrared away from the photodiodes. The diodes are also sensitive to infrared light, but because infrared is invisible, it would only distort readings of visible light.

4 The photodiodes by themselves are color blind. They can measure only the intensity of light, not its color. So next, the concentrated light passes through a color filter matrix situated above the layer of photodiodes. There is a separate filter—either blue, green, or red—for each of the pixels. The most common design for the matrix is a Bayer array. It patterns the three colors so that no two filters of the same color are next to each other and so there are twice as many green filters as either red or blue. The reason for so many green is because green light is in the center of the visible spectrum and records more detail, which is more important than color information in creating an image. It also compensates for the photodiodes being less sensitive to green light.

5 When light strikes the top layer—the P-layer—of silicon, the light's energy is transferred to electrons, creating a negative charge. That negative charge and the positive charge that was applied to the N-layer before the image capture began create an electric field in which electrons from the P-layer are drawn by the positive force into the diode's depletion area, a narrow strip separating the negative and positive layers. The stronger the light that hits a pixel, the more electrons travel to the depletion layer.

6 Each photodiode continues to collect electrons as long as the shutter is open unless it reaches its capacity limit, called its **well**. Some photodiodes capture as many as 300,000 electrons before their wells are full. If full diodes continue to receive electrons, **blooming** can occur. Blooming is when the charges spill over to neighboring pixels, causing them to be overexposed. To protect against blooming, sensing devices are built with materials between the cells that block and absorb excess electrons.

Electrons

How Image Sensors Differ

The image sensor we looked at in the previous illustration is based on a common design used in most digital cameras. But there are exceptions to the layout of the light receptors for the different colors. And once the photodiodes, in any configuration, have gathered their information, there are differences in how that information is turned into digital data that the camera's microprocessor can tweak before storing it on a memory card. Here are the most important exceptions to the rule.

How the Fuji SR Sensor Has Double Vision

 The ultimate challenge for photographers is to capture the greatest dynamic range in their photographs. **Dynamic range** is the ratio of the highest non-white value and smallest non-black value. More simply, it means that details are easily discernable in the lightest and darkest portions of the photograph. In this picture, there is enough light to delineate the granules of dark soil but not so much light as to burn out the details on the highlighted portions of the leaves.

2 The photos to the left show how adjusting exposure can't always compensate for an image sensor's poor dynamic range. If you increase exposure to show the details in the shadows of the lighthouse, the colors in the sunset wash out. If you decrease exposure to capture saturated colors in the clouds, the lighthouse details are lost in the shadows.

3 In digital photography, the size of the photodiodes influences dynamic range. Think of the diodes as buckets catching rain. A photodiode that is full is pure white. If the photodiodes are too small, the rain overflows and floods adjacent buckets so they are all full, resulting in something called **blooming**—a patch of full photodiodes that produces a white area with no detail. If the buckets are too big and there's little rain, the water might not even cover the bottoms of the pails, and there's nothing to measure. In photodiodes, that amounts to a part of a photograph being completely black, without the relief of any details.

R (range) Pixel *Low sensitivity*
Captures bright light area with high detail, but under-exposes dark areas

S (Sensitivity) Pixel *High sensitivity*
Captures bright dark areas with shadow detail, but over-exposes light areas

4 The Super CCD SR from Fujifilm is designed to solve the bucket problem with a technology called **spatially varying pixel exposures**. In simpler terms, the technology provides two sizes of pails to catch the photon rain. Each of the light receptor sites in the imaging sensor, arranged in a double honeycomb pattern, uses a large and a small photodiode to catch the same light coming through a single filter. The large photodiode does most of the light-gathering work, much like an ordinary photodiode. It captures detail in shadows, but overexposes highlights.

5 The smaller photodiode is set at a lower sensitivity and works as if it wears sunglasses. This prevents it from filling up quickly and causing blooming. As a result, it can capture the detail information in the areas that are so bright that they blind the large photodiode, which stares at the same light with a wide open eye.

6 A fast algorithm built in to the camera's processors combines the readings taken by each pair of photodiodes to create the optimum exposure for the pixel that they represent, with each diode providing a proper exposure where the other can't. By combining the results, the Super CCD SR produces a picture comparable to those produced with a 12-bit color scheme, which has a range of 4,096 brightness levels, even though the photodiodes, individually, yield only 8 bits, or 256 brightness levels.

How the Foveon Image Sensor Stacks It On

An obvious drawback of image sensors using the Bayer matrix is that each pixel captures only a third of the color. To get red, green, and blue (**RGB**) values for each of the pixels, the camera's processor has to **interpolate** the two values each pixel lacks from the values of those colors found in adjoining light sensors. Just as obvious, an image sensor can gather more information from which to create a photograph, if it can get raw RGB values from each one of its pixels. Here's how that works—and how some camera makers have come up with different solutions to the problem.

B 125

G 116

R 200
G 118
B 125

G 120

R 200

1 To obtain approximations of the two missing color values for one pixel, the microprocessor runs an algorithm on four surrounding photopixels. In the example here, the processor adds the values of the two green photodiodes and then divides by 2. This value is joined with the values of the red and blue to produce a virtual pixel that has values of red 200, blue 125, and green 118. (RGB color values range from 0 to 255, with 0 representing black and 255 representing the most intense shade of any of the three colors.)

2 The use of an area comprising four photodiodes to produce a single pixel of roughly one-fourth that area corrupts the resolution and accuracy of the digital image. If you have enough pixels in an image sensor, the effect is not that obvious, although it can still appear in moirés where fine patterns appear in a photograph.

 3 The Foveon X3
image sensors found in
some Sigma and Polaroid
cameras attack the deficiencies of
Bayer matrix sensors by eliminating the
matrix. They use a natural property of silicon
that makes it absorb different colors of light at
different depths in the silicon. Blue light is absorbed
near the surface, green farther down, and red deeper still.

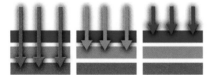

4 In the Foveon photodetectors, each of the three levels converts the energy from the three colors of light into three
separate electrical signals that are used to represent a single color pixel. In contrast with the Bayer matrix photo-
detectors below, no light is lost to filters absorbing two of the three colors and less surface area is lost to the layout
of the separate receptors for each color.

The Digital Rainbow

The Bayer pattern, on the left end, is the most used arrangement of red, blue, and green pixels for
capturing images on a microchip. But it's not the only way to arrange your pixels. In fact, red, blue, and
green aren't the only colors you'll find lurking in a **color filter array (CFA)**. Second is a Bayer pattern
substituting the subtractive primary colors, as found in Kodak DCS620x. Third is a red/green/blue array to
which Sony's DCS F828 adds an emerald filter. The fourth pattern sports cyan, magenta, yellow, and green
pixels, used by some video cameras to create a compromise between maximum light sensitivity and high
color quality. On the right end, an unfiltered photoreceptor is nestled in an array of photocells filtered
yellow, cyan, and green, a scheme that Hitachi created and that JVC uses in some video cameras.

How an Image Becomes Data

The street you're driving down doesn't suddenly end here and start again over *there*, with no way to bridge the gap. Time doesn't stop for 5 minutes and then pick up again where it left off. Of course, if it did, how would we know? The point is that we're used to thinking of things as analog—smooth, continuous objects without any quantum gaps between here and there. But in the computer world—and your digital camera is a computer—nothing is smooth and continuous. It's digital. There are gaps between this point and that one, between this moment and the next. Before we can do all the wonderful things available to us now that a computer is packed into our camera, we and our cameras have to communicate— we with our words; the cameras with a mathematical alphabet of only 0s and 1s.

1 Anything in the universe can be measured in analog or digital terms. **Analog** simply means that the expression of the measurement is analogous to whatever it's measuring. An old-fashioned thermometer with red-dyed alcohol in a tube gives an analog representation of how hot it is because the alcohol rises, literally, as the temperature rises. A **digital** thermometer expresses the temperature in numbers on a small LCD screen. The numbers themselves don't grow larger as the temperature rises.

2 Film is an analog method of recording a photo. Where light strikes the silver-halide crystals embedded in film, the crystals clump together. Where the light is stronger, more crystals clump. Where the light is dimmer, fewer crystals clump.

3 The photodiodes that replace film in a digital camera don't look any different after a picture is snapped than they did before. They don't shift about on the surface of the image sensor to clump where the light is stronger. But there is an unseen analog process afoot when a digital photo is taken. Each of the photodiodes collects photons of light as long as the shutter is open. The brighter a part of a photograph is, the more photons hit the pixels that are analogous to that part of the scene. When the shutter closes, all the pixels have electrical charges that are proportional to the amount of light they received. If you picture the photons piling up like little heaps of glowing pebbles, you've got the idea.

What happens next depends on whether the image sensor is a **CCD (charged-coupled device)** or **CMOS (complementary metal-oxide semiconductor)**. Don't bother with the full-fledged names. Everyone uses the acronyms, and they won't be on the quiz. You will hear a lot of techno-hype from camera makers citing reasons one technology is better than the other. You can ignore that, too. The type of imager is just one factor that contributes to the photo that eventually will come out of your printer. It's the print that's important. Whether you're happy with it or not doesn't hinge on the type of image sensor. But here, for the sheer joy of knowledge alone, are the differences in how the two types of chips work.

CCD

4 The charges in an **interline CCD** imager, which is what most CCDs are, begin an orderly procession toward their future existence as digital numbers like well-behaved schoolchildren in a fire drill. At one end of the imager, the charges move down and out at the bottom of the column as if someone were continually pulling the bottom can of Coke out of a dispenser.

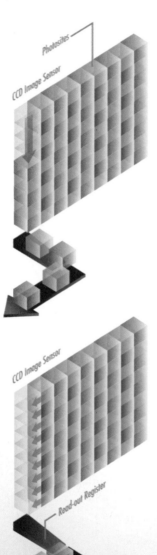

5 When the last charge has rolled out of the bottom of the column, the charges in the second column shift to fill the vacancies left by the newly departed charges. The charges in the third column move to the second column, and the thousands of remaining columns follow their lead like a panoramic Busby Berkeley number.

6 When a column of charges falls out of the imager, it is detected by the **read-out register**, which takes them to an amplifier. Until they are amplified, the charges are more faint static electricity than electrical current. The amplifier pumps energy into the charges, giving them a voltage in proportion to the size of each charge, much as a flagging video game character is pumped up with "life force" by jumping on a coin.

CMOS

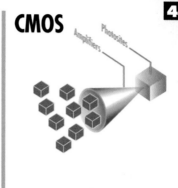

4 Unlike the photosites in CCDs—pretty much passive **capacitors** that do little but store an electrical charge until a control somewhere else tells them what to do with it—a CMOS sensor is able on its own to do some of the processing necessary to make something useful out of the charges the photosites have obtained from the light.

5 The first thing the CMOS image sensor does is use the amplifiers that are part of each photosite. This eliminates the need for the charges to go through an amplifier in single file after they've left the sensor.

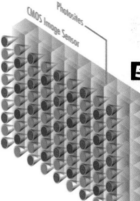

6 More importantly, the onsite amplifier eliminates the slow classroom drill CCDs use to leave their nest. As soon as the amplifiers have turned the charges into actual voltages, those voltages are read over a grid of X-Y wires whose intersections correspond to locations of the photosites. It's the voltages' way of saying simultaneously, "Beam us up."

How Algorithms Smooth Out a Picture's Rough Spots

RAW

In the creation state, while each photodiode was soaking in the rays of either red, blue, or green light colored by the filter hanging above it, the diode was ignoring the other two colors. That means two-thirds of the information needed to make up our photograph is missing! Of course, there must be some scientific, high-tech methodology the camera can use to supply the missing colors for all those millions of pixels. There is. It's called guessing. But because scientific types who design cameras don't like to be caught making guesses, they have another name for it: **Interpolation**. And on days they feel particularly self-conscious, they call it **demosaicing**.

1 If we could look at a photograph before it was processed and otherwise manipulated by the camera, it would look something like this. It's a red, blue, and green mosaic, which helps explain demosaicing; it means becoming something other than a mosaic. (We faked this photo, by the way. Just so you know.)

2 As soon as the newly digitized color values come out of the analog-to-digital converter, they are rushed over to another chip, the **array processor**. Its job is to guess the values of the missing colors based on the third of the values it does have and **algorithms**—a cross between a formula and a plan of attack. One such algorithm is **bilinear interpolation**. To determine the missing green and blue values of the pixel in the center, now occupied by only red, bilinear interpolation averages the values of the four nearest green and blue pixels.

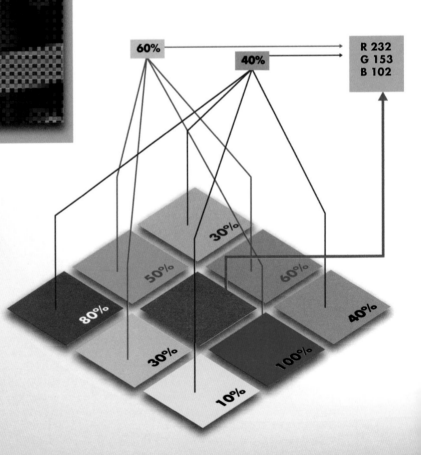

3 Still other algorithms reach out to pixels located farther away than their nearest neighbors. Different algorithms battling to achieve the perfect interpolation weight differently the values of different pixels. By applying those weights to different patterns, the array processor sharpens some areas and blurs others. And, sometimes, the results are not what was expected. In the lighthouse photos here, different algorithms have been applied to the same photo, revealing common **artifacts**, visual characteristics that are not a natural part of the photo's subject. In addition to the **blur** in the upper-left version, the interpolation used on the copy next to it exhibits **tiles**. You might have to study the photo a bit to see the pattern of vertical and horizontal lines added to it. In the bottom-left interpolation, the **watercolor** effect washes out the color in some areas, such as the red life preserver. And **shift color** in the bottom-right rendition produces hues that were never in the original photos. Also, look for loss or gain in detail with different interpolations, as well as moiré patterns on the building to the left and on the fence, color artifacts on the light house above the building attached to it, and the good-to-terrible rendering of the lighthouse window.

ORIGINAL, UNSAMPLED PHOTO

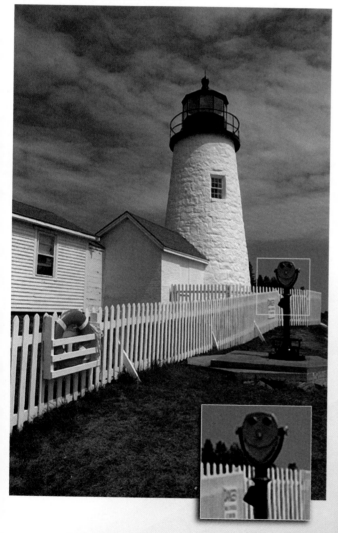

BLURRED

TILED

WATER-COLORED

SHIFTED COLOR

How Software Compresses Pictures for Storage

Everyone agrees the more megapixels, the better. That's what gives digital photos detail and depth. But mega-megapixels come with a megaproblem—how to store all those millions of pixels. Each pixel may take as many as 24 binary bits to accurately represent the exact shade and intensity of the color that the pixel is recording. When a camera records a photo to a memory card—and the same is true when a computer is writing an image to a hard drive—it creates a bitmap, a map of the location and color or each pixel that make up the photo. There are three ways to record the picture, depending on the sophistication of the camera: **RAW** format, **uncompressed**, and **lossy compressed**.

 RAW is simply an unaltered record of the light readings from each of the pixels in the camera's image sensor. This is the most graphic information the camera can provide, and though it consumes a lot of storage, it's the format of choice for photographers who trust themselves more than their cameras to interpret that image data.

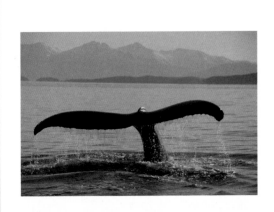

 Uncompressed files, such as those in the .TIFF format, have been through the camera's processing to correct such attributes as white balance, sharpness, and exposure. In the process some of the raw data is lost, but no data is discarded simply for the purpose of making the photo file smaller.

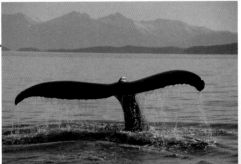

 Lossy compression, the most common of which is JPEG (also known as .jpg), discards some of the information gathered by the image sensor in the quest for ever smaller files. JPEG files can be saved with more or less compression, meaning more or fewer bits are thrown away. It is the most common file format for photos on the Internet because small file sizes lend themselves to traveling faster from someone else's computer to yours and the graphic's losses are not readily noticeable within the limits of a computer screen.

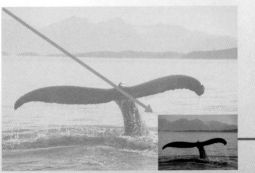

BEFORE JPEG COMPRESSION

AFTER JPEG COMPRESSION

4 Software, in a camera or computer, that compresses a file in the JPEG format examines the file for pixels whose absence is unlikely to be noticed by the uncritical human eye. More accurately, it's not their absence that's overlooked—it's the fact they've been disguised to look like neighboring pixels. If half of the area of a landscape photograph is devoted to a cloud-less sky, saving the color values of each of the pixels making up the sky is an extravagance when many of the pixels are exactly the same shade and intensity of blue.

5 Rather than recording the 24 bits needed to describe each pixel, the compression software records the bits for only one—the **reference pixel**—and then writes a list of the locations of every pixel that is the same color.

6 For more drastic compression, another trick is to divide an image into 8-by-8 pixel blocks and calculate the average color among the 64 pixels in that block. If none of the pixels are too different from the average, the compression changes the colors of all the pixels to the average, and your eye is none the wiser.

7 A problem with JPEG compression has been that a photo is recompressed—with more original pixels thrown away—each time it is resaved to the JPEG format. If it's saved too many times, you increase the appearance of unnatural **banding**—obvious strips of color instead of smooth gradations as you see, for example, in the sky. It also causes **artifacts**—shapes and colors that weren't in the original photo and are solely the product of mathematics. Eventually the photo may come to look **posterized**, so named after posters that have been simplified by using only a few colors.

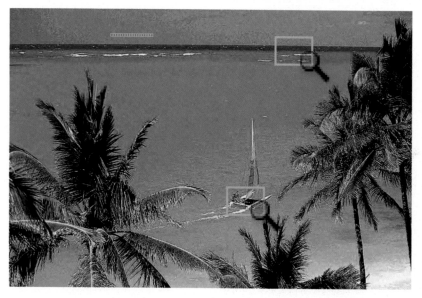

8 A new form of JPEG, called **JPEG 2000**, compresses photos by using **wavelet** technology—a type of mathematical calculation that transforms pixel values into strings of numerical **tokens** for frequently recurring combinations of pixels, such as combinations of red and blue pixels that might be used to create a brown tree trunk. The strings replace the cruder blocks of JPEG compression and result in smaller files without the same types of visual artifacts seen in standard JPEG photos. JPEG 2000 uses a **.jp2** or **.j2k** file extension. It is not yet widely supported.

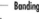

Banding

Artifact

How Pictures Are Stored on a Chip

Whatever format you choose for saving your photos, the first stopping place will be some sort of **flash memory**. Flash memory comes in the form of thin cards, fat cards, chewing gum-size sticks, and even key chains. Increasingly, flash memory makers are developing faster methods of getting data from a camera into the memory to keep pace with cameras that take multiple shots in a few seconds. The faster memory cards move data more than 100 times as fast as the slowest. What they all have in common is that they do not lose whatever is stored in them simply because someone turns off the camera.

Compact Flash Types I and II

About the size of a book of matches, Compact Flash cards were developed by SanDisk in 1994. In addition to memory chips for storing data, the circuit boards of CF cards contain controller chips to manage the flow of that data into the card. Manufacturers constantly tweak the chip to beat their competitors in the race to save photos, an important factor when shooting bursts of exposures. Although larger than many other types of memory cards, Compact Flash is valued by professional photographers for the capacious storage. CF Type I stores as much as 6GB; Type II Compact Flash, which is nearly twice as thick as Type I, holds up to 12GB.

xD-Picture Card

Although it's only about the size of a postage stamp, the xD (eXtreme Digital) Picture Card holds up to 8GB of data. It has no controller chip built into it and works only with cameras that have their own controllers for managing transfers to the memory card. The card is used for the most part only by Fuji and Olympus cameras.

SD Card

The SD (Secure Digital) Card was developed to comply with the copy protection devised by the Secure Digital Music Initiative. But once that protection was cracked, the SD aspect of the card became moot. The dime-sized card has taken the largest market share for digital cameras because of its relatively low cost and capacity to store up to 4GB, expected to rise to 8GB. The SD Card is unique in having a tab on one edge that can be moved to a write-protect that prevents erasure of the card's contents.

Sony Memory Stick

Sony introduced the Memory Stick in 1999 as the only memory card that works with most of Sony's products. Roughly the same dimensions as a stick of gum, the Memory Stick has been replaced largely by a Pro version that holds up to 4GB of data, compared to the original stick's 128MB. Its greatest advantage is that data on a Memory Stick can be used with a variety of Sony products that have built-in readers. Photos recorded to a Memory Stick, for example, may be displayed on many Sony televisions.

Compact Flash

xD-Picture Card

SD Card

Memory Stick

Smart Media

Smart Media

Smart Media (SM) cards today are rarely used with any devices post-2001. They have no controller built into them, so they will work only with hosts that have the appropriate controller. SM cards hold a maximum of 128MB, which lags far behind the gigabytes of storage other media hold.

How Fast Is X-Rated Memory?

Most flash memory cards use an X rating to indicate how quickly they store data from a camera. The X refers to the speed of the first flash cards, which moved 150KB a second. A card that bills itself as 80X is claiming to transfer 12,000KB/s.

Jump drives
(not used in cameras but a popular form of flash memory.)

How Flash Memory Works with the Power Off

1 Unlike ordinary memory, in which a single transistor is used to store either a 0 or a 1 and must be constantly refreshed by a supply of electricity, flash memory uses two transistors on different electrical lines that intersect each other to save a single 0 or 1 bit. One of these transistors is called the **control gate** and the other is called a **floating gate**.

2 To write a 1 to the intersection of the two transistors, an electrical charge passes through the floating gate, through a layer of metal oxide that separates the transistors, and on to the control gate.

3 Energy from the current also causes electrons to boil off the floating gate and through the metal oxide, which drains them of so much energy that they cannot return.

4 A **bit sensor** near each of these intersections compares the strength of electrical charges on both gates and, if the charge on the control gate is at least half that of the floating gate (which it would be after getting that transfusion of electrons), the bit sensor proclaims that the value stored there is a 1. If the sensor doesn't detect a significant charge, the bit is a 0.

5 When it comes time to erase or rewrite the bits stored in flash memory, a strong electrical current flows through the circuitry to predetermined sections of the chip called **blocks**. The energy in the blocks disperses the electrons so they are again evenly spread among the gates.

Flush current

Block

Bit line

Sensing bit

Floating gate

Metal oxide

Electrons

Control gate

Word line

Number of Photos Based on Flash Card Capacities (Approximate)

Sensor Size	File Size	16MB	32MB	64MB	128MB	256MB	512MB	1GB	2GB
2 Megapixel	900KB	17	35	71	142	284	568	1,137	2,275
3 Megapixel	1.2MB	13	26	53	106	213	426	853	1,706
4 Megapixel	2.0MB	8	16	32	64	128	256	512	1,024
5 Megapixel	2.5MB	6	12	25	51	102	204	409	819
6 Megapixel	3.2MB	5	10	20	40	80	160	320	640
8 Megapixel	3.5MB	3	9	18	36	73	146	292	565

Source: Multiple Internet sites.

How a Digital Camera Squeezes Video Down to Size

Compressing one picture on-the-fly is daunting enough for a digital still camera. But consider the task that confronts a video camera: compressing 15 to 30 images each second—and putting the squeeze on sound at the same time. There is no time for lossless compression, even if it could do a good enough job to store even a short feature on a DVD. The technology universally used for professional and amateur video is a lossy compression called MPEG, named after the organization that created it: the Motion Picture Experts Group. MPEG compression is likely to be used on anything you watch on TV, your computer, or iPod.

352x288

 An essential part of video compression strategy is to limit the amount of work the video camera has to do to record so many frames each second the camera's rolling. Standard TV (non–high definition with a 4:3 aspect ratio) is made up of 720 pixels across and 576 pixels vertically. Depending on the sophistication of a digital video camera, frames may be limited to 640 pixels wide and 480 pixels high, or even as few as 352 ×288. At 640 × 480, the camera is relieved of the task of recording information for a hundred thousand pixels for every frame it processes.

640x480

2 Inside a video camera, you'll find a chip that specializes in MPEG compression (or circuitry that does the same job built into the master microprocessor). Part of the job MPEG performs is similar to the lossy JPEG compression used to shrink still photos. MPEG looks for redundant data. The wall in the background of a video may be painted a solid red, making it unnecessary for a video camera to record the same information about each of the red pixels that make up the wall. As JPEG compression did with a blue sky in the example a few pages previous, MPEG establishes reference values for the wall's shade of red and refers all the pixels that make up the wall to that color.

720x576

Microprocessor

3 Of course, few things in the real world are consistently the same color. Vagaries of light and shade cause a spot in the background to be a slightly different shade. MPEG makes a decision: Will anyone notice if it makes that errant shadow the same color as the rest of the wall? If the decision is "no," that's a few thousand more bits saved.

4 One compression technique assumes, rightly, that much video changes little from one frame to another. To save space recording the video—and broadcasting it, for that matter—the technique combines part of one frame with part of the next one. In the case where there is little change, the economy works.

But in this case, for example, where the scene changes abruptly from one frame to the other, the technique results in a fleeting visual glitch.

5 The same premise is behind **motion estimation**, which assumes that consecutive frames will be the same except for changes caused by objects moving between frames. By examining the changes in two of the frames, MPEG predicts the position of objects in a third frame.

6 **Key frame** compression records only certain crucial frames and deduces from them what the missing intervening frames should look like.

7 A similar technique makes a record of one frame that is largely unchanged in subsequent frames. Then the only data recorded is the **delta**— the differences from that original reference frame that occur in the frames trailing it.

CHAPTER

8

How New Tech Changes Photography

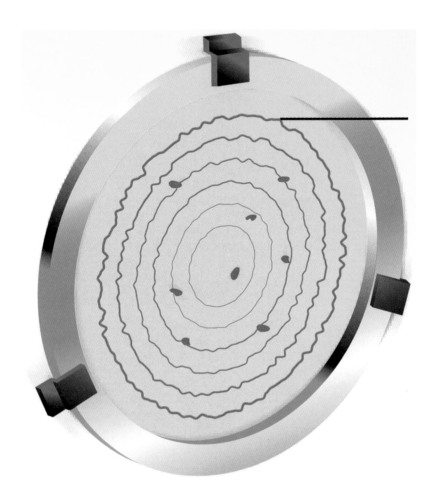

Blessed be the inventor of photography! I set him above even the inventor of chloroform! It has given more positive pleasure to poor suffering humanity than anything else that has "cast up" in my time or is like to—this art by which even the "poor" can possess themselves of tolerable likenesses of their absent dear ones.
Jane Welsh Carlyle, in a letter to her husband Thomas, 1859

For half a century, photography has been the "art form" of the untalented. Obviously some pictures are more satisfactory than others, but where is credit due? To the designer of the camera? To the finger on the button? To the law of averages?
Gore Vidal

FOR most of the time that photography has been in existence, artistry or quality hasn't been a consideration. For most people, photographs were in the same category as singing dogs. We aren't impressed because a dog sings beautifully; we're amazed that a dog sings at all. And so it has been with photographs of long departed or far distant friends and relatives. We haven't required that their photographs be works of art or even that they be in perfect focus and color. We were happy enough to have something by which to remember our loved ones or to tell us something about an ancestor we could never meet.

Why were we so undemanding? It's not so much as Gore Vidal complains, that we are without talents beyond pressing buttons, that we are simply singing dogs. Our casual approach to photography comes, rather, from being largely middle-class hounds—except for professional photographers and those amateur shutterbugs who were so obsessed by photography that they would sell the family cow for a few rolls of Kodachrome.

The sheer expense of taking photos as an avocation has been prohibitive. Even second-tier cameras and lenses amounted to thousands of dollars. Processing film and prints cost still more and demanded hours in smelly, dark rooms. Just the price of film and prints from the drugstore stopped most people from shooting more than a couple of dozen frames at a time, unless they had a second family cow handy.

Digital photography is already changing that. For less than the cost of an iPod, you can buy a digital camera with features and optics that would have roused the jealousy of pros a decade ago. The cost of film and processing is no longer a factor. You may take hundreds of pictures in a single afternoon, and if most are embarrassments, at least they're free embarrassments. Printing is still an expense, but only for the pictures that look good enough on an LCD screen to warrant printing.

Does this mean we're in for an explosion of new Arbuses, Avalons, Leibovitzs, Steichens, Cartier-Bressons, and other talented photographers with names that are difficult to pluralize? Yes. Yes, it does. Think of all the people you know who are now carrying decent cameras in their purses and pockets, who are willfully exposing themselves to the photography virus. Where enough dogs congregate to harmonize, a few are bound to sound...not so bad.

How Digital Tech Changes the Way Lenses Work

So far, our look at how lenses work has applied to the traditional film camera as well as digital cameras. So much so, in fact, a reader might be tempted to believe there's no difference between film and digital cameras as far as optics go. But the differences are significant. They arise out of the nature of the electronic image sensor that replaces film. We'll be looking at the image sensor in microscopic detail in the next chapter, but while we're talking about lenses, let's look at how digital sensors transform the power of lenses while wreaking not inconsiderable confusion.

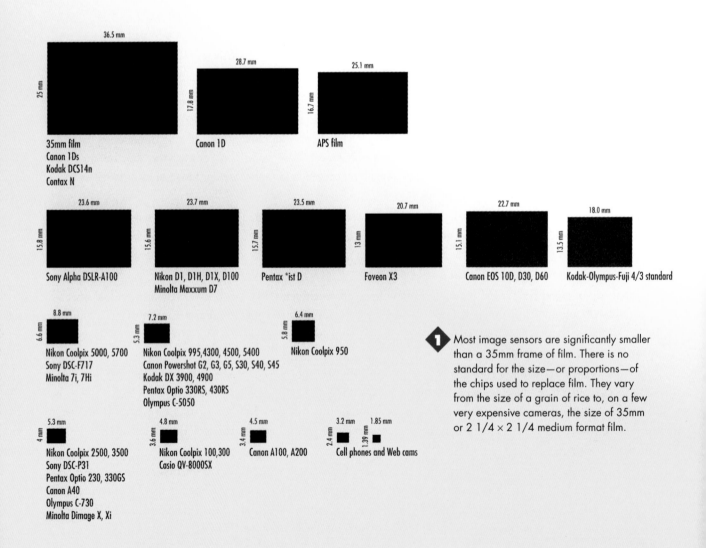

36.5 mm / 25 mm
35mm film
Canon 1Ds
Kodak DCS14n
Contax N

28.7 mm / 17.8 mm
Canon 1D

25.1 mm / 16.7 mm
APS film

23.6 mm / 15.8 mm
Sony Alpha DSLR-A100

23.7 mm / 15.6 mm
Nikon D1, D1H, D1X, D100
Minolta Maxxum D7

23.5 mm / 15.7 mm
Pentax *ist D

20.7 mm / 13 mm
Foveon X3

22.7 mm / 15.1 mm
Canon EOS 10D, D30, D60

18.0 mm / 13.5 mm
Kodak-Olympus-Fuji 4/3 standard

8.8 mm / 6.6 mm
Nikon Coolpix 5000, 5700
Sony DSC-F717
Minolta 7i, 7Hi

7.2 mm / 5.3 mm
Nikon Coolpix 995,4300, 4500, 5400
Canon Powershot G2, G3, G5, S30, S40, S45
Kodak DX 3900, 4900
Pentax Optio 330RS, 430RS
Olympus C-5050

6.4 mm / 5.8 mm
Nikon Coolpix 950

5.3 mm / 4 mm
Nikon Coolpix 2500, 3500
Sony DSC-P31
Pentax Optio 230, 330GS
Canon A40
Olympus C-730
Minolta Dimage X, Xi

4.8 mm / 3.6 mm
Nikon Coolpix 100,300
Casio QV-8000SX

4.5 mm / 3.4 mm
Canon A100, A200

3.2 mm / 2.4 mm · 1.85 mm / 1.39 mm
Cell phones and Web cams

1 Most image sensors are significantly smaller than a 35mm frame of film. There is no standard for the size—or proportions—of the chips used to replace film. They vary from the size of a grain of rice to, on a few very expensive cameras, the size of 35mm or 2 1/4 × 2 1/4 medium format film.

35mm FILM

MINOLTA MAXXUM D7

2 The **image circle** that lenses cast on the sensors of two cameras are the same size and cover the same field of view—provided the lenses are set to the same focal length on both cameras. The picture on the left was taken with a traditional 35mm film Minolta Maxxum 7000 using a 100mm lens. Like all 35mm film, the diagonal of the frame is 43.25mm.

SIZE OF 35mm FRAME

SIZE OF DIGITAL IMAGE SENSOR

3 The photo on the right was taken with a Minolta D7 digital using the same lens. The Minolta has an image sensor with a diagonal of 28mm. On both cameras, the lens creates image circles of the same size, but the D7's digital image sensor takes in only a portion of the image circle while 35mm film takes in more. That's why the same focal length lens on the digital camera becomes, in effect, a telephoto lens.

4 The difference in fields of view is the **digital multiplier**: the factor by which the focal length of the film camera's lens would have to increase to match the same field of view as the lens on a digital camera. If a digital camera has a multiplier of 1.5, a 100mm lens has the same telephoto powers as a 150mm lens on a standard 35mm camera.

5 The value of the multiplier is determined by the size of the image sensor. To determine the digital multiplier for a camera, divide 43.25mm—the diagonal distance of a 35mm film frame—by the diagonal size of the camera's image sensor. For the D7, that's $43.25 \div 28 = 1.54$.

$$\text{Digital multiplier} = \frac{43.25}{\text{Diagonal size of image sensor}}$$

The Upside-Down Math of Digital

The effective focal length of a lens isn't the only thing affected by the sizes of digital image sensors. For example, using the Minolta D7 and a 35mm camera:

- The D7 has 1.5 times *more* depth of field than that found in a 35mm camera—provided the cameras' distances from the subject matter are set up so that they have an equivalent **field of view**, which is the vertical and horizontal expanses that can be seen through the lens.
- The D7 has 1.5 less depth of field using the same lens that the 35mm image would have. Of course, the images would be different because the fields of view would be different.
- Take a picture of the same subject matter at the same distance using the same lens on a D7 and a 35mm camera. Then crop the 35mm image so you have the same field of view as in the uncropped D7 image. The depth of field of both will be identical.

How Four Thirds Digital Cameras Create a New Standard

Because 35mm still cameras have dominated photography for nearly a century, the first digital cameras have been like Frankenstein's monster cobbled out of the still-breathing 35mm standard. But the lens and camera bodies of the 35mm world are not a natural match for digital photography, where electronic image sensors only rarely have the same dimensions as a frame of 35mm film. It's as if, when 35mm film first came into vogue, photographers had kludged it into the then-prevalent 4" × 5" sheet film cameras. Now some digital camera makers, including Olympus, Kodak, Panasonic, Samsung, and Fujifilm, want to avoid making digital photography a jury-rigged form of 35mm. To that end, they proposed the Four Thirds, or 4/3, System standard. The standard includes lenses made to work specifically with image sensors, rather than film, and standardization of components for interchangeability among brands. Olympus was the first to produce a 4/3 camera: the E-1. Reviews substantiate many of Olympus's claims for 4/3 technology, but whether it becomes a true standard depends as much on the marketplace as the optics lab.

1 One of the tenets of the 4/3 System standard is that light strikes film and a digital image sensor differently. With film, the **silver-halide** grains that capture the nuances of light and shadow are just below the surface of the emulsion layers holding them. They react equally to light from any direction, much like a sunbather standing outside hoping to get a tan.

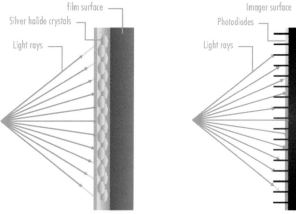

2 The light-sensitive pixels in a digital image sensor, on the other hand, are more like someone trying to get a tan by standing at a window. The pixels are located at the bottom of wells created by walls of electrodes and the grid that holds the pixels in their rigid pattern. The walls block light coming in at oblique angles, which becomes even more the case for pixels located toward the edges of the image, particularly with wide-angle lenses. The result can be a dim peripheral image with inaccurate color and poor resolution. Ideally, the pixels need to be exposed to light coming straight through the lens and hitting the pixels square on.

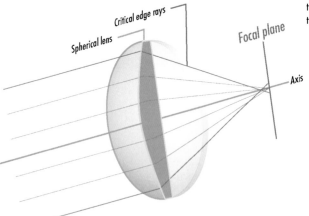

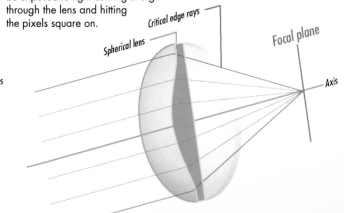

3 The 4/3 System standard has led to new lenses designed specifically for image sensors. The lenses use aspherical elements and extra-low dispersion glass (ED glass), which minimizes the separation of colors found in the chromatic aberration that plagues lenses. (Refer to "How a Lens Bends Light," in Chapter 3.) The continuously changing curvature in the aspherical lens that increases toward the lens's edge does a better job of gathering light from all parts of the lens to a single spot. While not achieving the ideal of organizing the light into parallel rays, the aspherical lens does bend the light so that it hits the pixels more directly.

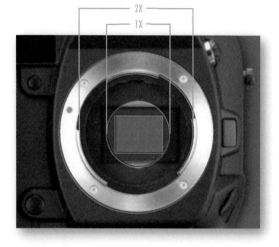

4 Because the worst defects of ordinary lenses occur at the edges, the 4/3 System standard pushes those edges farther out, where they can do no harm. The 4/3 design requires that the diameter of the lens mount be about 50mm, roughly double the diagonal of the 33.87mm image circle. The more errant light rays from the perimeter of the lens fall harmlessly out of the image sensor's territory. The light that does hit the sensor comes more from the lens's center where light rays come closer to a path perpendicular to the sensor's surface. 4/3 also requires that the three-claw bayonet mount be standardized in fit and distance from the focal plane so that a lens from one brand of 4/3 System camera can be used with a different 4/3 System camera body.

5 Because the 4/3 System lenses are designed specifically for digital cameras with sensors half the size of 35mm film, they have the benefit of producing the same field of view found in a film camera lens while using half the focal length. The 4/3 System lenses can be made shorter and lighter. Many of the lenses have their own microprocessor in addition to the three processors found in the camera body. The lens sends the information about itself through nine electrical contacts built in to the bayonet mount. The camera's processors and built-in software use that information to correct lens distortions, such as pin cushioning.

OBJECT

PINCUSHION DISTORTION

6 4/3 standardizes the diagonal size of the image sensor at 22.55mm so it fits within the image circle that the standard dictates. The Olympus E-1 sensor has proportions of 4:3, which makes it a little taller than and not as wide as the 35mm frame, covering about half the area. But 4:3 proportions are not required. A sensor can be any shape, including square, as long as it fits inside the image circle. There is no requirement as to the technology used in the sensor—it can be CCD, CMOS, or Foveon X3, all of which we'll examine in Chapter 7, "How Light Becomes Data."

35 mm film format

Four thirds format

25 mm

13.5 mm

18.0 mm

36.5 mm

4/3 = What?

In the confusing tradition of aperture numbers, in which the bigger the number, the smaller the aperture opening, the nomenclature for different types of digital image sensors defies any comprehension. The 4/3 System standard is not a measurement—1 1/3—of the sensor or anything else you'll find on a 4/3 System camera. The same goes for other sensors, such as the 1.8, 2/3, and 1/2.5. Some experts claim the system refers to the aspect ratio of the sensors. That might hold true for 4/3, but it breaks down with other sensors. It's also suggested that the designations come from a system used in the movie industry to identify lenses and have no real meaning for the rest of us. It's best not to give it much thought. Just accept it and don't ask questions.

How Digital Cameras Cure the Shakes

Next to the precision accuracy of a camera's focus and the native depth of field that is inherent and different in every lens and at every f-stop, there is a third factor that heavily influences the sharpness of a photo: your hands.

A sharp image is the photographer's holy, and elusive, grail. You can be focused down to the breadth of an eyelash. You can have depth of field from shining sea to purple mountain majesties. But your hands, at their steadiest, still are wiggling one to five times a second, undermining your careful focusing. Even on a tripod, a gust of wind or a truck rumbling by is enough to ruin a photo. The slightest tremble, twitch, tic, or tremor makes a picture look as if it were taken during an earthquake. The light passing through the lens continues along a straight line, but the imaging sensor shifts and dodges the incoming light as if they were playing dodge ball. Instead of creating neat little points of color, the sensor records a blur. The longer the shutter time and the longer the focal length, the wider the blur.

The rule of thumb has been that, to avoid noticeable blurring, the shutter speed must be faster than *1/focal length*. In 35mm terms, that means if you're using a normal lens of 50mm, you're going to get blurring with shutter speeds that photographers commonly resort to when they're using available light: 1/25 of a second, 1/30, 1/2, 1/60, or simply any shutter speed slower than 1/100 of a second. Screw on a telephoto lens, which exaggerates any movement, and you must use even faster shutters. Most digital cameras multiply the telephoto tremble. The average image sensor is smaller than a frame of 35mm film, but most pictures recorded to film and those captured by sensor wind up being printed the same size. But the digital photo has to be blown up more to match the size of a film-based picture. Any of the flaws in a digital photo end up being bigger relative to

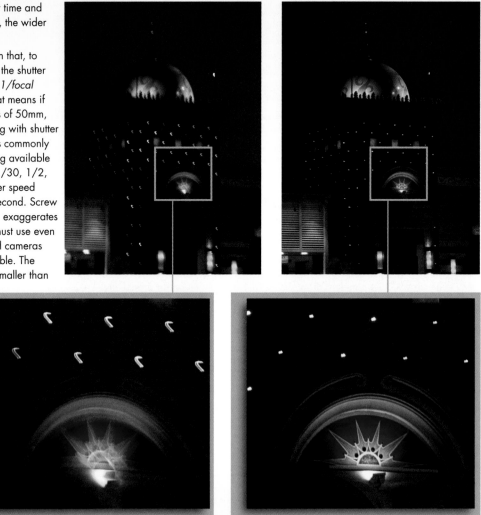

the same flaws in a film print. A photo taken by a handheld camera, shooting at 1/60 of a second, is likely to turn out like the left photo on this page.

Camera makers have come up with several ways to stifle vibrations in both still cameras and camcorders. To be effective—which means reducing vibration so much that the photographer can use a shutter speed two to three stops slower—a VR (vibration reduction) system must counteract vertical vibration (**pitch**), side-to-side (**yaw**), and every direction in between. And it needs to make the correction within a few thousandths of a second.

How Vibration Creates Blurred Images

 Normally, light rays from a scene being photographed pass through the object lens element at the front of the lens and stay true to the lens's optical axis.

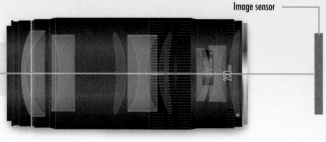

TO SUBJECT

Image sensor

2 When the lens moves, the beams of light pass through elements of the lens at the wrong points. More importantly, the image sensor moves out of position and the light is smeared across the surface of the sensor, blurring the subject. Preventing vibration and movement is virtually impossible. Any system that seeks to reduce blurs caused by camera movement must do something to put the light beams back on the right path before they hit the sensor. Electronic image stabilization, which we'll look at on the next page, is the one exception to this rule. It corrects the blur with software after it has occurred.

TO SUBJECT

Image sensor

How Cameras Detect Movement

1 Many antishake systems remain dormant until the photographer has the shutter button partially depressed. This is so the photographer can move the camera to frame a shot without having to fight the camera to position it. When the system is active and something jostles the camera, the movement is detected by two gyrosensors, which are gyroscopes attached to devices that measure motion. One gyrosensor is positioned to detect yaw, or horizontal movement. The other gyrosensor, mounted 90° away from the first, reacts to pitch, or vertical tilting of the lens.

CAMERA MOVEMENT

INERTIA REACTION (PRECESSION)

FIXED

ACCELEROMETER

MOVED BY GYROSCOPE

2 A **gyroscope** is basically a highly developed spinning top. The rapid rotations of its heavy metal disk build up **inertia** along the same plane that the disk spins. The inertia makes the gyro resist any force that would change the orientation of its axis. When this happens, the gyroscope, in effect, pushes back. The pressure the gyroscope exerts is measured by an accelerometer, which consists of two metal plates connected to each other and that sandwich a third plate that floats freely between them.

3

The force from the gyroscope moves the floating plate toward one or the other of the plates on either side of it. The change in distance also changes the amount of the electrical charge on the two outside plates. The charge increases on the plate that the floating plate moves close to and decreases on the other plate. The data the sensors pick up is sent to a high-speed microcomputer. The microchip measures the charge differences and calculates from that the distance and direction the lens has moved.

Electronic Image Stabilization

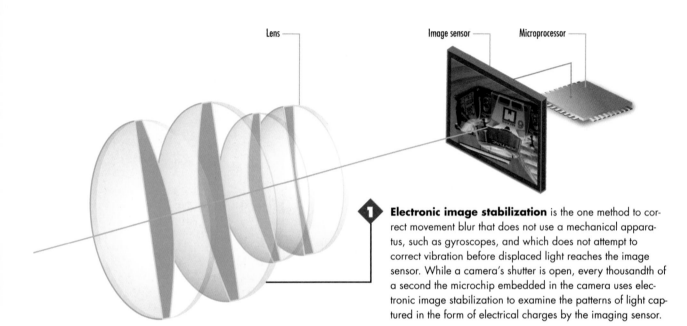

Lens — Image sensor — Microprocessor

1 **Electronic image stabilization** is the one method to correct movement blur that does not use a mechanical apparatus, such as gyroscopes, and which does not attempt to correct vibration before displaced light reaches the image sensor. While a camera's shutter is open, every thousandth of a second the microchip embedded in the camera uses electronic image stabilization to examine the patterns of light captured in the form of electrical charges by the imaging sensor.

2 The processor compares that image with the first one that was sent from the image sensor a thousandth of a second earlier. If the colors of all the pixels match, the processor puts the new image into storage along with its predecessors, and their combined electrical charges are added together to contribute further to the final digital photograph or frame of video.

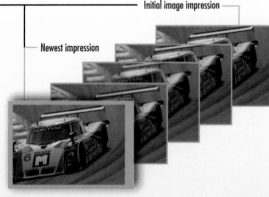

Initial image impression

Newest impression

3 But if the images do not match, the processor looks for a pattern that does match the previous impression. Then the processor shifts the new electronic charges coming from the pixels so that they line up with the charges that preceded them.

4 Because this method involves the processor manipulating the raw data on-the-fly, there is some image degradation.

Vari-Angle Prism System

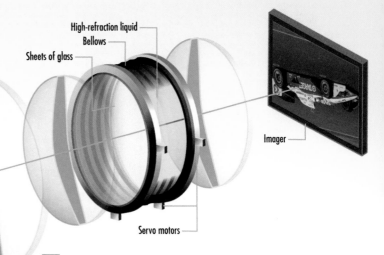

High-refraction liquid
Bellows
Sheets of glass
Imager
Servo motors

1 In a lens using a **vari-angle prism (VAP)** to correct movements, such as some of Canon's video camera lenses and binoculars, gyrosensors are used to detect the slightest wiggle. The sensors send electronic information to a microprocessor built in to the lens.

2 The microchip sends an electrical signal to **voice coil motors**, much smaller versions of the motors used to vibrate the cones in speakers. The motors sit at 90° angles to each other on the rim of the vari-prism. The VAP, which is positioned among the lens elements in the path the light passes, is made of two plates of glass connected by a flexible resin bellows. The space between the plates contains a clear liquid with the same refractive characteristics as glass. Ordinarily, light passes through the VAP without a change in direction.

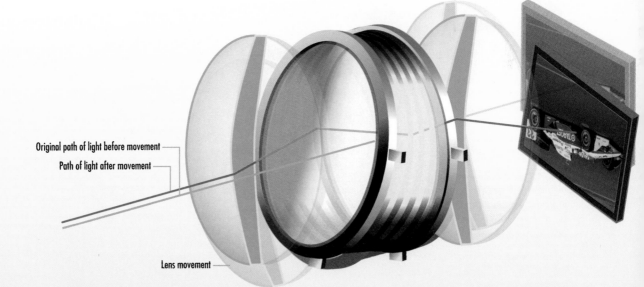

Original path of light before movement
Path of light after movement
Lens movement

3 The chips' electrical signals create magnetic fields in the voice coils that, in turn, push or pull a metal plate onto which the glass walls are mounted. The voice coils widen or narrow different areas of the liquid-filled chamber so light now strikes the VAP at an angle. The size of the angle is calculated so that rays passing through the VAP are refracted precisely to put the light beams back on the correct path.

Piezoelectric Supersonic Linear Actuator Stabilization

Most digital cameras with anti-shake mechanisms try to bend the errant light rays as they pass through the lens so they still strike the correct pixels on the image sensor. It's like trying to deflect an arrow on the way to its target. A year or so before Konica Minolta got out of the camera business, it patented an attack on the shakes that takes the opposite tact, as if some poor loser were forced to hold the target and move it to wherever the arrow's coming in. To achieve this, Konica Minolta had to develop new technology throughout the process—technology now in the hands of Sony, which bought Minolta's camera business and is now showing up in other digicams as well.

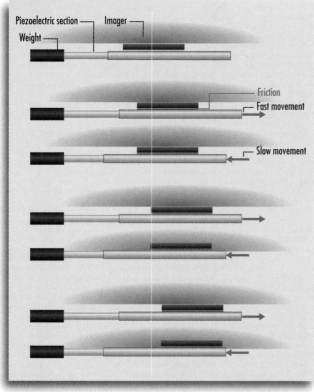

Motion Correction

1 A microprocessor inside the camera body receives movement information from the angular velocity sensors mounted next to the imaging sensor. One digital gyroscope is positioned to detect only vertical movement; the other detects only horizontal. The microchip combines the information to get a two-dimensional picture of camera motion, although the microchip cannot compensate for forward and backward motion, which has a smaller effect on photo sharpness.

2 The microchip sends electrical signals of its own to two piezoelectric supersonic linear actuators—also known as **SIDM**s, for **smooth impact drive mechanisms**. Like the movement sensors, the SIDMs are mounted at right angles to each other to handle vertical motion (the Y-axis actuator) and horizontal motion (the X-axis actuator).

3 When current reaches an actuator, it's directed to a piezoelectric element mounted between a weight and a shaft. The current causes the piezo to expand or contract, depending on the direction necessary to make the correction. The shaft moves slowly at first because the weight is designed to hold it back.

4 Each of the actuators' shafts presses against a different plate holding the image sensor. One plate is free to slide vertically while the other can move horizontally. Only friction connects the shafts to the plates, which is one reason for the initial slow movement of the shaft—so the movement doesn't overcome friction and cause a shaft to lose its grip on the plate. (Actually, this talk of slowness is deceptive. Because these corrections happen in a few thousandths of a second, any "slowness" is purely relative.)

5 When the image sensor is in its new, corrected position, the shaft withdraws by contracting or expanding quickly so as not to take the correctly positioned image sensor with it, like a tablecloth being jerked off a table so fast it leaves the table settings in their places.

Microprocessor

Horizontal (X-axis) slider

X-axis actuator

Image sensor

Vertical (Y-axis) slider

Y-axis actuator

X-axis actuator

Shift Image Stabilizer

1 This form of **_image stabilization (IS)_** is among the most common and is found in lenses by Canon, Nikon, and Panasonic, among others. It relies on an IS lens element mounted among the other elements that make up the complete lens. This element is like the other lenses that make up the complete lens, except it can change position.

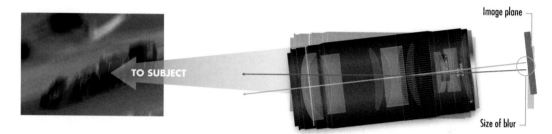

2 Shift image stabilization technology uses one sensor to detect vertical movement and another to detect horizontal movement. Diagonal movements are detected by combining the results of both sensors. When gyrosensors send signals to the lens's own microprocessor telling how much the camera has moved, the microprocessor quickly sends signals to the voice coil motors mounted at 90° angles to one another along the edge of the IS lens element.

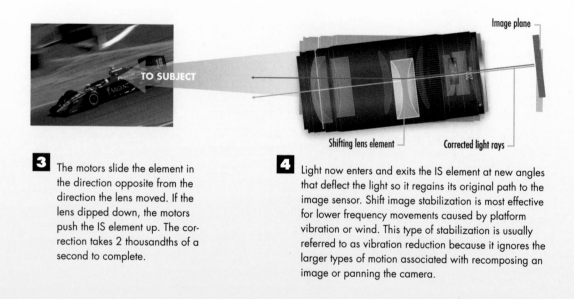

3 The motors slide the element in the direction opposite from the direction the lens moved. If the lens dipped down, the motors push the IS element up. The correction takes 2 thousandths of a second to complete.

4 Light now enters and exits the IS element at new angles that deflect the light so it regains its original path to the image sensor. Shift image stabilization is most effective for lower frequency movements caused by platform vibration or wind. This type of stabilization is usually referred to as vibration reduction because it ignores the larger types of motion associated with recomposing an image or panning the camera.

How Lenses Tilt with Images

It's all but a given that we use a camera to photograph something straight in front of us. But sometimes it's better if we cheat a bit. For that cheating, we use a lens that shifts what the camera is focused on over to the side. Or it can tilt its focus to make objects near and far part of the same sharp image. Not surprisingly, the lens is called a **tilt-and-shift** lens. At one time, just about all lenses were tilt-and-shift. The bellows you find on ancient **view cameras** lent themselves perfectly to a lens that could turn and sway. Today's tilt-and-shift lenses are expensive, used primarily by architectural photographers who need to keep the horizontal and vertical lines of a building on the beam. And strangely, to have descended from an instrument so wedded to precision, there is the tilt-and-shift's black sheep nephew, the Lensbaby, which uses the same laws of optics found in the older lens to introduce intentional distortion and blur.

1 When taking a photo of a tall building, most photographers do one of two things. The first is to angle the camera up so it captures the entire building. Because the focal plane is no longer parallel to the side of the building, this approach produces a perspective that may work for some photos but not for others.

Axis

Focal plane

2 The other method is for the photographer to move back far enough so that the entire building is included in the frame while the camera remains level. This keeps the lines of the building parallel. But it's not always possible to get far enough away to have a clear shot of a tall building, and even when it's possible, this method winds up with streets and parking lots taking up half the frame. The photographer is throwing away half the camera's pixels.

3 The front elements of a tilt-and-shift lens move—shift—vertically and horizontally. Seemingly minuscule movements produce jumbo changes in the photograph. Shifting the lens a couple of millimeters gets the same results as if the photographer had climbed a 20-foot ladder.

TILTED 0 DEGREES

TILTED 4 DEGREES

TILTED 8 DEGREES

RAVI SHANKAR NORI, NORIRAVI.COM

4 Ordinarily, the range of focus covered by the depth of field is parallel to the focal plane. When the lens tilts—forward, back, or to the sides—as much as 8 to 10 degrees, the range in focus tilts also, as shown in the three photos of a medal with different degrees of tilt. The tilt can let the camera focus on only one object from among several that are an equal distance from the camera.

MICHAEL REICHMANN, LUMINOUS-LANDSCAPE.COM

5 Or the tilt can be used to extend the range of focus by covering both near and distant objects, as in the photograph of a highway outside of Monument Valley.

Oh, Baby!

Tilt-and-shift lenses often cost more than $1,000. For about $100–$150, a lens called the **Lensbaby** provides some of the thrill of a tilt-and-shift lens, if not the precision. The Lensbaby consists of a **doublet** (a positive lens and a negative lens cemented together) inside a flexible plastic tube. Aperture is controlled by dropping disks with different-sized holes into the tube, where a magnet holds them suspended so they don't scratch the lens. Focusing, shifting, and tilting are done manually—literally manually. The photographer uses his fingers to move the lens back and forth and from side to side. Three fancy bolts let the photographer lock the twists and turns in place. The result is a dreamy, impressionistic photograph that would be difficult to create with any other lens or even in the digital darkroom using a tool like Photoshop.

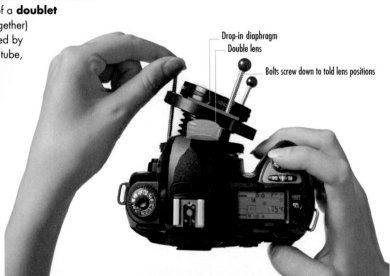

Drop-in diaphragm
Double lens
Bolts screw down to told lens positions

How Two Lenses Work As One

Any photographer who has to lug around even a fraction of the lenses that can be used on the same **single lens reflex (SLR)** cameras must have stopped at one time, rubbed his back, and wondered why someone couldn't create one single zoom lens that could cover all focal lengths—a lens that went ultra, super-wide at 10mm, or even a **fisheye** 180-degree view, all the way out there to a 1,000—no, *2,000*mm telephoto that let you count an eagle's feathers. Well, there's a reason no one's made such a lens. It's hard. It's too hard, in fact. The complexity in spanning more than a hundred or two millimeters in focal length grows as image quality shrinks. But when you're working with digital cameras, you have more options—such as using two lenses instead of one, as Kodak has done in the V570 and V610 digital cameras.

3 Behind the primary elements are prisms. One facet of each prism is coated with a reflective layer and positioned at a 45-degree angle to light coming in through the primary.

1 To create a single camera with a 5X wide-angle optical zoom in the V570 and V705, and a 10X telephoto zoom in the V610, Kodak built two lenses into each of the compact camera bodies, each less than an inch thick and about two inches tall.

2 Images enter the camera through two lenses whose front elements— **primaries**—are located vertically in the center of the cameras. Even when zooming, the lenses do not stick out from the bodies of the cameras.

4 The images reflect off the coated surfaces and continue through the rest of the lenses, which are mounted one above the other lengthwise inside the cameras' bodies. This is where the lens elements move back and forth as needed to focus an image or to change the zoom factor. This arrangement is also why the lenses do not protrude beyond the camera case.

5 The twin lenses in both cameras are aimed at separate image sensors.

6 Which lens is active depends on how the photographer has set the zoom. In the V570, the bottom lens zooms through a 3X range of 39–117mm (translated into 35mm film camera focal lengths). If the photographer zooms wider than 39mm, the **ultra-wide** top lens takes over with a fixed focal length equivalent of 23mm for another 2X power.

7 In the V610, the top lens zooms for the equivalent of 130–380mm. The bottom lens covers 38–114mm.

8 The A570 pushes its wide-angle capabilities further still through an in-camera panorama mode that stitches three photos together to produce one wide, low photo covering almost 180 degrees. That's the equivalent of an 8–10mm wide-angle lens on a 35mm camera.

9 After the photographer shoots the leftmost of the three pictures, the A570 first locks in the white balance and exposure and turns off the flash so that the next two shots will have matching exposures. Then the camera retrieves about a fourth of the previous image from the right side and displays it in a semi-transparent overlay on the left edge of the camera's LCD viewfinder. By aiming the camera so that the overlay matches the new left edge of the frame, the photographer shoots second and third frames that can meld smoothly into the panorama.

How a Light Field Camera Can Focus Anything

We've all wished there were a magic control on our cameras that would let us refocus a picture after it's been taken. But we were told, not in the camera, not in the darkroom, not in our computers, was there any magic that would let us turn a badly focused picture into a sharp image. But a Stanford grad student named Ren Ng has found one place you can refocus a photograph—the fourth dimension. Ng has built a camera that records not simply one thin slice of light, but all the light rays that pass through the lens, and where their focal points will land—before, behind, or smack on the image sensor.

1 In an ordinary camera, the light rays coming from each point making up the subject the camera is focused on are bent so that they converge at the camera's focal plane, where film or a light-sensing microchip waits to record those points of light. Light rays originating outside that focus area miss the mark, converging behind or before the focal plane, creating blurry circles of confusion (see Chapter 3).

Image sensor

Microlens

2 In the **light field camera** developed by Ng, the light rays pass through another set of lenses between the camera's main lens and the image sensor—90,000 lenses, in fact. The lenses are microlenses arranged in a lenticular lens array that covers the surface of the sensor.

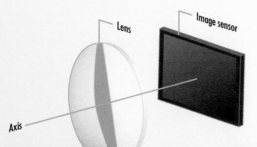

Lens

Image sensor

Axis

3 Light passing through the microlenses is not focused on one point. Instead, each of the lenses divert the rays to a patch of phototransistors that collect light for the image sensor. Like the compound eyes of an insect, the microlenses produce multiple images of the light coming through the aperture.

4 The microprocessor inside the camera receives the multiple landing locations of the rays of light that make up the **light field**, which is the information carried by all the light entering the camera as opposed to the thin slice of focused light in conventional equipment. These locations represent the patterns of focused light rays that would have converged on the image sensor had the lens been focused nearer or farther from the camera. (There remains a limit to how near or far the camera can go to record extra focus information, but in even the first version of the camera, the depth of field is expanded six times.)

Microprocessor

5 The processor does not record the actual focus locations of the light field. Instead, the chip first converts the information using an algorithm known as a **Fourier transform**. The operation winds up with a collection of values that have a point-for-point equivalence to each of the original point values captured by the image sensor. But in a Fourier transform, the chip can place some of these values in a mathematical fourth dimension.

6 After the transformed image has been saved to a computer file, a reverse Fourier transform is applied to any collection of values that represent any chosen plane that lies within the light field camera's expanded focal range. The computer can generate several photographs from the same image values, each bringing into focus different objects in the photo.

How Digital Cameras Tidy Up

Most of the time dust is not a major threat to photography. In the darkroom, photographers have always tried to keep dust off negatives and photo paper while making enlargements. But if a mote here or there escaped their attention, there was no great harm done. Digital SLR cameras are different. When a photographer changes lenses, he opens up the door to dust and the camera's electrical signals invite dust to party on an image sensor that is often a faction of the size of a film frame. Because most digital sensors are smaller than a film frame, what would be negligible dust on film swells to the size of boulders, relatively speaking, when it's on the surface of a digital camera's sensor. Olympus was the first to find a way to tell dust to take a powder.

Gasket

Image sensor

1 In the Olympus EVOLT E-300 and E-330, a clear, optical class filter in a round, metal frame sits between the camera's shutter and the image sensor that captures a photo.

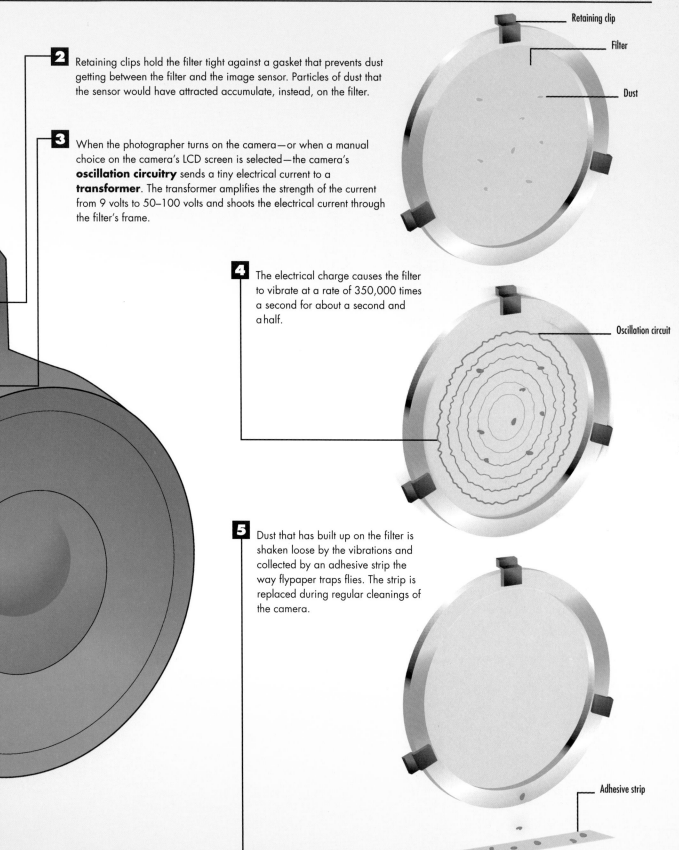

2 Retaining clips hold the filter tight against a gasket that prevents dust getting between the filter and the image sensor. Particles of dust that the sensor would have attracted accumulate, instead, on the filter.

3 When the photographer turns on the camera—or when a manual choice on the camera's LCD screen is selected—the camera's **oscillation circuitry** sends a tiny electrical current to a **transformer**. The transformer amplifies the strength of the current from 9 volts to 50–100 volts and shoots the electrical current through the filter's frame.

4 The electrical charge causes the filter to vibrate at a rate of 350,000 times a second for about a second and a half.

5 Dust that has built up on the filter is shaken loose by the vibrations and collected by an adhesive strip the way flypaper traps flies. The strip is replaced during regular cleanings of the camera.

Retaining clip

Filter

Dust

Oscillation circuit

Adhesive strip

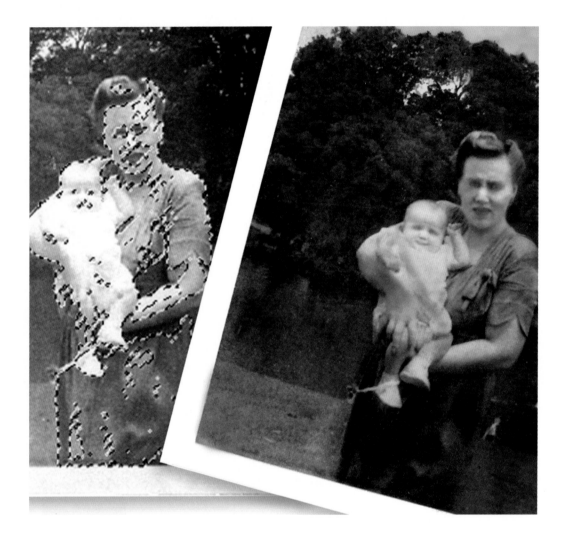

P A R T

3

How the Digital Darkroom Works

C H A P T E R S

I have often thought that if photography were difficult in the true sense of the term—meaning that the creation of a simple photograph would entail as much time and effort as the production of a good watercolor or etching—there would be a vast improvement in total output. The sheer ease with which we can produce a superficial image often leads to creative disaster.

Ansel Adams

IT SEEMS unfeeling to speak of converting a beautiful photograph to data. Whether the photo is of a soldier at the moment of his death or a centerfold at some less painful moment, surely no one would suggest that all that is beautiful and exciting in a work of art can be reduced to a few million binary numbers. Well…yes, we would. As unromantic as it may seem, nearly anything we can experience with our senses can be expressed as numbers.

How about an example? I'm betting you know "The Great Gig in the Sky," one of the tracks from Pink Floyd's *Dark Side of the Moon*. It's sung a cappella and without lyrics by a woman whose wordless wails burst with the emotions of loss, mourning, and despair. How about we all sing "Great Gig" in the language it was recorded in—binary! All together now…one, two, three!

110110001110000011101000111101010000000100001101000101010001111001010010011010101000010100100101010001010111010110100101110110111111011000010110010001100110011011001011011000110111001110001111001....

What's the matter? Don't speak binary? Well then, how about hexadecimal? Ready? Everybody!

36 38 3A 3D 40 43 45 47 4A 4D 50 52 54 57 5A 5D 5F 61 64 66 69 6C 6E 71 73 76 79 7B 7E 80 83 86 88 8B 8D 8F 92 95 98 9A 9C 9F A1 A4 A7 A9 AC AE B0 B3 B5 B8 BB BD C0 C2 C5 C7 CA CD CF D1 D4 D6

Okay, you get the idea. No matter what something is, there's a number for it. The blue of your true love's eyes? That's Pantone 468. Do you have a hard time remembering exactly that cute cleft in the chin of your high school sweetheart? There's a differential calculus function that describes it perfectly—at least to anyone who passed Calculus 101.

Luckily, for those of us who crawled, bleeding, out of high school trig, we don't have to know all the math behind computer programs that constitute the digital darkroom. Such software as Adobe Photoshop, Paint Shop Pro, ACDSee Pro, Microsoft Digital Image Suite, and PhotoImpact do a sterling job, most of the time, in hiding numbers behind onscreen sliders, brushes, curves, multiple choices, check boxes, and icons that look like rubber stamps, pencil erasers, and eye droppers.

You know that picture of your children you've carried in that wallet in your hip pocket until it's grown creased and frayed and torn? Run it through a scanner. That divides the photo into millions of microscopic areas and assigns each of them numbers representing color, brightness, and hue—something for an image editor to work with. The editor attacks those ravages caused by ever relentless time and your ever expanding butt. Some editors are smart enough that you don't even have to point out what's wrong. They calculate which numbers seem out of place with those surrounding them. It changes the misfit numbers to something similar to their neighbors. You may have to tell the editor that the picture's faded and discolored, but it's not a hard job at all for the editor to add to some numbers here and subtract from some numbers there until the color is nicely balanced. The final result, a completely restored photo, surpasses most airbrushing jobs that were a restorer's main attack against aging before arithmetic joined the army.

Math is essential to creativity in the world today. That gets overlooked when a lot of people talk about multimedia and computers. The babble usually goes that audio and video have added so much to the computing experience, but it's really the other way around. By overlaying music, shape, color, and a range of other human experiences with a digital, numerical framework, computers have expanded what can be done with art, science, music, writing, and communications. The ability to tinker and toy with a digital photograph endlessly after it has been taken is the answer to Ansel Adams's complaint that not enough time and effort go into photographs. One can now work in front of a computer as earnestly as Adams did in the darkroom to perfect an image that was caught on a negative, as only a starting point.

CHAPTER 9

How Software Changes Pixels by the Numbers

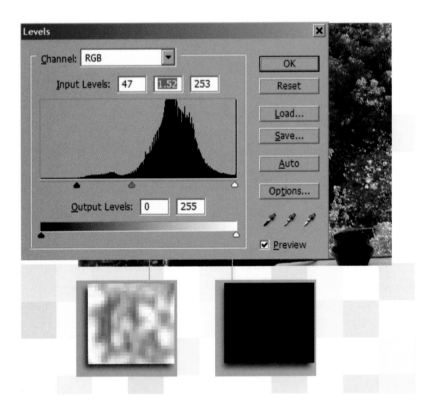

The pictures are there, and you just take them.
Robert Capa

…I had only one plate holder with one unexposed plate. Could I catch what I saw and felt? I released the shutter. If I had captured what I wanted, the photograph would go far beyond any of my previous prints. It would be a picture based on related shapes and deepest human feeling—a step in my own evolution, a spontaneous discovery.
Alfred Stieglitz

THE quotes at the top of this page represent not only the different attitudes of two accomplished photographers, it also is emblematic of the change that photography is going through because of the development of digital cameras and the digital darkroom.

Robert Capa photo of a soldier at the moment of his death.

For war photographer Robert Capa, a photograph is totally the product of one single moment and a particular place. His most famous photograph, "Death of a Loyalist Soldier, Spain, 1936," shows a soldier on a rampart at the second he has been struck by a bullet. He is bending back. His rifle is slipping from his hand. A second earlier he was a fighter. A second from now, he will be another body on the battlefield. But right now, he's dying. It is a unique moment, the type of moment that shaped the thinking of Capa and many of his contemporary photographers—that a photo had a unique existence tied to particular coordinates of time and space.

Although Alfred Stieglitz was largely a product of the same deterministic attitude toward photography, his words above reveal his suspicion that great photographers are not just those who happen to be in the right place and time when the makings of great photos are taking place around them. His thoughts show a realization that the photographer makes an emotional and intellectual contribution to the creation of a great photograph. But you also sense Stieglitz's despair at the thought that he will only have one chance to capture the image he conceives, and then the opportunity is forever lost.

Today, Stieglitz might be less pessimistic because few photographers now accept the notion that they are stuck with whatever image they capture when they snap their shutters. In this chapter, you see what Stieglitz would have liked to: how you're only a few numbers away from improving that picture for an off-color hue here, a touch of red eye there, or on the more drastic side, ridding family photos of irritating relatives entirely.

How Software Manipulates Images on the Pixel Level

The humongous advantage of using numbers to represent images is that you can lighten an image, darken it, bring out contrast, sharpen it or blur it, turn it upside down, or transform it into a psychedelic abstract, all by using simple arithmetic. It's not so simple that we can sit at a computer with the Mona Lisa on the screen and subtract numbers from the color values in Mona's portrait, turning her smile into a frown. It would be an excruciating job, the kind of job computers are made for. A PC can calculate a frown job on Mona in less than 10 seconds. It's all just a numbers game.

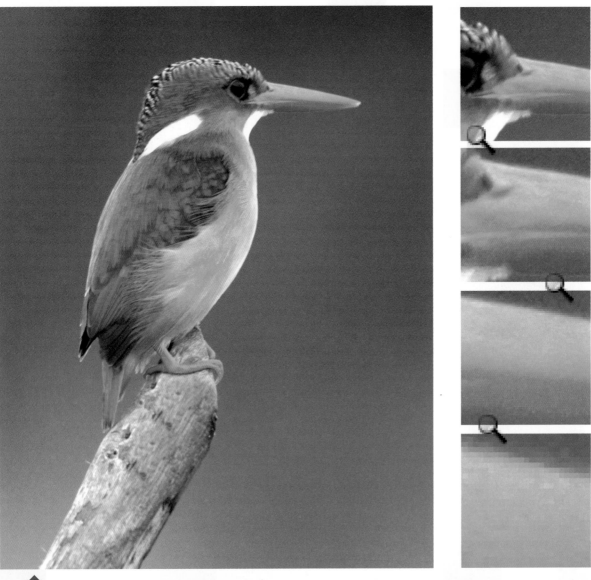

1 Your digital camera records your digital photo as a set of tiny pixels. As you look closer at a photo, though, you begin to see the pixels as jagged edges and then squares. What you thought were distinct lines and boundaries turn out to be more gradual transitions between colors.

Red value: 107
Green value: 114
Blue value: 67

Red value: 242
Green value: 149
Blue value: 153

2 Zoom in far enough, and you see that each pixel is actually a tiny square consisting of a single, solid color.

3 When you tell your image editing software to make a change, such as sharpen, brighten, or apply effects, the software looks at the differences in color between pixels. Often, it compares those values with pixels that are close but not touching the pixels under scrutiny.

SHARPEN FILTER

4 The software applies a mathematical formula to recalculate the color of each pixel. It starts with the formula for the type of editing or effect you are asking it to do. It also takes into account the differences in color between pixels, often those in or near transition areas.

5 Not all pixels are changed equally. Some pixels might retain the same general color but take on a slightly darker or lighter tone. Other pixels might be assigned a very different color. Pixels that are not near a border area might not be changed at all.

How the Digital Darkroom Focuses Pictures After They're Taken

When a digital camera translates the continuous gradations of color into discretely colored pixels, finer details get approximated. The result is a slightly softer look than photographic film will yield. To compensate, digital cameras usually do a bit of electronic sharpening before they send the image to your computer. Once on your computer, your digital darkroom can add sharpening effects using the same methods.

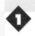 What does it really mean to **focus** an image you've already taken? To the digital darkroom, it means increasing the contrast between certain pixels by making some darker and others lighter. You can see this when you zoom in.

 Dark lines are a bit darker, and the light areas next to them are a little lighter.

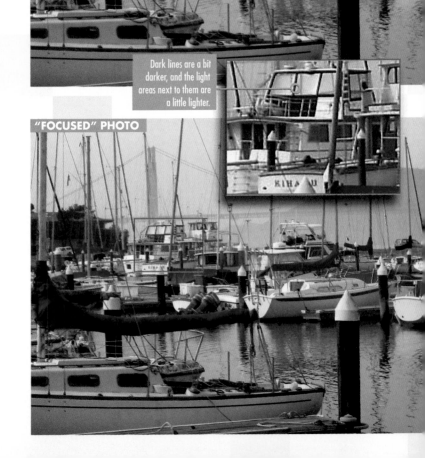

ORIGINAL PHOTO

Dark lines are a bit darker, and the light areas next to them are a little lighter.

"FOCUSED" PHOTO

3 To determine which pixels it will change, the digital darkroom compares neighboring pixels to see if the tone of one exceeds the color of another by a preset **threshold**. (You can, with some photo editing programs, set the threshold to fine-tune the degree of sharpening applied.)

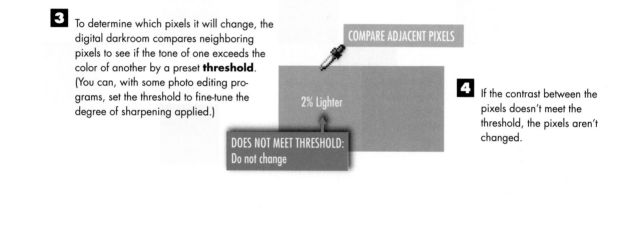

COMPARE ADJACENT PIXELS

2% Lighter

DOES NOT MEET THRESHOLD:
Do not change

4 If the contrast between the pixels doesn't meet the threshold, the pixels aren't changed.

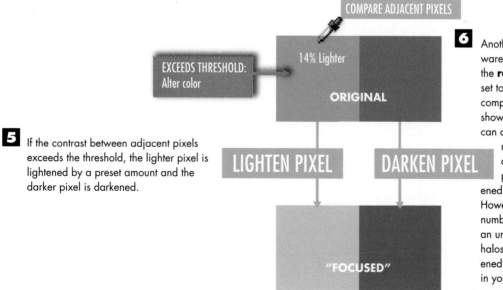

COMPARE ADJACENT PIXELS

EXCEEDS THRESHOLD:
Alter color

14% Lighter

ORIGINAL

LIGHTEN PIXEL DARKEN PIXEL

"FOCUSED"

5 If the contrast between adjacent pixels exceeds the threshold, the lighter pixel is lightened by a preset amount and the darker pixel is darkened.

6 Another number the software considers is called the **radius**. If the radius is set to 0, only pixels being compared are changed, as shown here. The radius can also be set to a larger number so that more of the surrounding pixels are also lightened and darkened. However, setting the radius number too large results in an unnatural look, with halos around the sharpened edges of the subjects in your photos.

When Unsharp Is Sharp
Photo editing programs have more than one way to sharpen an image. Commands such as **Sharpen** and **More Sharp** don't require a lot of explanation. The function described here is called **_Unsharp Mask_**, a term that seems to be going in the wrong direction. It gets its name from the fact that areas with significant changes in contrast look sharp while areas without big changes in contrast look smooth and less defined and are therefore effectively masked from the sharpening filter.

How Blurred Becomes Better

Much of our time and effort as photographers is to get the focus *just* right. We welcome innovations such as autofocus and anti-shake mechanisms that help us get sharp images. Crisp focusing is so important that it seems contrary to a photographer's instincts to deliberately make a photo blurry and *less* focused. But blurs do have their place.

 Sometimes you want to hide things in a photograph as much as you want to show other elements. For instance, the high level of detail gives this photo a harsh appearance.

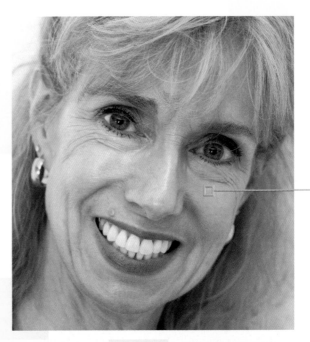

 Applying a slight blur gives you a more aesthetically pleasing effect.

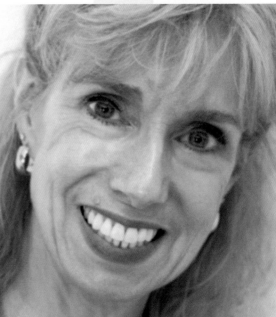

There are many different ways to apply a blur to a digital photo, but all blur functions recalculate the color value of a particular pixel by averaging it with the pixels around it. Of course, if you averaged the color of every pixel in the entire photo, and applied it to every pixel, our portrait would look like the brown square to the left.

4 Instead, blur functions calculate a **weighted** average of neighboring pixels that looks something like this. The color of the pixel being considered (center) carries the most weight in the averaging process.

5 Pixels directly adjacent are weighted less, and the weighting falls off drastically after that.

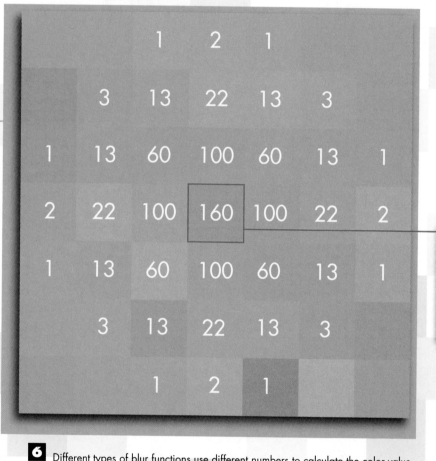

Here, the color of the pixel itself is counted 160 more times than a pixel at the end of the radius of pixels being used to calculate the new color.

6 Different types of blur functions use different numbers to calculate the color value of the pixels, or widen or narrow the radius of pixels being used. Some blur functions use this method to change every pixel in the image, while others will not make changes at perceived edges.

How Software Changes Exposure After the Shot

There are two different exposure problems that can occur when you take a picture: underexposure and overexposure. These can happen even with the finest digital equipment because not all subjects are lighted equally nor are all photographers equally gifted in capturing a scene. If the equipment doesn't make a mistake, the photographer will, sooner or later. Luckily both types of poor exposure can be fixed in the digital darkroom.

Underexposure

1 Underexposure is a result of not enough light getting into the camera. The shutter speed is too fast or the aperture set too small. Although you might not see them, details of your image can hide in dark tones and shadows.

2 In an underexposed photo, too many of the pixels have brightness values at the low end of the dynamic range. If you simply raise the brightness of every pixel equally, you get a washed-out look. The digital darkroom fixes underexposure by treating different levels of brightness differently.

3 Colors will be made brighter to different degrees, depending on how dark they are, how much of that color exists in the picture, and where they are located. If there are no absolute whites in the photo, the lightest color might be brightened to white to increase contrast.

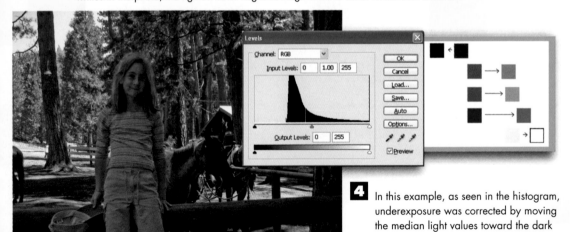

4 In this example, as seen in the histogram, underexposure was corrected by moving the median light values toward the dark end of the dynamic range.

Overexposure

Overexposure, when too much light gets into the camera, can be corrected much in the same way, by recalibrating the lightest and darkest pixels, and then by darkening pixels in the mid-toned colors and highlights.

1 Overexposed images can be more difficult to correct than underexposed photos. Overexposed images can lose details in the highlights, yielding white areas with little or no information.

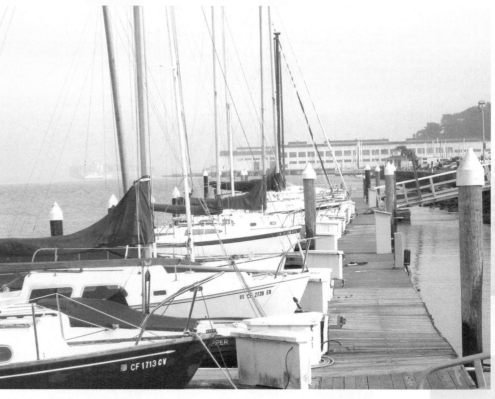

2 Here, the boats run together without borders. The more sensitive human eye can distinguish among different shades and intensities of paint used on the boats. Those subtleties are lost when the camera captures so much light that the distinctions are washed out.

4 Only the correctly exposed photo contains enough detail to distinguish between the white boats. This is why, even when you're taking digital pictures, it's better to lean toward underexposure than overexposure.

3 Correcting the image can't add the needed detail. Although the digital corrections to exposure make the blue sail darker along with the brown gear on the near boat, it can't pull out details that weren't captured because of the overexposure.

How Software Corrects Bad Lighting

One of the most common problems of the amateur photographer is that of the backlit subject without a flash. Here, the camera makes its adjustments based on the bright background, which turns out perfectly exposed. Unfortunately, because light from behind a subject puts it (or him or her) into shadow, the subject is left underexposed.

1 While use of a flash would have prevented the problem, the digital darkroom can provide a flash fill after the fact. It treats the photo like two photos: one that is perfectly exposed and one that is underexposed. To find the two areas, it calculates the brightness values of groups of pixels.

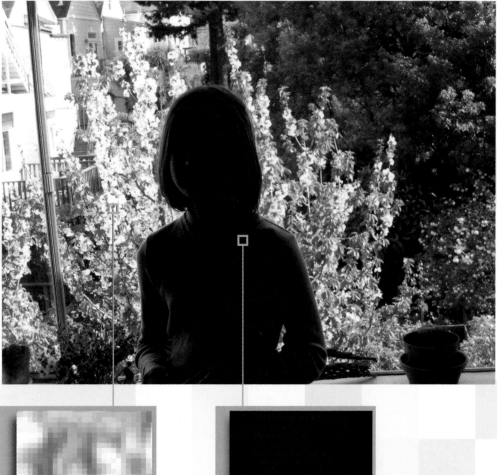

2 Areas with a balance of tones are judged to be correctly exposed.

3 Areas that are predominantly dark are designated as part of the underexposed portion.

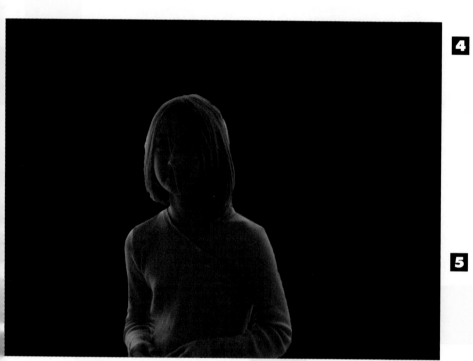

4 The digital darkroom masks off the areas that have a balance of color tones and leaves these areas alone.

5 To the remainder of the photo, the software applies the routines it would use for an underexposed photo, adding the same amounts to the values for the three colors that make up the pixels. The higher values represent lighter shades.

6 The result is that the correctly exposed background is retained and the underexposed subject has come out of the shadows. Notice, however, that this correction still doesn't manage to bring out any highlights in the subject because all color values are raised equally. The image of the girl lacks **dynamic range**. For fuller explanations of dynamic range, see "How Histograms Run the Gamut" in Chapter 5 and "How Photoshop Multiplies a Photo's Dynamic Range" in Chapter 9.

How Bigger Pictures Preserve Little Details

Suppose you have just completed an attractive mosaic covering a wall when the boss comes along and says there has been a change in plans. The wall is going to be twice as long and twice as high; you'll have to make the mosaic four times bigger. There are a few ways you could do this. You could replace every 1" × 1" tile with tiles of the same color that are 4" × 4". Or you could spread out the tiles you have and try to figure out the colors of all the missing tiles that need to fill up the spaces between the original tiles. Or, you could quit and become a video software engineer, which means you'd still face the same problem.

50 PERCENT ENLARGEMENT
851 X 1134 pixels, or 965,034 pixels total

1 If you zoom in close on the hub of the front wheel, you can see that the hub is made up of more pixels in the enlargement than in the original.

Original 567 X 756 pixels, or 428,652 pixels total

2 You can best see how your software creates the new pixels by looking at the pixel level. This simple image is made up of only 4 pixels. We'll perform a five-fold enlargement, bigger than most, but good to illustrate the process.

3 First, the software spreads the existing pixels apart.

4 Next, it fills in the white space with duplicates of the existing pixels.

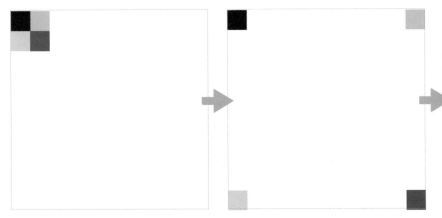

Better Ways to Enlarge Images

If you want to enlarge your image substantially, it's better that you do it in a series of small increments of no more than 110% at a time until you reach the desired size. The reason is that your image editor will have smaller gaps to fill in after spreading the existing pixels and your final result will look much smoother than if you tried to make a substantial enlargement in one pass. Think about it this way: It's easier to walk up or down a flight of stairs one step at a time. You can probably skip every other step without too much of a problem. But things will be more difficult the more steps you try to skip on your way up or down.

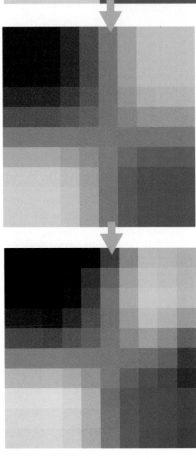

5 Leaving the photo like this will result in a blotchy-looking image. To prevent this, the software uses one of many algorithms to create transition among the original colors.

6 The software might then perform a Sharpen process (as described earlier in this chapter), which will give you something like this. The software can also apply a blur for a different effect.

How a Digital Darkroom Improves Even Correctly Exposed Photos

Most of us would be delighted if the only thing darkroom software could do is save our photography from our mistakes. But it gets better than that. You can improve photos you think can't be improved—at least not technically—by running them through programs such as Photoshop and Paint Shop Pro. Maybe you have been looking at marginal photos for so long that they look perfect to you. It's similar to our inability to distinguish among shades of white. We don't see that a photo's slightly overexposed or underexposed, that there's a greenish cast to it, or that it has a dullness that's not really apparent until darkroom software banishes the flaw. Software makes good shots into photos that pop off the screen and the paper. These improvements are based on the information the software finds in a **histogram**, which is a record of the color and brightness values of every pixel that makes up your picture. Here's how it works.

1 To each pixel, the software assigns a tone value, a number from 0 (representing pure black) to 255 (for white). The software then counts how many pixels of each tone value are contained in the picture and can often display this information in a bar graph called a *histogram*. Along the horizontal axis are the tonal values. Each bar displays the number of pixels in the photo that have that tonal value.

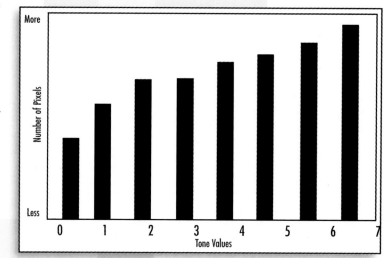

2 When you graph all 256 tones and the millions of pixels in an image, the histogram can look something like this. There is no "right" way for a histogram to look. It can have a single, bell-shaped curve in the middle, or it can have multiple humps. A photo with a lot of snow or sand will have a big hump on the right side, while a night scene might have a lot on the left side.

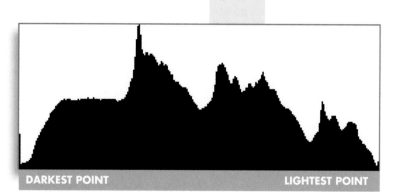

DARKEST POINT LIGHTEST POINT

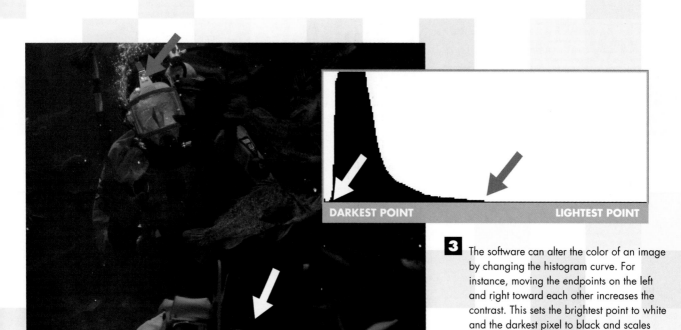

DARKEST POINT **LIGHTEST POINT**

3 The software can alter the color of an image by changing the histogram curve. For instance, moving the endpoints on the left and right toward each other increases the contrast. This sets the brightest point to white and the darkest pixel to black and scales the pixels in between.

4 This was done to the picture on this page, but we also see that the curve was moved slightly to the right and tilted in that direction. This has the effect of boosting the midtones, bringing out the color in the uniform and in some of the fish.

DARKEST POINT **LIGHTEST POINT**

5 When the color scale was stretched out to fill the range from 100% black to 100% white, the software recalculated the color values of some of the pixels to incorporate the new values into the photograph. The change expands the photo's **dynamic range** so that more areas of the spectrum are represented.

How Photoshop Multiplies a Photo's Dynamic Range

1 This photo is a "normal" exposure, meaning it's a picture that was impossible to expose correctly. The light coming through the windows is overexposed, burning out the details of a lovely delicate design in the curtains. At the other extreme, the rocks in the vase exist only in silhouette, and the wood grain in the table is smothered in darkness.

The holy grail of all photographers is to stretch the dynamic range of their pictures so that it captures details in the deepest shadows and the brightest whites. But there has yet to be invented a film or a digital sensor that captures the range of light and shadow as well as the human eye. We're left with a photo that looks as if it was taken by a camera that "squinted," cutting out light carrying the details that gave the scene life when the picture was taken. Adobe, with Photoshop CS2, introduced **high dynamic range (HDR)**, a tool that captures the dark and light details of a scene by ganging up on them with multiple photographs.

2 Here is a photo of the still life that hides nothing with excessive light or dark. But in truth, it's really eight photos that have been blended in Photoshop.

3 High dynamic range begins by taking at least three pictures of the same subject, with at least a two-stop difference from one shot to the next. The changes in exposure were accomplished by varying the shutter speed so that aperture, and therefore the depth of field, remain the same. High dynamic range images open up a world of possibilities because they're allowed 32 data bits for each of the three color channels.

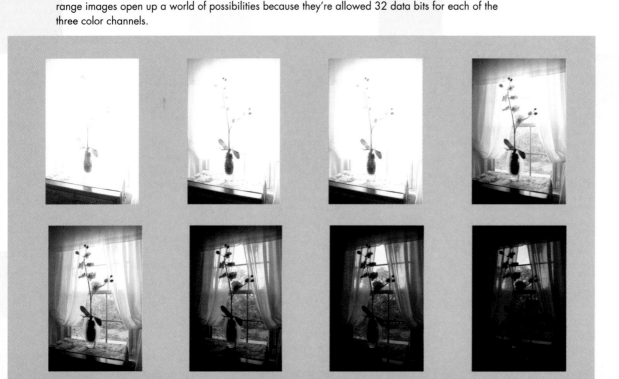

4 In Photoshop, you tell the program's HDR feature the shots you want it to combine. HDR analyzes the photos and assigns then an **EV (exposure value)** of 0, +1, -1, +2, -2, and so on. If it's able, Photoshop aligns all the shots and adds together the extremes of light and shadow from all the photos to produce a single image that incorporates the highlights from the underexposed areas and the lowlights from the overexposed.

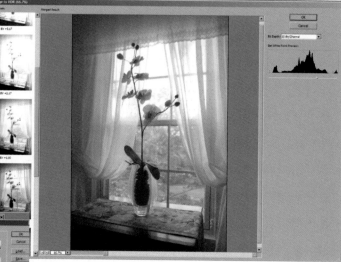

5 The result is not the finished product. In fact, it may not be particularly attractive. That's because Photoshop created an image with a greater dynamic range than most monitors can display. At this point, Photoshop invites you to set a white break point, which lets you adjust the image to create something that works in the 16 bits per channel that are all your monitor displays.

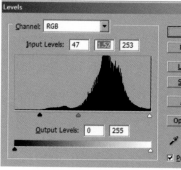

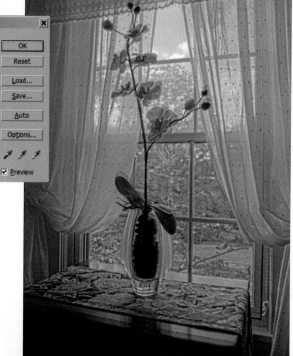

6 The final image is created when you open a 32-bit Preview Options dialog box. There you instruct Photoshop to adjust the exposure and contrast to reduce the image to 16 bits, to compress the highlight values in the image so they fall within the luminance range of a 16-bit photo, or tinker with other renditions so that you wind up with a photo that is the sum of many images. As you can see from the four examples here, the adjustments produce widely different results. The final image on the facing page came from tweaking levels, curves, and brightness.

How Layers Serve and Protect Photos

Step back a while to high school biology. Remember that frog illustration in the biology textbook? It was made of several sheets of clear acetate. The top sheet showed the belly of the frog. Lift that sheet and the skin went with it to reveal the muscles lying just beneath. Lift that and you could see the frog's guts. One more sheet and you were down to the bones. If you're familiar with *ranunculus acetatus*, then you'll have no trouble at all understanding **layers**, Photoshop's primary tool for changing an image while at the same time protecting it.

 Ideally, in Photoshop no editing is ever done directly to a digital image. Instead it is done on a **layer**—a copy of all or part of the image that is virtually suspended over the original. It's as if you lifted the first sheet of acetate, with froggy's tummy on it, only to find a second sheet with an identical frog belly. You could scribble on the first sheet until the bell rang, and the image beneath would be unscarred.

2 A Photoshop layer, however, is not always a duplicate of the original image. We can start with one photo, such as this one of a lily pad and over that place a layer displaying another image, one of, say, a frog.

3 In this instance, the original full-frame frog image completely obscures the lily pad on the bottom layer. But the frog is on virtual acetate. We can erase everything in the frog layer that's not the frog to reveal the lily pad in the layer below. Or better yet, make a duplicate of the frog image on the second layer and do the erasing on that new, third layer.

COPY OF FROG LAYER

SHADOW LAYER

4 Photoshop offers more than one type of layer. Some of them are specially endowed to aid specific types of editing, such as changing colors, filling areas with gradients, or creating shadows. The layer here lets us create a shadow for the frog so that it looks more natural in its new setting.

FROG LAYER

5 Separately, we have four images that look like these. Because few graphics formats support layers when we save the edited image, we tell Photoshop to **flatten** all the layers into a single image. Photoshop uses a technique called **Z-buffering** by giving each pixel a Z value that indicates its third dimensional value in the composite photo. Based on the order in which the layers are arranged, the Z values identify which pixels would be covered by pixels in other layers. Photoshop eliminates all the pixels it decides would be obscured and replaces them with the topmost pixel for that location. This is the result.

LILY PAD LAYER

CHAPTER

How Digital Retouching Rescues Family Heirlooms

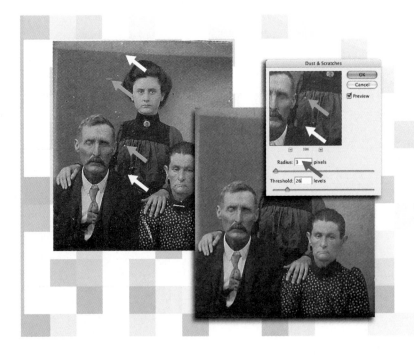

A photograph never grows old. You and I change,
people change all through the months and years,
but a photograph always remains the same.
How nice to look at a photograph of mother or
father taken many years ago. You see them as
you remember them. But as people live on,
they change completely. That is why I think a
photograph can be kind.
Albert Einstein

YOU have to give Einstein a lot of credit when it comes to figuring out the big picture of the time, the universe, and all that. But he obviously doesn't know much about what can happen to photographs that don't receive meticulous care.

Once upon a time your ancestors were younger than you are. They were filled with life, color, and energy, and although it was a rare thing to happen back then, they decided to have someone take their photograph. If we're talking ancestors far enough removed from the present day, it was a big event and your ancestors put on their Sunday-go-to-meeting clothes and their most solemn faces and stood still for a photograph that was, no less than the pyramids, a declaration to future generations: "We were here and this is what we looked like and we mattered."

Or it might have been a snapshot Mom and Dad took on their first date using Grandpa's new Brownie.

Either way, these are more than photographs. They are pieces of time that can never be done over again. And way too many ancestors are fading, peeling, crumbling, or serving themselves up as lunch for cockroaches in the attic.

A few years ago, that story wouldn't have changed. If you could find all your old family photos, art restorers were expensive and many of them didn't guarantee their work for this lifetime, never mind the next lifetime and the one after that and the one after that.

Then came Photoshop and its kind, and suddenly everyone's a photo retoucher—a damn good one, too. It's now possible to restore a photo as well or better than the job done by the so-called pros. There are many ways to restore photographs, and we wouldn't be able to tell you all of tricks in just one chapter. But here's enough to get you started and show you how simple it can be.

If we had a picture of Einstein handy, we could even do something about that hair.

How Software Removes Dust and Tears

The advantage of digital photos is that they can live indefinitely in the form of 0 and 1 bits without the slightest mar. But most photographs taken a generation ago or more aren't digital (yet), and they've usually suffered the scratches and soils of shoe boxes, drawers, and wallets. Scanners come to the rescue, but they need help from a photo editing program to erase the scars of your heirloom photos' previous existence. The first tools of choice for photo restoration are the *Cloning* and *Healing tools*, which easily fix a photo album full of imperfections with a dynamic form of copy and paste. To see how, let's look at where an ordinary copy and paste fails.

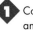

1 Copy a patch that is similar in texture and color, and paste it on top of the dust specs in the hair.

2 With the hair, the texture and color match, but there's no transition from the patch to the surrounding area.

3 With the cheek, the pattern is fine, but the color tone is too different.

4 However, two other tools found in photo editing software produce different results: the Cloning and Healing brushes. These tools don't simply cover the photograph wherever they paste. Instead, they use different methodologies to mix the new material with the old, so that the new retains elements of the area it is covering up. More advanced photo editing software lets you clone specific qualities from one part of a photo, such as the colors, without including other elements, such as the patterns. Both tools also use *feathering*, a common feature in photo editing software that smoothes the boundary of the patch so there is a gradual transition between new and old materials.

5 Even when you look very closely, it's tough to see where the new material has been pasted. But these are relatively minor repairs. In the next illustration, you see how these and other tools can restore an almost hopeless photographic heirloom.

How the Digital Darkroom Revives Your Ancestors

Minor dust specks and scratches are one thing, but what about a discolored old photo that has partly disintegrated or has tears? This photo, easily 100 years old, shows its age. Tiny scratches and spots show up against the dark clothing and backgrounds. The seated woman has deep scratches across her collar and dress sleeve. And all three of them look miserable. Still, there's virtually no job that a team of touch-up tools can't get together to take care of.

1 Compared to the previous retouch job, the spots and scratches here are a bug infestation. The Dust & Scratches tool in Photoshop is an insecticide bomb, cleaning them all out at once. It affects the entire photo (or the area you've selected) covering over spots and scratches, such as those marked here with white arrows, using the colors of the surrounding pixels. It only works on flaws that are smaller than the limitations the red arrow is pointing at for Radius (size) and Threshold (how different pixels must be to become suspect). If the Radius and Threshold are set too high, the entire picture becomes blurred. That's why some spots—those marked with blue arrows—must each be blotted out manually.

2 Here are the results of the Dust & Scratches (D&S) and other touch-ups. The D&S tool softened the standing woman's hair, so the Sharpen tool was used to bring back the suggestion of strands of hair. The scratches on the sitting woman's dress were too big also, but because of the spots on the dress, we couldn't use the Healing tool. The Clone Tool works, copying everything from a user-selected source a set distance away onto whatever the tool is pointing at. It's similar to the Healing Tool except it's more a manual operation that works well for large jobs.

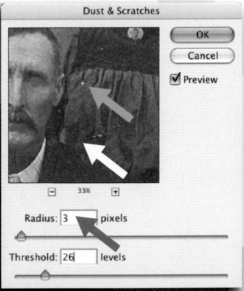

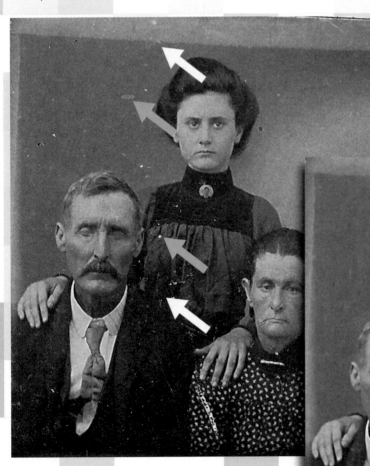

3 All that was left to do was try to help the man in the picture not look as if he couldn't stay awake. This sort of touch-up requires a leap of faith. You assume the younger woman is his daughter, and therefore she's likely to have inherited his eyes. The Healing tool enables an organ transplant of sorts. The eye on the left fit with little fuss, but the eye on the right required some darkening with the Burn tool, which emulates when photographers in film-based darkrooms let light shine through circles they made with their hands to darken chosen areas of a print they were exposing with an enlarger.

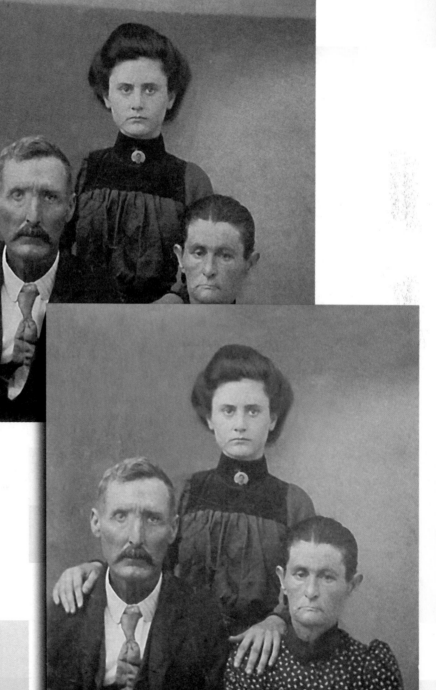

4 For a final touch, a sepia tint not only gives the photo an antique touch, but helps disguise any flubs in the touch-up job. With a bit more work, we might have been able to make the family smile. But that would have been wrong.

How Darkroom Software Brings Pictures Back to Life

Color photos are subject to the same slings and arrows of outrageous shoe boxes that torment black-and-white pictures—the dirt, the creases, the spills, the humidity, and of course the fatal reactions that occur when the still-active chemicals of one photograph are crammed up against those of another picture for a decade or so. But the chemicals in color photos are still more volatile and more susceptible to turning the only picture of beloved Uncle Ernie into what looks like an extraterrestrial blob of protoplasm. Luckily for all the myriad misfortunes that can affect photos, we have an arsenal of E.R. weaponry to bring them back from the brink. There are so many tools in the digital darkroom, there's no space to cover them all in detail, but here are some of the most common devices available in programs such as Photoshop, Elements, and Paint Shop Pro to bring color—the right color—back to the cheeks of fading ancestors.

Levels (histograms) is the most versatile of several methods to isolate and tame discolorations that have taken over the photograph.

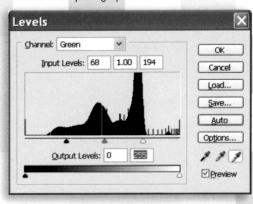

Burn and **Dodge** duplicate the techniques of the old chemical darkroom so the retoucher can darken and lighten specific portions of the photo.

Healing brush repairs numerous dust spots, scratches, and assorted and unexplained flaws by duplicating the pixels surrounding the damage so they cover the defects seamlessly.

Selection tool isolates the mother and baby so that they can be worked on without affecting the background. The selection can also be reversed to work on the background without worrying that touch-ups will spill over into the mother and child.

Layers provide a way of working on a duplicate of the photograph within the same file and then controlling how changes are blended into the original picture. Two duplicate layers of the washed-out image that emerged from color changes were *multiplied* to increase the contrast and color depth of the photo.

Gradient tool fills a sky that has lost all hint of color, permitting the blue to fade as it approaches the horizon.

Airbrush brings out clouds that had been submerged by the blue gradient. The airbrush also adds a hint of eyeballs that had been lost entirely in the shadows of the mother's eyes.

Cloning tool covers bigger and more complex flaws by copying, through a sort of artistic wormhole, good portions of the photo to replace flawed areas with the same control you have using a brush. Here, some of the dark trees on the right were replaced with light trees from the left of the photo.

Variations are used as a final touch so the retoucher is able to see and choose from a selection of thumbnail versions of the same photograph in which hues and brightness are slightly varied. This enables the retoucher to see, at a glance, which variation produces the most pleasing result.

Sharpen tool restores definition to edges that have become blurred through fading or by the retouching itself.

CHAPTER
11

How the Digital Darkroom Makes Good Photos into Great Fantasies

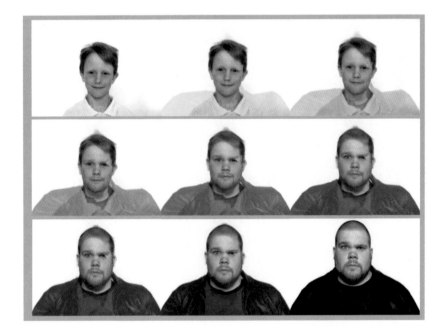

When I get a college brochure, the first thing I look for is racial diversity. If I don't see a few minority faces in the pictures, I toss it aside, because who wants to go to some podunk college that can't even afford Photoshop?

Bill Muse

PHOTOGRAPHY tends to be thought of as a realistic art. But it doesn't have to be that way, you know. Photographers are kids, too, and they get delight out of playing with photos or rendering a small touch of magic. With Photoshop, Paint Shop Pro, and dozens of other software programs, you can abandon your search for truth and create a really cool fantasy.

The solution for sure-fire, unambiguous ridicule is to start with a photograph just to make sure everyone knows exactly who you're making fun of. There are plenty of software programs out there already configured to let you convert a photo of a boss, loved one, political figure or the goat of the moment into a professionally rendered, photorealistic source of general mirth. They're called morphing programs. Here we show you what you can do with these home-sized versions of the same special-effects technology that lets the villain of *Terminator 2* change form so easily.

Then there's Rob Silvers, who invented the photomosaic process while at the MIT media lab. Since then, his photos, made out of legions of smaller photos, have been on the covers of *Newsweek*, *Sports Illustrated*, and *Playboy*, and his hands have been in the pockets of Fortune 500 companies clamoring to have their own photomosaics. You can hire him, too, or you can use some of the cheap or free software to build your own. And doing it digitally is a lot easier and neater than pulling out glue, scissors, and the family's photo collection. You'll get started the digital way in this chapter.

Of course, size matters. Have you ever been to IMAX? The bigger a picture, the more impressive and intriguing it gets. Before digital photography, the most common way to create a panoramic photo—the kind that stretches on and on horizontally, perfect for bridges, chorus lines, and mountain ranges—was to use back-breaking cameras costing thousands of dollars. Their lenses revolved to expose a long strip of film. Now Kodak has a camera that takes panoramas you can carry in a shirt pocket. Not that you need a special camera at all—provided that what you do use is digital. You'll find in this chapter how to do it digitally.

How to Change a Red Rose to Blue

One of the most magical tricks of the digital darkroom is the ability to take a real-world object and give it a new color. We like red and yellow roses, but without too much effort, we can turn several of them blue. The thing that makes the change convincing is that the original shading is retained. Highlights are still highlighted and dark spots are still dark—they're just a new color. (Notice, too, that the yellow roses turned out to be a lighter shade of blue than the red roses.)

 How this is done might not be obvious. If we took a paintbrush in normal painting mode and painted a rose blue, it would end up as a solid blob of color, without shadings or edges. And, roses that started out red and yellow would both end up the same blob of blue.

2 In place of a normal painting mode, the image editing software offers a special color-blending mode. It preserves the gray levels of the original colors while blending in the hue and saturation of the new color.

3 Each pixel in a digital photograph is made up of three dots of color: red, blue, and green. Each of the colors is assigned a number from 0 to 255 that describes how light or dark the color is. So, instead of painting the rose one shade of blue, the digital darkroom calculates the values of gray represented by the pixels and uses shades of blue that correspond to the different values of gray. This gives us a range of blue, like this.

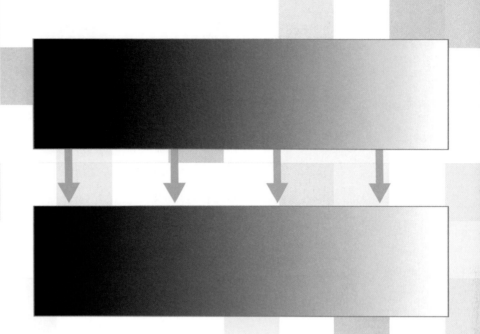

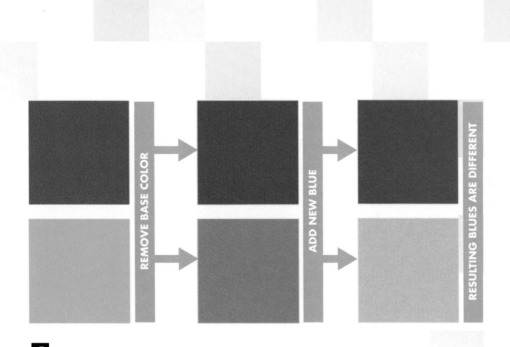

4 The reason the yellow roses come out to be a lighter shade of blue than the red roses is that the gray values of the pixels in the yellow roses are lighter than those of the red pixels.

How Digital Photos Make Fun of You

Raising a young boy to be a man is no easy chore—unless you have morphing software. **Morphing** converts one image into another in a number of discrete steps, each of which is a blend of the characteristics of both. Although there are many mathematical methods of morphing, the basic procedure is a combination of two techniques: cross dissolving and warping.

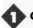 **Cross dissolving** is the same technique used in slideshows and PowerPoint presentations: One image fades out while another fades in. A computer producing the effect begins by holding both images in memory simultaneously as it displays the first image.

2 The morphing software randomly chooses some of the pixels in the first image and replaces them with the pixels from the same positions in the second photo. It repeats the process until it replaces all the original pixels. This gives us a dissolve, a commonplace feature of any movie. But it's not yet a morph. It needs to warp as well.

3 In one common **warping** method, the user manually places dots on one face and partner dots on the other face to identify major features, such as the nose, mouth, and eyes. The more pairs of dots used in the warp, the more realistic the result. The program here uses a variety of colors for the dots to help the user keep track of what's been done.

4 The software also makes a record of what is inside each of the regions the dots define. It uses this information when it performs a cross dissolve, replacing pixels in one photograph with pixels from the other. The software simultaneously repositions the transported pixels and the polygons they form to warp the emerging image so the pixels move steadily toward the positions they occupied in the picture from which they came.

5 The end result is the same as the cross dissolve: One picture replaces the other. But when all the stages are displayed in an animation, warping makes the subject of one photo morph gradually into the other. (By working with two copies of the same photo, you can warp without dissolving. The effect is to distort the original image so it grows a bigger nose, longer hair, or bulging eyes.)

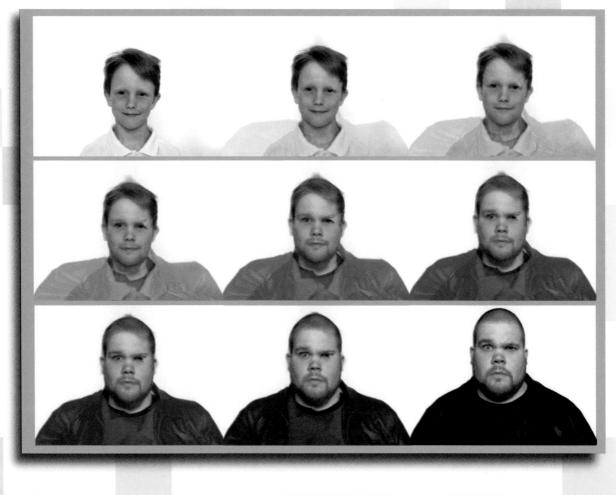

How Software Makes One Photo Out of Many

We are by now used to the fact that most pictures in our everyday life are not made of solid fields of color and unbroken lines. They are made up of dots. Take a close look at your computer display or TV, and you'll see the changing, colored pixels that create their displays. Even Tim Down's gorgeous illustrations in this book are—at their base—collections of colored dots. (Check them with a magnifying glass.) But the dots here are no more than dots. They are other pictures, **photo mosaics**, that are also composites, but composites of other, smaller photographs. They're pictures within pictures.

1 One of the best image processors is the human brain. It's capable of taking the skimpiest visual information and turning it into a larger, more coherent image. This image, for example, has only 216 pixels. But most people can recognize instantly who it is.

2 This example, however, depends heavily on showing a well-known person. Most photo mosaics are not nearly so familiar, but they also have many more pixels, thousands, that create a more detailed large photo, such as this one.

4 The program divides the main photo into a number of **cells**, usually the same size that make up a grid.

3 Using software, photo mosaics can be created in a matter of minutes on an average PC. The one here, which consists of 3,600 smaller photos, took ten and a half minutes to produce on a 3-gigahertz Pentium 4 computer, using AndreaMosaic, which is available at http://www.andreaplanet.com/andreamosaic/download/.

5 Each cell is compared to each of the photographs that have been gathered to make up the larger photograph. On an aesthetic level, it's more interesting if the smaller photos have some relationship to the larger image, such as using Matthew Brady photos, to create a portrait of Lincoln. But their content is immaterial to the software. The program is comparing the cells to the photos for color, brightness, texture, and density values. (Some other programs rotate cell photos or change their brightness or hue to better match the large photo, but that seems like cheating.)

6 The resulting larger picture appears to have more resolution than it does because the program also compares the colors and shapes within each smaller photo to match cells that contain markedly different areas, such as the edge of an object that cuts diagonally through a cell.

How Panorama Programs Stitch Several Photos into One Superwide

We like our pictures to be wide. We like the wide screens of IMAX and HDTV. If a landscape photo is awe-inspiring, it inspires even more awe the wider it is. There's no explanation why we are so impressed by elongated dimensions, but photographers have been shooting panoramas since the first panorama camera was built in 1843. From then until the advent of the digital camera, panoramas were shot with specially built cameras. Digital photography lets us combine two or more photos taken with ordinary cameras into one wide, mind-blowing panorama. Here's how it's done, all without human intervention, by Autostitch, a program created by Matthew Brown and David Lowe at the University of British Columbia (free at http://www.cs.ubc.ca/~mbrown/autostitch/autostitch.zip).

1 **Stitching** software, part of many photo editing programs, joins several photos into one panorama. Most require human intelligence to judge when individual photos are fitted together properly. Autostitch uses artificial intelligence to make the decisions, including what images selected from a directory full of photos are ripe for stitching, and pieces them with no human directions.

2 Autostitch begins by examining all the photos in a directory for features that are **invariant**— that is, features that resist basic changes even if they are enlarged, rotated, or seen from a slightly different perspective. This is done in a search called a **SIFT** (scale-invariant feature transform).

3 The program checks the images with the greatest number of feature matches for an image match. A **RANSAC** (RANdom SAmple Consensus) counts a random number of matching features that are within a certain distance of their statistically predicted locations. The sample set with the most features more or less where they should be, called **inliers**, is kept as the working solution.

4 Using the prevailing set of matching inliers, Autostitch determines the geometrical changes between images. This tells the program which pixels on the edge of one photo should be joined to pixels along the border of another photo. Doing so is likely to require distorting, twisting, and resizing of the pictures to overcome incongruities caused by perspective, random camera movements, and the characteristics of the camera's lens. Autostitch projects the stitched images onto a flat plane, but other programs, such as those that produce the 360-degree panoramas of family rooms and kitchens seen on real estate websites, wrap their stitchwork onto cylindrical or spherical surfaces.

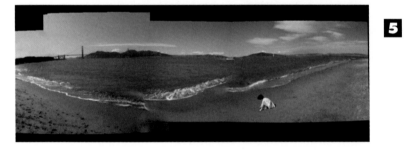

5 The regions where the pictures join are likely to have inconsistencies caused by different exposures, parallax errors, or people, clouds, or traffic present in one image but not another, producing **ghosts**, semitransparent or truncated objects. The ghost problem is solved by eliminating the person or other object creating the apparition.

6 Autostitch resolves differences in hue and brightness through **multi-band blending**. The program samples several pixels from a broad stripe at the photos' intersection, averages them, and repeats the process until the change is made gradually— and hopefully unnoticeably—from one image to the other.

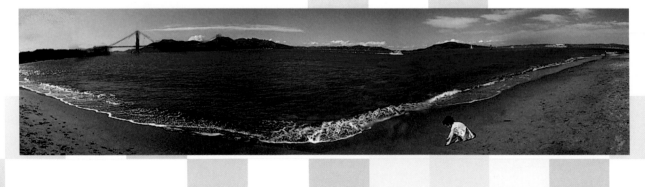

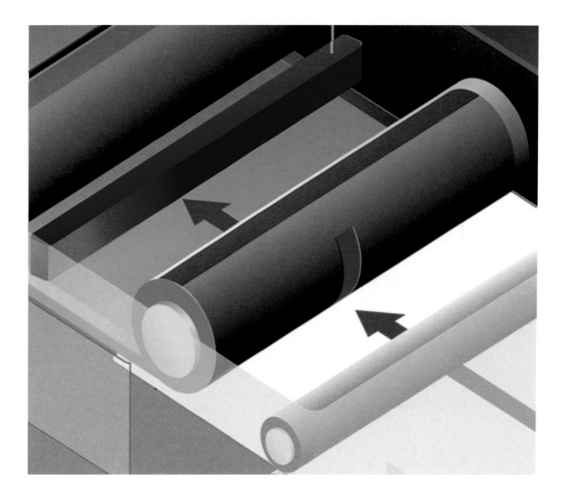

P A R T

4

How Digital Print-Making Works

C H A P T E R S

You don't take a photograph, you make it.

Ansel Adams

ANSEL Adams' fame rose from his photographs that captured the splendor of mountains, prairies, forests, and rivers in the still-pristine western half of the United States. His photographs of the Tetons and Yosemite, still best-sellers in posters and calendars, glow with what seems at times to be their own light. It's hard to look at Adams' photos without experiencing an emotional rush born of a purely aesthetic sense. And yet in his own approach to photography, Adams functions more as engineer than artist. As he created photographs, the reality before his cameras was not as significant as how he transformed that reality into a print he could hold in his hands.

In addition to creating the Zone system—covered in Chapter 5—to take guesswork out of exposures, Adams just as carefully formulated specific, predictable methods for creating prints. He would labor for hours in the darkroom on a single photo, and he was reported to say that he would be pleased if he produced but 12 good prints a year.

Although printing digital photographs with an ink-jet or dye-sublimation printer is a dog-leg departure in technology from Adams' own methods. I suspect he would have been a fan of photo editing software and the new machines for turning out photographs. Both provide the engineering controls needed to improve on the original photo and to achieve consistent results.

This is going out on a limb when you write about someone who is undisputed master in his field, but I wouldn't be surprised if today's ink-jet and dye-sub printers didn't fool Adams completely in their disguise as "real" photographs. The first color ink-jet printers produced graphics in which the dot matrices of color were painfully obvious. Hard copy coming out of photo printers today is free of those dots, produces color as faithfully as traditional methods, promises not to fade or change color for a century, and doesn't reek of darkroom chemicals.

But if you were never into the hidden mysteries and aromas of the traditional photographer's inner-most sanctum, fair warning: Photo printers can easily make a trip to the photo counter at the drug store seem like a privilege you will never again take for granted. The cruelest trick of the printer gods is that after you spend so much time with Photoshop trying to correct a shot of your daughter to banish the blue cast that's invaded her red hair, the picture churns out of your printer with the blue gone, only to be replaced by green. The more minor mischiefs the gods rain on us include paper too thick to feed through the printer, the need to keep track of eight or more ink cartridges, and the "Pyramid Paradox." The latter problem is this: Now that you have absolute control over every aspect of your prints, from tone to gloss to saturation, you will never be satisfied—you will tweak endlessly until all the discarded prints create a paper pyramid on the floor. A corollary of the Paradox is that after you shoot 300 pictures at the family picnic, you spend so much time on retouching one shot you're particularly fond of that you never get around to printing the other 299 despite the pleas of cousins and sisters-in-law.

It's such entanglements as these that have given hope to traditional photo processors, who are making it as cheap and easy as possible for you to give them your digital pictures. For the serious photographer who also is recruited regularly for his own family's picnics and parties, the best set up is a fast plug 'n' printer for churning out copies of every picture for everyone, and on the side a high-end, large format printer suitable for photographic masterpieces. After all, Ansel Adams was happy with only 12 really good prints a year.

CHAPTER

12

How Computers and Printers Create Photographs

In visual perception a color is almost never seen as it really is—as it physically is. This fact makes color the most relative medium in art.

Josef Albers

YOU don't get exhibited in the Guggenheim, as Josef Albers did, unless you know a little about color. But you don't have to know as much as Albers, who literally made a career out of painting the same squares different colors. To experience the capriciousness of color, all you have to do is twiddle with the controls for your computer monitor.

Turn off all the lights in the room, and call up the screen that lets you adjust brightness, contrast, gamma, and the amounts of red, blue, and green used to create all—remember that—*all* the colors of the universe. Now display any of several test screens for adjusting color. You'll find a good assortment on one of Norman Koren's pages (http://www.normankoren.com/makingfineprints1A.html) and at the Digital Dog (http://www.digitaldog.net/tips/index.shtml), where you'll also find an excellent collection of articles on all the pesky aspects of color. Adjust the screen so that what should look white looks as white as you can get it. You can use only your eyes and best judgment.

Now turn off the first monitor and if you have another monitor handy, hook it up and repeat the procedure. If you don't have a second computer monitor, try the screen on a laptop, even a TV—whatever you can find in place of the test screen. When you're done, put the two test screens next to each other, and turn them on. The chance of white looking exactly alike on both screens is about the same as that of photographing a masterpiece by running your delayed shutter timer and tossing your camera in the air.

The problem is this: Us. We humans have a remarkable ability to know what color something *should* be and then convince to ourselves that we see is what we think we should be seeing. Any photographer already knows about this. That's why there are different types of film for indoors and outdoors and white balance adjustments on digital cameras. Most photographers have by now accepted that trick of the universe and learned how to deal with it. The trouble is that digital camera image sensors, monitors, scanners, and printers each have their own alternate universe, although they're called something else: color spaces. A color space includes each and every hue, shade, and intensity that particular equipment can capture or reproduce. Of course, no one color space matches any other color space. A color space for just one device might not match itself over time. The color spaces change as phosphors fade, and paper yellows, and pigments settle. What it comes down to is this: If you want your photograph to display the same colors you saw when you snapped the picture or the same color on your screen when you Photoshopped it, check out this chapter to get an idea of all that's involved in making white white.

How a Camera's LCD Displays Photos

Long before your photo appears as a print, it has a brief life on a liquid crystal display (LCD) screen, either the small one on the back of most digital cameras or the larger screens on your laptop or desktop computer. LCD screens and their older, more cumbersome cousin, the **cathode ray tube (CRT)**, use different methods to produce the same three colors that blend into full-color pictures. But curiously, they don't use the same colors that photo-quality printers use. All color screens use red, green, and blue, which is why you'll hear them referred to at times as **RGB** displays. Printers use two off-shades of red and blue (magenta and cyan) and a standard yellow—at least to begin with. Now the more overachieving color printers are adding more colors and subtler hues to reproduce richer and more accurate color prints. We'll get to them in the next couple of illustrations. For now, let's look at your pictures on an LCD screen, whether on a desk or camera.

Light source

First polarizing filter

1 A fluorescent panel at the back of an LCD screen emanates a white, even light. Each light wave vibrates as light waves normally do, in all directions perpendicular to the direction it's traveling.

2 When the light waves hit a polarizing filter, most of the waves are blocked by the filter's microscopic structure, like the blades of a Venetian blind that let pass only those light waves vibrating in a specific direction. The polarizer has some leeway in the waves it permits through, which is why the LCD screen can produce different shades of red, blue, and green.

3 The polarized light next passes through a sheet made up of thousands of liquid crystals in a grid pattern. One of the properties of the crystals is that they twist when an electrical current passes through them, and the light rays follow the curve of the crystals. The stronger the current, the greater the distortion until some of the light waves leave the crystal panel vibrating 90° from their original orientation.

4 The light passes through sets of red, green, and blue filters grouped together to form colored pixels.

5 Light waves from the different cells—some still vibrating in their original orientation, some turned 90°, and the rest twisted at some point in between—encounter a second filter mounted so it polarizes light in an orientation 90° from the direction of the first filter. Light that underwent a full 90° twist passes through the second filter completely to create a dot of red, blue, or green. Light waves that were not distorted at all are blocked totally, producing black dots. All the other rays of light, being twisted to varying degrees, pass through the second filter partially, producing some greater or lesser shade of color. Our vision perceives the colors of the adjoining light rays as a pixel of one color from the thousands this method can create.

Liquid crystal layer

Second polarizing filter

Protective cover

How Colors Are Created

In digital photography, two totally different ways of creating color blend into one another so seamlessly that it seems as if some master painter—and joker—must be at work. At one end of the spectrum, so to speak, the colors on your computer monitor, on your camera's LCD screen, on your TV, and in the movies are all created using light. At the other extreme, the colors in this book, on billboards, on cereal boxes, and in photograph prints are created with paints and dyes and pigments in an entirely opposite process. Yet most of the time, anyway, color moves from one medium to another with grace and beauty.

1 All the colors we perceive come to us through light, more specifically through various wavelengths we see as the different colors in the spectrum. The spectrum we see when a prism breaks up white light is a seamless infinity of hues. We can reproduce not all, but most, of those colors using only three of them. (The ones we cannot reproduce are never missed.)

2 Color created by the joining of differently colored lights is called **additive color**. The colors add to each other's capacity to produce light. If you shine a red light on a white surface and then shine a green light on the same area, the two colors join forces to create a third color: yellow. If you then shine a blue light on the intersection of red and green light, the three together produce a white light. Those three colors have added up to white, the total of all light in the visible spectrum. Red, green, and blue are the colors used in a monitor, a TV, or any device that *shines* light to create color and images, giving us the **RGB** (**r**ed, **g**reen, **b**lue) standard.

3 When two colors are mixed together in the form of an ink, a paint, a powder, or a pigment, they subtract from each other's capability to **reflect** light. They form **subtractive color** because each color absorbs (subtracts) a part of the spectrum found in white light. The more colors in the mix, the more colors deducted from the light reflecting from whatever the mixed colors are used on until the mixture becomes black and reflects no color at all.

4 In conventional color printing, four colors are used to produce the rainbow of the spectrum under a scheme called **CMYK**, for **c**yan (a blue-green), **m**agenta (a purplish red), **y**ellow, and blac**k** (B is already taken by blue). These are the colors used on all printers, although some printers designed especially for photo printing now have other colors, such as green and light shades of pink and blue to increase their **gamut**, or the range of colors they can produce.

5 Photo printers create images by one of two ways. Some lay down tiny dots of ink thickly or thinly, depending on how dark a shade they need to reproduce. The printers might employ different patterns of dots called **dithering** to disguise the fact that a color is changing from one shade to another. The newest inkjet printers are capable of varying the sizes and shapes of the dots they produce to more effectively produce gradations and shades of color. Other printers produce **continuous tone**, which more closely resembles airbrush work in that there is no perceptibly abrupt change from one color to another.

Diffusion dither

Pattern dither

Noise dither

Continuous tone

6 To mix inks to create different colors, a continuous tone printer lays down its inks or dyes on top and overlapping one another. In conventional color printing (such as a printing press) and in most types of laser printing, CMYK inks and toners can't be varied continuously in an image. Instead, the printer usually simulates the color variations with **halftoning**. It prints CMYK ink dots of varied sizes in overlapping grids that are laid out at different angles so all the dots don't print directly on top of each other. The always accommodating human eye completes the job of blending the dots into a single perceived color.

How Color Calibration Works

It might be true that a rose is a rose is a rose. But a red rose is not a red rose is not a red rose. Although there are only seven basic colors in the spectrum, there are so many shades and tones that the number of colors the human eye perceives quickly jumps into the quadrillions. Needless to say, at least a few million of them are some variation of red. The trouble is that none of the hardware used in digital photography—cameras, scanners, LCD screens, CRT monitors, printers, and projectors—can capture or display all those colors. At best, most equipment can work with four billion colors. The problem is that the billions of colors your monitor can display are not necessarily the same billions of colors your printer can produce. That's why a photograph that looks dead-on perfect on your screen comes out of your printer murky and off-color. It's the job of **color calibration** and **color profiles** to ensure a red from your scanner is a red on your monitor is a red on a print.

1 Each device that produces or measures color has its own **color space** based on the inks, dyes, pigments, phosphors, lights, filters, and other colored materials that are intrinsic to how the device handles color. None of these color spaces match the others' precisely, not even two identical monitors of the same model and maker. Over time a device's color space might not even match itself. Phosphors decay, inks fade, and even the changing temperature of the day can alter the color space of some hardware.

VISIBLE LIGHT SPECTRUM

- MONITOR (RGB) GAMUT
- FILM GAMUT
- PRINTER GAMUT

2 As a result, colors can change unpredictably as a graphic works its way through the production process. The solution is to **calibrate** all the graphics hardware so their results are consistent.

3 Because the human eye and perception are notoriously unreliable, most color calibration systems use a **colorimeter**, a device that measures the intensity and color of light. The colorimeter is placed on a computer screen while accompanying software displays specific shades of gray, blue, red, and green. (It can be used with TVs and other color sources, as well.)

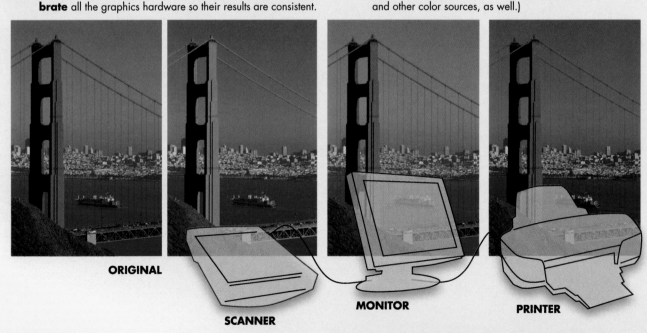

ORIGINAL **SCANNER** **MONITOR** **PRINTER**

4 On the side of the colorimeter facing the screen are three to seven **photon counters**, similar to light meters. The counters are set into walled cells to prevent them measuring ambient light from the sides.

5 If the colorimeter is being used with an LCD screen, light from the screen first passes through a filter that removes ultraviolet light that the photon counters would otherwise have added into their count hits, inflating their readings. On a cathode ray tube (CRT) monitor, the thick glass at the front of the display absorbs the ultraviolet.

6 After the light is evenly spread out by passing through a **diffuser** made of a material that could be mistaken for a plastic milk jug, it passes through the **color filters** mounted above each photo counter. The seven filters roughly correspond to the main divisions of the visible spectrum: red, orange, yellow, green, blue, indigo, and violet. The software switches the color on the screen among red, blue, and green to give the meter a chance to gauge each color.

7 A microprocessor in the colorimeter converts the counters' readings for red, green, and blue into digital values on the scale of the color space the meter uses. A color space lets any color be defined by a set of three numbers called the **tristimulus values**.

8 The software uses this information to adjust the monitor's settings so it has the widest possible ranges for the three colors (RGB). If the monitor cannot be controlled by the software, the program turns to the video card, tweaking the controls that send color signals to the monitor.

Suction cup

9 Finally, the software writes a file that contains the monitor's **color profile**. This is simply a short record of the color space values for a few key colors the monitor can produce. This information can be used by scanners, printers, cameras, and other devices to adjust their colors to match those of the monitor. Because the color values are different for different devices, color matching is not perfect.

Color Calibration on the Cheap
Color calibration systems that include a colorimeter cost at least $100. You can take a software-only approach for free. PPTools provides a free printable color chart and software to calibrate a monitor (http://www.pptfaq.com/FAQ00448.htm). Monitor Wizard 1.0 is freeware that also does the job (http://www.hex2bit.com/). How well do they work? If they were perfect, they wouldn't be free. They all require your perceptions, which are subjective. In my opinion, the best software-only tool for monitor measurement and maintenance is Display Mate (http://www.displaymate.com/). It costs about $70, but in addition to calibrating, it lets you test every aspect of your display.

CHAPTER

13

How Photo-Quality Printers Work

For me the printing process is part of the magic of photography. It's that magic that can be exciting, disappointing, rewarding and frustrating all in the same few moments in the darkroom.

John Sexton

A QUARTER of a century ago, when I started writing about computers, a magazine sent me a couple of machines to test and write about. They were called "plotters." At the time, they were the peak of technology when it came to computers printing anything other than text.

Each plotter filled a table, and they were a wonder to behold. I clamped in place a large sheet of paper on one of the plotter's broad, flat beds. It took me about an hour to get the plotter and my computer to talk to each other, but when they got their acts together, *zowee!* A mechanical arm moved to one of several ink-filled pens lined up on one side of the plotter's bed. Servos clamped the tip of the arm shut about the pen, pulled the pen from its holder, and whined and growled as they pushed the arm back and forth over the paper. It drew with the boldness and certainty of an artist who knows exactly what he wants down to the tenth of a millimeter. Suddenly the arm would rush back to the sidelines to exchange one pen for another and add strokes of another color to the emerging art work. For all this rushing around, completing a drawing could take an hour, which was fine because watching the creation of the artwork was always far more interesting than the finished artwork itself.

Plotters, welcomed at the time by architects and draftsmen, were not destined to be the tool that took computers into the brave new world of digital graphics. They were too slow and lacked any subtlety in their pen strokes. The only other output devices for color graphics at that time were crude printers with multi-colored ribbons, marketed to schools and children.

Color graphics printing and photo printing went mainstream with improvements in the ink-jet printer. The first ink-jets, with only three or four colors printing on common paper, were hardly fit for photos. Photographers owe a debt to Canon and Epson—later joined by Hewlett-Packard—for pursuing a goal of better and better ink-jet printing that has come to rival traditional photo printing. They did this at a time when there were no guarantees many people would ever care. Now they're the method of choice for creating prints, not only for the amateur photographer, but the pro as well. The promise of inexpensive, versatile photography through digital cameras would never have come true without the appearance of this unbidden blessing.

How a Printer Rains Ink to Create a Picture

Once considered little more than a toy for home PC users who wanted to play with graphics programs, the inkjet printer has come into its own as a serious tool for serious photographers. Where once photos from an inkjet were crude and quick to smear and fade, improvements have made some inkjet photos indistinguishable to the naked eye from a traditional print—and without the smears and fading.

1 Inkjet printers use one or more **cartridges** filled with different colors of ink in different reservoirs. The cartridges are locked into a **print head**. (Some printers combine cartridges and the print head as one unit.) The print head travels back and forth on a sturdy metal rod and spits colored inks onto a sheet of photo paper that the printer has grabbed from a stack and pushes beneath the print head.

3 Inkjet printers produce dots of color so small we don't even call them drops of ink. They're **droplets**. Droplets are measured in **picoliters**— 1/1,000,000,000,000 of a liter. That's smaller than the human eye can see. Droplets, such as those shown in this hugely magnified scan, range from 1 to 10 picoliters.

2 Some printers strive to create larger **gamuts**— the total range of colors they can produce—by including additional color inks, such as green and lighter shades of blue and red. A few printers accept cartridges that contain nothing but black and shades of gray for photographers who specialize in black-and-white photography.

1200% aliased

1200% antialiased

4 Droplets are so small, in fact, that it is only when they are combined that we have something big enough to measure in **dots per inch (dpi)**. All current-model inkjet printers can create at least 300dpi printed graphics, which is not fine enough to avoid such artifacts as the **jaggies**—also called **aliasing**—the stair-step edges you find along edges that should be smooth and straight.

5 The more dots that go into creating a photo, the sharper the details and the more it approaches the resolution of a good traditional photograph. The current state of the art is 9,600dpi, although that's likely to be only for black. A more common top resolution for color is 4,800dpi.

ginal image

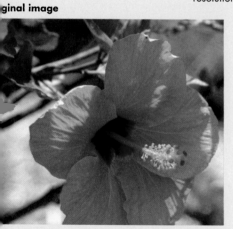

11 megapixel image 100%, 300dpi

6 megapixel image 100%, 300dpi

3 megapixel image 100%, 300dpi

How Photo Inkjet Printers Work

Inkjet printers vary the sizes of their droplets using one of two technologies to shoot ink out of their print heads. Hewlett-Packard, Lexmark, and Canon use **thermal nozzles**, whereas Epson uses proprietary **piezoelectric nozzles**. Both suck ink from the cartridges into their **firing chambers** and shoot the ink through scores of openings on the bottom of the print head that are too small to see.

Thermal Nozzle

1 When the printer sends an electrical current through a resistor built in to one of the walls of each of the nozzles, the resistor generates enough heat to boil the ink and create an air bubble.

2 As the bubble expands into the firing chamber, it creates pressure in the ink until the pressure is strong enough to overcome the surface tension holding the ink inside the nozzle. A droplet with a size between 6 and 10 picoliters bursts out of the nozzle to create a colored dot on the paper traveling beneath the print head.

3 At the same time, current to the resistor turns off, quickly cooling the resistor. A partial vacuum forms in the firing chamber, causing a new supply of ink to rush in from the cartridge to arm the nozzle for another firing. Heating the ink to higher or lower temperatures causes larger or smaller droplets to fire.

Piezoelectric Nozzle

1 The walls of a piezoelectric nozzle are made of **piezo**, a crystalline substance that bends when electricity passes through it. When current passes through one way, the walls expand, drawing in ink from the cartridge's reservoir.

2 When the printer suddenly reverses the current's direction, the walls contract, squeezing out a droplet of ink.

3 By varying the intensity of the current, the printer changes how much the piezo wall flexes. That, in turn, changes the size of the droplet, which typically ranges from three to four picoliters. That is equal to about one-fourth the diameter of a hair and is at the boundary of resolution for the human eye. Generally, the droplets from piezo-electric inkjet printers are smaller than those from thermal inkjet printers.

Dyes Versus Pigments

1 Inkjet inks consist of a **carrier fluid**, usually deionized water, that keeps the ink in a liquid state and is a vehicle for a **colorant**, which gives the ink its particular color. The ink also contains a **drying agent** such as isopropyl alcohol or glycerin that controls the ink's drying time. The colorant is the most distinguishing component of ink. It can be either a dye or pigment.

Pigments are extremely fine, colored powders suspended throughout the carrier fluid. Because they're not dissolved, pigments have a natural tendency to settle out over time. To combat this, the pigment particles are coated with a polymer substance that generates a static charge about the particles to keep them from forming large clumps that settle to the bottom sooner.

If the colorant is a pigment, the deposit consists of relatively large particles forming a rough layer of color lying on top of the paper. The thickness of the dried ink makes it less susceptible to bleeding and wicking on the paper fibers, which gives fine details an unwanted fuzzy quality.

2 After the ink is deposited on paper, the carrier and drying agent evaporate, leaving the colorant on top of or absorbed into the paper.

Dyes dissolve completely into the carrier fluid, forming a true solution. Once dissolved, the dye should never separate or settle out.

The dye dries to a smoother surface that is brighter and capable of a wider gamut of colors. The dyes are, however, still water soluble, and they easily smear or bleed. Dye inks also tend to fade unevenly, a failing that is overcome by applying an overcoating (or special laminate) that blocks ultraviolet rays, and by storing or displaying photos away from sunlight and heat.

Paper

Fiber absorption

Wax or varnish

Uncoated paper—the type commonly used with laser printers and copiers—has an uneven surface that scatters the light, creating a duller finish. It also has no barrier to prevent the ink carrier or dye from being absorbed into the paper and spreading out through porous fibers, which can make the colors look muddy and the details fuzzy. A high-grade matte finish photo paper also dulls the photograph but is more resistant to absorption.

Coated paper—covered in a layer of fine varnish or wax—has a smooth surface on which ink lies more evenly, reflecting light so that ink takes on an added brilliance. The coating also stops the ink being absorbed into the paper, which helps to make the image look sharper. Ceramic-coated porous papers absorb inks quickly, but the ceramic coating leaves dyes exposed to light and gases, making them more prone to fading and discoloration. Plastic-coated, swellable paper encapsulates both pigments and dyes when they seep into the paper's fibers, helping protect them from light and air.

Matched Sets

Printer manufacturers recommend specific papers for their printers. Although the recommendations suspiciously tend to favor papers they make, this is one time when you should believe them. Inks and papers that have been created to work well with each other usually do produce richer, more stable photographs than unrelated inks and papers forced into service with one another.

How Dye-Sublimation Printers Work

Of all the types of photo printers, there's no argument: The printer that turns out pictures looking the most like they're hot off the automated printer at the drug store is a **dye sublimation** printer. You don't often hear it called that, of course, because it sounds like techno-gobbledygook. It could be something one might do to suppress the urge to color one's hair. In fact, the name does reflect a process that people encounter so infrequently, it's no wonder so few people know what dye sublimation means. Well, now you have the opportunity to join the ranks of the photorati and to regale others at the next gathering with insights into the wonders of dye sublimation **(dye sub)**.

 1 Although a few dye-sub printers are capable of producing 8" × 10" photos, most of these printers are designed to turn out the 4" × 6" or 5" × 7" prints that are the standard size for nonprofessional photo fans. The printers themselves are smaller, usually no bigger than a thick hardcover book. Dye-sublimation printers accept digital photos from a variety of sources—a USB cable from a PC, a built-in card reader where the photographer can insert a flash memory card filled with the latest shots, or from a cradle where the camera is inserted for minimum hassle.

2 Because the computer is so easily squeezed out of the entire process, the dye sub is likely to have a small LCD screen and controls that let the photographer see rough images of the photos and choose which ones to print. Although not as versatile as working with an application such as Photoshop on a computer, the controls usually allow rudimentary adjustments such as exposure, color correction, and cropping.

Printhead

8 The gases produce no dots of ink with clear demarcations. Each layer of dye blends evenly with the layer before it, producing **continuous tone** images that are otherwise found only in traditional photographs.

7 After all the paper has passed under the print head for one color of dye, the paper train reverses direction and takes the paper back to the start, where it moves in unison with a second coat. This repeats until the four printing colors have transferred to the paper.

3 A microprocessor accepts the digital data that make up the photograph, along with any instructions generated at the onboard controls. The processor applies the changes to the photo data. It might, for example, add an equal value to each of the digital pixels to lighten the photograph. With the adjustments made, the processor translates the color information from the pixels into mixtures of cyan, magenta, yellow, and black needed to reproduce the digital picture.

USB

Memory card

4 A paper feeder draws a small sheet of photo paper from a stack and starts it traveling down a **paper train** of rollers that keep the paper moving at a steady pace.

6 The dye-covered film and the photo paper pass beneath a **print head** made of hundreds of tiny heating elements poised fractions of an inch above the traveling roll of dyed film. (This stage is why dye subs are sometimes called **thermal printers**.) The microprocessor, armed with its digital description of the photograph, sends bursts of electricity to the heating elements. They instantly soar to precise temperatures. The heat causes the dye to sublimate, changing it from a solid to a gas without going through the normal, intervening liquid stage. The clouds of dye fall on the photo paper and solidify instantly. Depending on how hot the heating element becomes, the cloud of dye gas produced is smaller or larger, allowing the printer to produce subtle tones.

Printhead

Color film

Heat

Paper

Sublimated ink

5 The train takes the paper beneath the path of a long roll of thin film that is coated with repeating rectangles of black, yellow, cyan, and magenta dyes in a solid form. Rollers keep the film moving in precise step with the paper.

Glossary

A

aberration A distortion in an image caused by a flaw in a mirror or lens.

achromatic color A color with no saturation, such as light gray.

acquire A software menu selection to scan from within the program (if it is TWAIN compliant).

ADC (analog-to-digital converter) A device that measures electrical voltages and assigns digital values to them.

Airy disc A disc of light caused when a pinpoint of light is diffused to form concentric halos about the original point.

aliasing The noticeable repeated patterns, lines, or textures in any photographed or scanned subject that conflict with the pattern of an electronic sensor's pixel arrangement. For example, diagonal lines represented by square pixels will produce jagged lines.

analog The measurement and recording of continuously varying values in the real world, such as sound, light, and size. The measurements correspond proportionally to other values, such as electrical voltage. Film cameras are analog devices. **See also digital**.

anti-shake One of several technologies to counteract the movement of a lens and the resulting blurring of a photo.

antialiasing A technique of blending variations in bits along a straight line to minimize the stair-step or jagged appearance of diagonal edges.

aperture The lens opening through which light passes, expressed by a number called the f-number (or f-stop). Typically, f-stops range from f-2 through f-32, although many lenses don't reach the extremes on either end. Each higher number represents an opening half the size of the previous number, with f-2 being the largest opening and f-32 the smallest. The aperture is one of the key factors in an exposure setting.

array A grouping of elements, such as the rectangular array of photodiodes that make up the digital film that captures an image.

artifact An unwanted pattern in an image caused by the interference of different frequencies of light, from data-compression methods used to reduce the file size, or from technical limitations in the image-capturing process.

aspect ratio The ratio of length to width in image sensors, computer displays, television screens, and photographic prints.

autofocus A lens mechanism that automatically focuses the lens by bouncing an infrared light beam or sound waves off the subject matter or by measuring the contrast in a scene. Some cameras use a combination of methods.

automatic exposure A camera mode that adjusts both the aperture and shutter speed based on readings from a light meter.

automatic flash An electronic flash that measures the light reflected from a subject, varying the duration and intensity of the flash for each exposure.

available light All the natural and artificial light a photographer uses, short of light provided by flash units. Or as one photographer put it, all the light that's available.

B

back-lit or back-lighting A setting that illuminates the subject from behind.

banding Areas of color that show no differentiation except to change abruptly from one color intensity to another so that what should be a gradual change of color is marked by noticeable bands of color.

Bayer pattern, Bayer matrix A distribution of red, green, and blue filters on an image sensor that provides twice as many green filters as red and blue because of the eye's sensitivity to shades of green.

bit depth The number of bits—0s and 1s in computer code—used to record, in digital image situations, the information about the colors or shades of gray in a single pixel, which is the smallest amount of information in a graphic image. The smaller the bit depth number, the fewer tonal values possible. For example, a 4-bit image can contain 16 tonal values, but a 24-bit image can contain more than 16 million tonal values.

bitmap An image represented by specific values for every dot, or pixel, used to make up the image.

black noise Also known as dark current, it is the signal charge the pixel develops in the absence of light. This charge is temperature sensitive and is normal in electrical image-sensing devices.

bleeding The color value of one pixel unintentionally appearing in the adjacent pixel or pixels.

blooming The bleeding of signal charge from extremely bright pixels to adjoining pixels, oversaturating those adjoining pixels. Masks or potential barriers and charge sinks are used to reduce blooming.

BMP file A Windows file type that contains a bitmapped image.

borderless printing A printing technique, offered on some photo printers, that prints photos from paper's edge to paper's edge, without leaving a white border.

bounce flash Light bounced off a ceiling, wall, or other surface to soften the light hitting a subject and eliminate the harsh shadows that often result from a flash aimed straight at the subject.

bracket A burst mode that, as a safety precaution, shoots extra exposures that are normally one f-stop above and below the exposure indicated by the light meter reading.

brightness One of the three dimensions of color—hue, saturation, and brightness. Brightness is the relative lightness or darkness of a color, ranging from 0% black to 100% white. **See also hue and saturation**.

burst mode The capability of a camera to take several pictures one after another, as long as the shutter button is depressed or until the memory buffer is full. The size of the memory buffer and the speed that the camera writes the data to a memory card determine the burst rate.

C

calibrate To adjust the handling of light and colors by different equipment, such as cameras, scanners, monitors, and printers, so the images produced by each are consistent to a defined standard of brightness, hue, and contrast.

catchlight Light that reflects from a subject's eyes and adds life to the portrait.

charge-coupled device (CCD) An image sensor made up of millions of photodiodes, which are transistors that convert light energy to electrical energy and transmit the electrical charges one row at a time.

chroma A quality of color combining hue and saturation.

circle of confusion Points of light focused by the lens into discs of light. The smaller the circles of confusion (the discs), the sharper the image appears.

clipping The loss of color information above or below certain cutoff values.

CMOS image sensor An image sensor similar to a CCD but created using CMOS technology. CMOS stands for complementary metal-oxide semiconductor.

CMYK (cyan, magenta, yellow, black) Often called process color; a color model used to optimize images for printing in which all colors are produced by combinations of these four colors. Inkjet, laser, dye-sublimation, thermal wax, and solid ink printers use CMYK as their primary colors. This creates a color-management problem on computers because converting the native colors of computing—red, green, and blue—to CMYK files causes color shifts.

color, additive The creation of colors in cameras, monitors, and scanners by combining the effects of pixels colored red, blue, and green, usually referred to as RGB. **See also color, subtractive**.

color, subtractive A system such as printing that creates colors by combining the absorption capabilities of four basic colors: cyan, magenta, yellow, and black. **See also color, additive**.

color balance The overall accuracy of the hues in a photograph, particularly with reference to white.

color depth The number of bits assigned to each pixel in the image and the number of colors that can be created from those bits. **See also bit depth**.

color fringing A digital-imaging artifact caused when color-filtering arrays or patterns of photodiodes on image sensors conflict with visual information in a scene, causing discolorations along the edges of some objects.

color intensity The brightness of a printed image controlled by the amount of ink applied to the page; lighter images use less ink and darker images use more.

color management system (CMS) Software utilities to calibrate color on input and output devices like displays, printers, and scanners. Color management systems control the accurate conversion of colors from RGB to CMYK.

color temperature The warmth or coolness of light, measured in degrees Kelvin (K). Midday daylight is about 5,500K. Light bulbs are about 2,900K, meaning they're more orange or warm. Color temperature is important to color balance.

CompactFlash memory Based on Personal Computer Memory Card International association (PCMCIA) PC card specifications, CompactFlash measures 43mm × 36mm and is available with storage capacities exceeding 8GB. Currently, the competition among CompactFlash makers is to produce cards that do a faster job of writing (saving) and reading (retrieving) data. Speeds are expressed as a multiple of basic speed of the original CompactFlash (1X). Current speeds read as much as 150X.

compression, lossless A file compression scheme that makes a file smaller without sacrificing quality when the image is later uncompressed. Zip and GIF files use lossless compression.

compression, lossy A file compression scheme that reduces the size of a file by permanently discarding some of the visual information. JPEG is the most common lossy compression format for graphics.

compression ratio The ratio of the size of a compressed digital file to the original uncompressed file. Ratios between 15:1 and 8:1 are the most often used in digital cameras. Highest quality ratios are less than 5:1, non-lossy compression is 2:1 or less.

continuous tone An image, such as a film photo, that has a gradual range of tones without any noticeable demarcation from one to the other.

contrast The difference between the dark and light areas of an image.

cropping An image editing technique that removes parts of the photo along the sides to eliminate unwanted details.

D

demosaic An algorithm used to fill in missing color information from an image captured by a camera's mosaic sensor.

density The capability of a color to stop or absorb light; the more light absorbed or the less light reflected, the higher the density.

depth of field The area between the nearest and farthest points that are in focus through a camera lens. Depth of field increases at smaller lens apertures.

Design Rule for Camera File System (DCF) An industry standard for saving digital images. This not only determines the file type, but also sets the rule for naming the folder and file structure. It allows the conversion of uncompressed TIFF files into compressed JPEG files.

diaphragm (Also **iris**.) A mechanism located in a lens that controls how much light passes through the lens. It is typically made of overlapping, interlocked *leaves* that form a roughly circular opening in the center of the diaphragm. When the exposure ring on the lens is twisted, the leaves contract or expand to allow more or less light through. **See also shutter**.

diffuser A translucent plastic or cloth placed between a flash and the subject. The diffused light softens shadows and contrast.

digital The measurement and recording of continuously varying values such as sound and light by frequently sampling the values and representing them with discrete numerical values, usually expressed as binary numbers. **See also analog**.

dithering The process of creating different colors by placing dots of ink coloring near each other in different combinations to create the illusion of other colors.

dots per inch (dpi) A measurement of resolution used for scanning and printing.

dye-sublimation printer The printing system that transfers colors from ribbons containing dyes that are heated and fused onto paper. Dye-sublimation printers are continuous-tone printers capable of producing photographic quality images.

dynamic range The range of the lightest to the darkest areas in an image. Its value is expressed as the ratio of contrast, tonal range, or density in an image between black and white. The number 0.0 represents white, and 4.0 is black. A flatbed scanner may have a dynamic range of 2.4–2.7 whereas a drum scanner may be as high as 3.6–3.8. The numeric ranges express the capability of the devices to record and reproduce the range of grays between black and white. The higher the number, the greater the detail in shadows and highlights in an image. Film is generally given a dynamic range of 4.0; most digital cameras and scanners range from 2.4–3.0. Dynamic range may also refer to the ratio of the maximum signal level a system can produce compared to its noise, or static, level. Also known as *signal-to-noise* ratio. **See also histogram**.

E–F

entrance pupil A virtual representation of a lens's aperture opening, the entrance pupil is a measure of the angles that light will take on its passage through the aperture. It is of more practical consideration in the shooting of panoramic photos, which are often taken as several shots using a camera that pivots to take in the wide vista that is later pieced into a single wide photograph. A hazard in panoramic photos is parallax error, caused when the camera does not pivot correctly about its center of perspective. The error can cause an object as immobile as a fence post to appear twice in the same photo, seemingly in different positions. To avoid parallax error, the camera must pivot on its center of perspective, which coincides with the entrance pupil. (Writings on panoramic photography often erroneously identify the center of perspective as a lens's nodal point.) **See also panorama and nodal points**.

EXIF (exchangeable image file) A file storage format used for images on flash memory cards and digital cameras. EXIF files contain either JPEG compressed files or uncompressed TIFF files along with extensive information about a camera's settings when a photo was taken.

exposure The amount of light used in a photograph, based on the aperture and how long the shutter stays open.

exposure compensation The capability to automatically change exposure by one or more stops to lighten or darken the image.

filter A mathematical formula applied to a digital image. Most image editors offer filters to correct flaws in exposure, color, sharpness, and other blemishes. **See also plug-in**.

fish-eye lens An extremely wide-angle lens that can take in a view as wide as 180°. The result is often a circular image.

fixed focus A lens made to permanently focus on the most common range, from a few feet to infinity. The focus is usually not as sharp as that obtained with a variable focus lens.

flash A short, brilliant burst of light.

flash, fill Flash used to fill shadows caused by overall bright lighting.

flash, high-speed In ordinary flash photography, the flash is synchronized to fire when the first shutter curtain is fully open and before the second curtain starts to close. High-speed sync extends the flash duration, making flash synchronization possible when using fast shutter speeds that form a slit between the first and second curtains when they are opening/closing simultaneously.

flash, modeling A longer flash fired before photographs are taken to determine how the placement of the flash will affect light balance and shadows.

flash, multiple A lighting setup using several flash units that may be wired to the same camera, or that are activated by radio signals or by the burst of light from a central flash gun.

flash, pre- (preflash) A low-output flash fired before the main flash to measure the distance to the subject and to calculate how the main flash should be fired to create a correct exposure.

flash, slave A flash unit that fires in response to the firing of a master flash unit.

flash, slow-sync mode To better expose in a night shot the background beyond the range of a flash unit, slow-sync holds the shutter open long enough to capture more of the background before firing the flash to expose the main subject in the foreground.

flash, stroboscopic A series of individual flashes fired quickly while the shutter is open, capturing multiple exposures on a single frame. Stroboscopic flash is effective for capturing movement against a dark background.

flash, x-sync An electrical setting that makes the flash fire when the shutter is fully open. In SLR cameras equipped with a focal-plane shutter, the x-sync speed is the fastest shutter speed at which the first and second shutters are fully open.

flash exposure compensation A flash unit adjustment that changes the amount of light the flash provides to fine-tune the balance between foreground and background exposure.

flash memory card A card containing chips that store images using microchips instead of magnetic media.

flash synchronization Firing of the flash as the shutter curtains open and close so that the scene will be evenly lit.

focal length The distance, in millimeters, from the optical center of the lens to the image sensor when the lens is focused on infinity. Also defined as the distance along the optical axis from the lens to the focal point. The inverse of a lens's focal length is called its power. Long focal lengths work like telescopes to enlarge an image; short focal lengths produce wide-angle views.

focal point The point on the optical axis where light rays form a sharp image of a subject.

focusing Adjusting a camera's lens system to bring the subject into sharp view.

formatting Completely erasing and resetting a camera's memory card so that it can accept new photos.

G–H

gamma A mathematical curve created by the combined contrast and brightness of an image, which affects the balance of the middle tones. Moving the curve in one direction makes the image darker and decreases the contrast. Moving the curve in the other direction makes the image lighter and increases the contrast. The blacks and whites of an image are not altered by adjusting the gamma.

gamma correction Changing the brightness, contrast, or color balance by assigning new values to the gray or color tones. Gamma correction can be either linear or nonlinear. Linear changes affect all tones, non-linear changes affect limited areas tone by tone, such as highlights, shadows, or mid-tones.

gamut The range of colors a device captures or creates. A color outside a device's gamut is represented by another color that is within the gamut of that device.

GIF (Graphics Interchange Format) A compressed image format. GIF was the first commonly used image format on the Web, but it has been largely replaced by JPEG.

gigabyte (GB) A unit of data equal to 1,024 megabytes.

grayscale At least 256 shades of gray from pure white to pure black that represent the light and dark portions of an image.

guide number A number keyed to the amount of light a flash emits. The number, divided by the aperture setting, provides the distance to the subject for the optimum exposure. Divided by the distance to the subject, the number yields the correct aperture setting.

histogram A graph showing the distribution of light and dark values throughout a photograph, roughly equivalent to a photo's dynamic range.

hot shoe A clip on the top of the camera to which you can attach a flash unit; it includes an electrical link to synchronize the flash with the camera.

HSB The color model that most closely resembles the human perception of color. It is made up of 160,021,403,206 colors.

hue One of the three dimensions of color. (The others are saturations and brightness.) Hue is the wavelength of light reflected from or transmitted through an object, seen in the visible spectrum. Red, yellow, blue, and so on are the names of the hues. **See also brightness and saturation**.

I

IEEE 1394 A personal computer port capable of transferring large amounts of data at high speeds, often used to upload graphic and video files. It's known as i.Link on Sony systems and FireWire on Apple computers.

image editor Software to edit and modify digital images. With an image editor, you can add special effects and fix certain composition problems, as well as add new elements to the image.

image sensor A microchip that records images by converting the scene's light values into an analog electrical current that travels to a memory chip to be recorded as digital values.

intensity The amount of light reflected or transmitted by an object, with black as the lowest intensity and white as the highest intensity.

intermittent flash Simulating a longer-lasting flash by repeatedly firing the flash unit(s) at high speed. Intermittent flash is used for high-speed sync and modeling flash.

interpolation A process used in digital zooms and digital darkrooms to enlarge images by creating the new pixels. This is done by guessing which light values they should have based on the values of the original pixels in the image that would be next to the new ones. **See also zoom, digital and zoom, optical**.

interpolation, bicubic Two-dimensional cubic interpolation of pixel values based on the 16 pixels in a 4- × 4-pixel neighborhood.

interpolation, bilinear An enlargement in output pixel values is calculated from a weighted average of pixels in the nearest 2 × 2 neighborhood.

interpolation, nearest neighbor An enlargement by copying pixels into the spaces created when the original pixels are spread apart to make a bigger image, just like film grains under an enlarger.

ISO Named after the organization that defined this standard, it's a numerical rating that indicates the relative sensitivity to light of an image sensor or photographic film. A higher ISO number represents a greater sensitivity to light and requires less exposure than a lower ISO number does.

J–K–L

jaggies The stair-step effect in diagonal lines, or curves that are reproduced digitally.

JPEG Also known as JPG and .jpg, it's a popular digital camera file format that uses lossy compression to reduce file sizes. It was developed by the Joint Photographic Experts Group.

JPEG-2000 A JPEG compression standard that uses a totally different approach to compression to obtain a higher compression ratio without losing image quality. Created specifically for digital cameras and imaging software, it was supposed to become the new standard starting in 2001, but it is still far from universal among digital cameras. A JPEG-2000 file typically has an extension of .jp2.

lag time The time between pushing the shutter button and when the exposure is made by the camera.

LCD A liquid crystal display is the most prevalent technology used on digital cameras to view and preview digital photos.

lithium-ion batteries A long-lasting, rechargeable battery technology used in digital cameras; lithium is the lightest metal and has the highest electromechanical potential.

long lens A telephoto lens.

lossless **See compression, lossless**.

lossy **See compression, lossy**.

M

macro mode A lens mode that allows focusing on objects only inches away.

main flash The flash fired after the preflash when the shot is actually taken.

megapixel An image or image sensor with about one million pixels.

memory card (Also **flash memory**.) A removable microchip device used to store images by most digital cameras. Unlike a computer's RAM, this card retains data even without electricity. Six main types of memory cards are in use today: CompactFlash, SmartMedia, Secure Digital, Memory Stick, Multimedia Cards (MCC), and xD Picture Cards.

memory card reader A computer component or an attachment that reads the image data on a card and sends it to the computer.

Memory Stick A flash memory storage device shaped like a stick of gum, developed by Sony, that can hold up to 8GB of data.

metering, autoflash Measurement of light that occurs when a light sensor meters the light reflected by a subject after the flash begins firing. The flash output is then controlled instantly so that the subject is exposed properly.

metering, center-weighed A light reading that emphasizes the intensity of light reflected from objects in the center of the viewfinder's frame.

metering, matrix A light meter reading produced by reading the light from several areas throughout the frame.

metering, spot A light reading taken of a narrow area, smaller than that used in center-weighted metering, usually in the center of the frame.

midtones Light values in an image midway between the lightest and darkest tones. **See also zone system**.

MPEG A digital video format developed by the Motion Picture Expert Group.

N–O

NiCad batteries (also **nicad** and **NiCd**) Once a serious improvement over common alkaloid-based batteries, nickel cadmium batteries are losing favor because they must be recharged frequently.

NiMH batteries Rechargeable nickel metal hydride batteries store up to 50% more power than NiCad batteries.

nodal points The front nodal point in a compound lens is where rays of light entering the lens appear to aim. The rear nodal point is where the rays of light appear to have come from after passing through the lens. The nodal point (singular) is often wrongly cited as the point around which a camera should rotate to avoid parallax error. The correct point is the entrance pupil.

noise A random distortion in an analog signal causing dark or colored flecks in an image, particularly in dark areas. It can be caused by electronic noise in the amplifiers that magnify the signals coming from the image sensor, nearby electrical spikes, heat, or other random electrical fluctuations. Noise is more prevalent at higher ISO levels.

normal lens A lens with about the same angle of view of a scene as the human eye—about 45°.

optical character recognition (OCR) A scanning technology that recognizes letters and translates them into text that can be edited onscreen.

P–Q

panorama An exceptionally wide photograph. Generally, they are expected to have about the same field of view as the human eye—about 75° vertically by 160° horizontally—although there are no hard and fast standards. Some panoramas encompass a 360° horizontal view. Whatever the view, a panorama is expected to retain details that you would not get by simply cropping and enlarging a photo with a normal aspect ratio. Panoramas may be produced by specialized cameras, or *segmented panoramas* may be created by using software to *stitch* together several normal photographs that by themselves contain only parts of the final vista. **See also entrance pupil**.

parallax A composition error caused by the discrepancy between view fields of an optical rangefinder and the lens. Also caused by pivoting the camera incorrectly while taking a segmented panorama. **See also entrance pupil, nodal points**.

photodiode A semiconductor device that converts light into electrical current.

PictBridge An industry open standard that allows photos to be printed directly from digital cameras connected to a printer without an intervening PC.

pixel A picture element, the smallest individual element in an image.

pixelation An effect caused when an image is enlarged so much that individual pixels are easily seen.

pixels per inch (PPI) A measurement of the resolution of an image based on the number of pixels that make up 1 inch.

plug-in A software module that adds new capabilities to imaging programs such as Adobe Photoshop and Paint Shop Pro. **See also filter**.

preview screen A small LCD screen on the back of a camera used to compose or look at photographs.

prime lens A lens whose focal length is fixed, as opposed to a zoom lens, which has a variable focal length. Prime lenses are not as versatile as zooms; often they cost less and yet have better optics because it's easier to optimize optics for a single focal length. **See also zoom lens and fixed focus**.

R

RAW format The uninterpolated data collected directly from the image sensor before processing.

red eye An effect that causes eyes to look red in flash exposures; it's caused by light reflecting off the capillary-covered retina.

red-eye Reduction mode A mechanism that fires a preliminary flash to close the iris of the eye before firing the main flash to take the picture.

resolution The sharpness of an image that's measured in dots per inch (dpi) for printers and pixels per inch (ppi) for scanners, digital cameras, and monitors. The higher the dpi or ppi, the greater the resolution.

resolution, interpolated A process that enlarges an image by adding extra pixels whose color values are calculated from the values of the surrounding pixels.

RGB The acronym for red, green, and blue, which are the primary colors of light and also the color model used for television, digital cameras, and computer monitors.

rule of thirds A rule in composing pictures that divides the frame into nine equal areas. The main objects in the photos should be aligned along one of the lines or at an intersection.

S

saturation The amount of color in a specific hue. More saturation makes the colors appear more vivid, whereas less saturation makes the colors appear muted. **See also brightness and hue**.

Secure Digital memory A memory card about the size of a postage stamp. It weighs about two grams; available with storage capacities as high as 4GB.

sharpening A function in digital darkroom software, some cameras, and some scanners that increases the apparent sharpness of an image by increasing the contrast of pixels along the borders between light and dark areas in the image.

shift-tilt lens A lens with a mechanism that lets part of it shift in any direction parallel to the camera's image plane or tilt in any direction. Shifting the lens is used to correct perspective distortions, particularly in architectural photography, caused when the camera is tilted, for example, at ground level to take in the entirety of a tall building. Tilting the lens changes the depth of field area that's in focus so that it is on a diagonal in relation to the camera, allowing the photographer to bring into focus more elements that are stretching away from the camera.

short lens A wide-angle lens that includes more of the subject area.

shutter The device in a camera that opens and closes to let light from the scene strike the image sensor and expose the image. **See also diaphragm**.

shutter speed The length of time during which the camera shutter remains open. These speeds are expressed in seconds or fractions of a second, such as 2, 1, 1/2, 1/4, 1/8, 1/15, 1/30, 1/60, 1/125, 1/250, 1/500, 1/1000, 1/2000, 1/4000, and 1/8000. Each increment is equal to one full f-stop. Increasing the speed of the shutter one increment, for example, reduces the amount of light let in during the exposure by half, so the lens aperture would need to be opened one f-stop to produce an exposure with the same tonal values as the exposure made with the original shutter speed setting.

shutter-priority mode An automatic exposure system in which you set the shutter speed and the camera selects the aperture (f-stop) used to make the exposure.

SmartMedia A memory card developed by Toshiba that uses flash memory to store data. It measures 45mm × 37mm and is less than 1mm thick. Available in capacities to 128MB.

softbox A lighting enclosure that includes one side fitted with a material that diffuses light to make lighting and shadows cast by it seem less harsh. The larger the diffusing surface, the softer the lighting. **See also umbrella**.

Speedlite and **Speedlight** Trademarked terms for flash units made, respectively, by Canon and Nikon.

T

tagged image file format **See TIFF**.

thermal wax printer Like a dye-sublimation printer, thermal wax printers transfer colors from RGB, CMY, or CMYK ribbons containing waxes, which are warmed and fused onto special papers. These printers generally have excellent imaging quality with poor text quality.

threshold A color or light value of a pixel before software or a camera does anything with the pixel's information. For example, blue values might be substituted with red values, but only if the blue pixels have an intensity within a certain range of values. The higher the threshold, the fewer pixels affected.

thumbnail A small image that represents a bigger version of the same picture.

TIFF A popular lossless image format used by professional photographers and designers. It is also the most common format for scanned images.

TWAIN An industry-standard method for allowing a scanner to communicate directly with image editing software or a word processor.

U–V

umbrella Literally, just what it sounds like it is. But in studio photography, umbrellas may be much larger than the ones used to ward off rain, and they are made of a white material that diffuses light passing through it. Studio light may be aimed into the "underside" of an umbrella so light passes through the material to cast a soft light on the subject. Or, the underside may be pointed toward the subject, and the light is then reflected off the concave surface to achieve much the same effect. **See also softbox**.

upload Sending files from a device, such as a digital camera or memory card, to a computer.

variable-focus A lens whose range of focus can be changed from a close distance to infinity.

viewfinder, optical A separate window that shows what would be included in a photograph, but only approximately.

viewfinder, single-lens reflex A viewfinder whose image comes directly through the same lens that will be used for taking the picture.

viewfinder, TTL (through-the-lens) A viewfinder that looks through the lens to use the same image produced by the lens to create a photograph.

W–X–Y–Z

white balance An automatic or manual control that adjusts the brightest part of the scene so it looks white.

white point The color that is made from values of 255, each for red, blue, or green in a camera's sensor image, a monitor, or a scanner. On paper, the white point is whatever color the paper is.

wide-angle lens A lens with an angle of view between 62° and 84°.

xD Picture Card Weighing 2.8 grams and not much bigger than a penny (20mm × 25mm × 1.78mm), the xD Picture Card is used in Olympus and Fuji digital cameras. There are two types of xD cards, M and H. Type H is the newer and faster of the two.

zone system A method developed by photographer Ansel Adams for setting exposure compensation by dividing the entire grayscale range in 11 zones from 100% white to 100% black.

zoom, digital A way of emulating the telephoto capabilities of a zoom lens by enlarging the center of the image and inserting new pixels into the image using interpolation. **See also interpolation**.

zoom, optical A method that changes the focal length of a lens to change its angle of view from wide angle to telephoto. Optical zoom is preferable to digital zoom.

zoom lens A lens that lets you change focal lengths on-the-fly.

Index

SM (Smart Media) cards, 114

smooth impact drive mechanisms (SIDMs), 128

snoot lights, 95-97

softbox lighting, 95-97

Sony Memory Stick, 114

spatially varying pixel exposures, 105

spectral sensitizers, 100-101

sports mode, 74

spot metering, 71

stabilizers, 21

stators, 45

step-up transformers, 86

Stieglitz, Alfred, 143

stitching software, 178

stop bath solution, 101

storing images, 12-13

strobes, 94

studio lighting, 94-97

subtractive color, 188

sync cables, 87

synchronizing flash and shutter, 90-91

T

tears, fixing, 164-165

telephoto lenses, 52-53

thermal (dye sublimation) printers, 198-199

thermal nozzles (printers), 196

threshold, 147

through-the-lens (TTL) viewfinders, 51

thyristors, 89

tiles, 111

tilt-and-shift lenses, 130-131

time value exposure mode, 75

tokens, 113

tools

 airbrush, 169

 Burn, 168

 Cloning, 164-165, 169

 Dodge, 168

 Dust & Scratches, 166-167

 Gradient, 169

 HDR (high dynamic range), 158-159

 Healing, 164-165, 168

 Selection, 168

 Sharpen, 169

 Unsharp Mask, 147

transducers, 40

transformers, 137

triangulation active autofocus, 41

trigger charges, 87

trigger plates, 87

tristimulus values, 191

TTL (through-the-lens) viewfinders, 51

twilight mode, 74

Type I (flash memory), 114

Type II (flash memory), 114

U

ultra-wide lenses, 133

ultrasonic motors (USMs), 44-45

ultrasonic waves, 45

umbrellas, 95,97

uncoated paper, 197

Safari®
BOOKS ONLINE
ENABLED

THIS BOOK IS SAFARI ENABLED

INCLUDES FREE 45-DAY ACCESS TO THE ONLINE EDITION

The Safari® Enabled icon on the cover of your favorite technology book means the book is available through Safari Bookshelf. When you buy this book, you get free access to the online edition for 45 days.

Safari Bookshelf is an electronic reference library that lets you easily search thousands of technical books, find code samples, download chapters, and access technical information whenever and wherever you need it.

TO GAIN 45-DAY SAFARI ENABLED ACCESS TO THIS BOOK:

- Go to **http://www.quepublishing.com/safarienabled**
- Complete the brief registration form
- Enter the coupon code found in the front of this book on the "Copyright" page

If you have difficulty registering on Safari Bookshelf or accessing the online edition, please e-mail customer-service@safaribooksonline.com.